SURVIVING
FIVE FINGER DEATH PUNCH'S
METAL MAYHEM

Death

DEY ST.
AN IMPRINT OF
WILLIAM MORROW PUBLISHERS

Punch'd

JEREMY SPENCER

DEY ST.

HarperCollins books may be purchased for educational, business, or sales promotional use. For information please e-mail the Special Markets Department at SPsales@harpercollins.com.

A hardcover edition of this book was published in 2014 by Dey Street Books, an imprint of William Morrow Publishers.

FIRST DEY STREET BOOKS PAPERBACK EDITION PUBLISHED 2015.

Designed by Janet M. Evans

Library of Congress Cataloging-in-Publication Data has been applied for.

ISBN 978-0-06-230811-5

19 PC/LSC 10 9 8 7 6 5 4 3

Plato says that the unexamined life is not worth living. But what if the examined life turns out to be a clunker as well?

—*Kurt Vonnegut*

CONTENTS

PROLOGUE

Lying in a king-size bed in an executive suite at the Mandalay Bay, I was shaking uncontrollably. My heart repeatedly skipped beats and I was about to check out . . . not from my room but from my life. Out the darkened window, the dazzling panoply of multicolored lights stared back as if to say, "In Vegas, even death is shrouded in glamour." Glamour . . . what a joke. The glitz might as well be a CGI creation, for nothing in Vegas is real except the potential for loss. People flock to this desert oasis, hoping to leave a "winner," to escape or salvage their lives, to right the sinking ship or somehow validate their existence, but if they stay long enough, the odds are guaranteed they'll end up losing: the next mortgage payment, life savings, homes, family, self-respect . . . maybe *everything*—including the will to live.

That's when I started thinking of my parents and how crushed they'd be if their son, who'd left home at nineteen, with $150 in his pocket, no job, and no prospects to pursue his dream of being in a successful rock band, died from a cocaine overdose.

That's when it hit me. *ENOUGH!* I'd been up for two fog-filled sleepless days. For the last seventeen frenetic hours, when I wasn't

fucking and sometimes even when I was, I had a cup of Jack Daniel's in one hand and a straw in the other. The chick I'd flown out for the weekend had ingested so much meth she lay—nude and unconscious—next to me. Like a crazed dog, I'd indulged in sex, booze, and cocaine to a point that I was now clutching my heart to keep it from exploding from my chest. It was fibrillating, skipping beats . . . and for a drummer, that's some scary shit. Still, all I cared about was snorting the last of my cocaine and getting more.

I mean, if there was any coke left, I had to do it. Need a visual? Try this: if there was a *Close Encounters of the Third Kind* mashed-potatoes pile of cocaine left, I had to do it . . . *all*. In case you've never seen the movie, what I'm saying is . . . it was a fucking huge pile of blow, similar to the mountain of mashed potatoes Richard Dreyfus compulsively sculpts into the Devil's Tower on his dinner plate while his family looks on in abject horror.

I'd had numerous parties, far too many, but this time the party had me. After snorting shitloads of coke and meth, my body finally gave out. Struck with the force of an electroshock current to the brain, I began convulsing and feared I couldn't stop.

This was it: The End.

All of the late nights had finally caught up with me. I was on top of the world with my third smash-hit album, and at that point, the coolest thing about gold records was you could snort cocaine off them.

CHAPTER 1

THE DREAM

2005

I'd had enough of the music biz.

For over ten years, I'd tried everything to break through, believing success was just round the corner. Band after band—some that had deals and lost them, others right on the cusp, and still others without a prayer—I'd experienced every kind but one that succeeded. All the while, I'd watched from the sidelines while gimmick bands or carbon-copy bands or flavor-of-the-month bands got deals, snared the gold ring, and hit the big time—knowing none was any better than some I'd been a part of.

It had taken years, but I suddenly realized the Golden Rule was a hoax and that hard work didn't always pay off. I hadn't done to others anything comparable to the shit that had been dealt my way. And furthermore, "the best" doesn't always win: not the best song, the best singer, the best musician, the best painting, the best artist, the best film, or the best actor—far from it. In fact, if the best does occasionally find itself in the winner's circle, it often has more to do with a behind-the-scenes payoff—whether a payback or a greased palm—or with sheer luck rather than brilliance. Unquestionably, luck appears to be way more important than talent. And fairness has little or nothing to do with how the game's played. As the saying goes, "It's not who you know, it's who you blow."

I'd recently had a close call of being a member of the venerable shock-rock band W.A.S.P., who peaked back in the mid-'80s. Not

exactly my dream gig, but after the close calls and disappointments I'd faced, W.A.S.P. was at least a bona fide band of heavy metal's glorious past. After a grueling audition process, I was hired by the founder and lead singer, Blackie Lawless. I was so happy I told everyone I knew and quickly quit my data-processing job to begin rehearsing. But, just days before we were to go on a big European tour, Blackie fired me—telling me their old drummer wanted the gig back. After years of disappointment, I decided my lifelong, fantasy-filled dream had dragged on long enough. I was over it. I called Dad in Tennessee and told him I'd given it my best shot, endured all the frustration I could withstand, and now—with the added humiliation of misinforming all my friends that I'd be touring with W.A.S.P.—I was more than ready to come home.

"I don't think so," he said.

"What do you mean? I've been out here grinding away pretty much since high school."

"Jeremy, you've almost always played in bands you either didn't like or you weren't really into. You've played music you hated or music you found lacking, and never once have you played the music you love . . . metal."

"The metal scene's dead, Dad."

"I'm not talking about selling quadruple platinum, I'm talking about finally allowing yourself to play music you care about."

"So what are you saying? You don't want me to come back?"

"You can come back anytime you need to, but in the long run, I don't think you'll be happy until you do what you were intended to do. Try to find some like-minded people, get together, and do your own thing. If it comes to nothing, at least you're playing music you've always been passionate about."

I hung up—thinking, *Great* . . . that all sounds good, but it's not gonna happen. And, knowing I couldn't exist another week without a paycheck, I faced further humiliation by having to call my old boss to see if I could have my mind-numbing data-entry job back. I felt both relief and complete defeat when she said yes.

The more I thought about it, the more I knew Dad was right. After nearly a dozen years, it was time I finally played in the right band, a band I helped form, playing the kind of music I loved: METAL.

As for the current metal scene, I'd been listening to Killswitch Engage, Trivium, and Shadows Fall. I liked those bands, even though their style wasn't what I was looking for. I wanted to be part of a band that had great songs with powerful melodic vocals, cool rhythmic guitars, and shredding double-bass drum. As opposed to a single bass used by most rock drummers, with the exception of Cream's Ginger Baker, Rush's Neal Peart, and a few others, the use of two bass drums hit its stride when the '80s head-banging bands emerged. If I had an edge as a drummer, it was that my double-bass playing sounded like a machine gun on a toxic dose of Dexedrine. I went to the Music Connection website, where musicians place wanted ads, and punched in "Shredding double-bass metal drummer."

In the past, when something really good was about to happen, I would notice a red-tailed hawk circling in the sky, sometimes swooping low overhead. Sounds mystical, I know, but it had happened enough times that I took it to mean an omen of good things on the horizon. However, there was no hawk flying over me this time, or if there was, it was obscured by the ever-present LA smog. Instead, a response to my ad appeared from a guy named Zoltan. Wow, it sounded

like the name of the magic wish machine Tom Hanks discovered on the Boardwalk in *Big*: Zoltar Speaks. Maybe this Zoltan would turn out to be a magic man. That was my earnest hope, anyway.

I fired off a reply e-mail with a track I'd originally recorded on my longtime friend Jason Hook's solo record, *Safety Dunce*. Immediately Zoltan answered back, saying he liked my playing, but he was looking at a few other guys including Jon Dette, who'd played with Slayer. I quickly responded, assuring him I was *the* guy, and we should get together—that there was no need to waste his time trying to find someone else.

It turned out that Zoltan Bathory, the former bassist with U.P.O., a band I was unaware of but that had minor success when they morphed from a late-'90s post-grunge-rock band into part of the nu-metal wave. Zo, who toured with U.P.O. briefly in 2004, had seen me play in another band, years before, and liked me then. I guess the brashness of my e-mail impressed him. He sent me some demos of his songs, and I dug what I heard. They had cool rhythm guitars, fast sixteenth-note-style picking, not unlike what I'd done with Jason. I thought, I could really add something to this.

I invited him to an upcoming show. I knew I'd be playing a drum solo and could further sell the idea of being the right guy for his project. He arrived with a scorching hot chick. I assumed she was Latina and he was Brazilian. Turned out she was Chinese and he was Hungarian. Clearly, I would not be working TSA airport security anytime soon.

Zoltan spoke fluent English, laminated with a distinctive Hungarian accent. It took some real concentration on my part to understand everything he said. However, my takeaway from that first meeting was, This guy is smart and serious. So I made every effort to

impress him, and it worked. We agreed to get together and start hashing out the material.

As personalities, the two of us couldn't have been more different. Whatever emotion I'm feeling, it's on display—whether I'm on the highest mountain peak or in the depths of despair. (Bipolar, anyone?) Whether feeling anger or enthusiasm, I hold nothing back. Some people find this refreshing, others exhausting, and some—deadly. When feeling threatened or deceived, my vitriolic tongue can penetrate the toughest skin, locate—like a heat-seeking missile—the ego's vulnerable G-spot, and verbally annihilate it! (Not proud of that defense mechanism; just trying to be honest.) I acquired that critical ability naturally, since I'd grown up listening to my family dissect plays, movies, music, and anything that tried to pass itself off as art but was less than perfect or just plain ersatz—like cubic zirconia being sold as genuine diamond. While the average family discussed their favorite TV shows or favorite potato-salad recipe, ours explored the psychological motivation for others' actions and revealed those findings in language usually reserved for literary essays. Therefore I come armed with a vocabulary honed by masters.

Zoltan, on the other hand, was a member of the Hungarian army at fifteen. He's into martial arts and expresses himself physically. Beyond stoic, he occasionally smiles, but most of the time he appears expressionless. Growing up, my family was effusive, supportive, and loving. Zo's was nondemonstrative, except when his mother was criticizing him, which he says she did relentlessly. My moods can shift with the phases of the moon; Zo is, for the most part, restrained and steadfast. Complementary, not opposing; yin and yang, the perfect balance . . . an indivisible whole. Early on, that's who we were and what we appeared to possess.

We moved through the material quickly, setting a date to begin tracking in the studio. This wasn't a laid-back studio experience. This was a get-in-and-out quickie, necessitated by the fact that we didn't have the cash to fuck around. We were serious and focused on getting it done right the first time. We tracked half a dozen things and I edited it all together. We both agreed it sounded pretty kick-ass. If the rest of this project proved to be as successful as those first tracks, we'd not only have something we could be proud of but also something unquestionably marketable.

Our attention then turned to finding the right guys to complete the band. Zoltan had heard from some people about a bass player and a singer who used to be in a band called Deadsett, which later became In This Moment (once they added Maria). The singer possessed a heavy scream but lacked the type of melodic voice we wanted. Still, I hoped we could make it work. The bass player, Matt Snell, barely said two words when he first walked in, appearing less than excited to be there. However, when we played them some material, they both agreed to get together.

After a couple of weeks of rehearsing, it was obvious the singer didn't dig what we were doing. Matt, who had a caustic mouth that matched my own, had mastered a look of extreme boredom and didn't appear to like it much either. But, when asked, he insisted he was into it. We decided to track the singer's vocals to see how his lyrics and voice matched up. I had to work, so Zoltan and Matt recorded him. I anxiously awaited the results. Zo sent me the songs with the vocals, which turned out to be less than stellar. When I asked him to rate what he heard, he said they were about an 8. I thought, Oh, man, our rating systems are way off. But when he added, "An eight on the Richter scale," I burst out laughing.

Finding a great singer is always the hardest part of forming a band; I'd been through it many times. In order for us to have any shot at a breakthrough, we needed someone better than just good enough: we needed someone killer. We knew we hadn't found him yet. When Zo told the singer we didn't think the marriage was going to work, he agreed—saying he wasn't really into our vibe anyway.

The search was on again.

Zo heard that Ivan "Ghost" Moody, from a band called Motograter, might be available, since they'd recently disbanded. (Great word, right?) He'd seen Ivan several years before at Ozzfest and said he was the real deal, a "motherfucker." In addition to being a great singer, he had a reputation for commanding the stage and owning the audience. Matt and I were like, "Cool, let's get him the fuck down here and see what he can do."

Getting him "down here" was a little more complicated, since Ivan lived in Denver. When contacted, he kept hedging, all the while saying, "Yeah, man, I'm coming down there." Still, the delays continued for several weeks. Matt and I were starting to think it wasn't going to work out after all.

Zo insisted, "He's great, be patient . . . it'll be worth the wait."

He sent Ivan a few unmixed tracks to try his hand at writing lyrics. They were so poorly mixed you couldn't hear my kick drums at all—only snare, hi-hat and crash. The first time I talked to Ivan on the phone, he asked, "Hey, man, do you even *play* double bass?" I just started laughing and explained about the bad mix. I could tell he was relieved.

After a few weeks, Zo got tired of Ivan's stalling and booked him a flight to LA. We were finally going to find out if this guy lived up to his billing. I had high hopes, but I'd been disappointed enough

times that I was withholding judgment until I could hear him in person. Though no one said it, we were all pinning our hopes on him.

I'll never forget the minute he walked into our rehearsal space. He looked like he was on the Ultimate Fighting circuit. He had a blond faux-hawk and a teardrop tat by his right eye. I didn't know if he'd been incarcerated and lost a loved one, if it identified him as a gang member, or if it was just a fad. I wasn't going to ask.

What I did know for certain was that he'd stopped on the way to the audition and picked up a bottle of lemon vodka and a Sprite. I spotted that right away, and I was torn between wanting to hear him sing and having a drink. Ideally, I could do both.

We introduced ourselves. Ivan acted really insecure and could barely make eye contact. We tried to put him at ease by making small talk, but when the conversation lagged, he said, "God, I'm nervous."

I thought that was great . . . and *real*. And man, how I longed for something real in a business usually as phony and trumped-up as the Hollywood sign and the Walk of Fame. We assured him there was no reason to be nervous. While he shifted from one foot to the next like a nervous schoolboy, Matt cued up a song through the PA—"Meet the Monster."

Please, for once, let this work, was all I could think.

When the intro blared, Ivan turned his back to us—facing the wall. Self-protective . . . or just how it would be onstage? The anticipation was killing me. I was hoping for something amazing, but I couldn't believe what I heard. In an instant, he transformed from a self-conscious guy into someone totally possessed. He wasn't singing to a wall in a shithole rehearsal studio, he was performing at Ozzfest before twenty thousand screaming fans. He was in total command, and I'm not exaggerating by saying he blew us away.

This will totally work! I thought. No question, he rocked the hardcore material, but what about "The Bleeding"? I knew that track had the potential to be our big breakout killer ballad. Matt cued it up and I held my breath. I wish I could describe the exact feeling I had when those first notes came floating out of Ivan's mouth. Beyond instant relief, it was a "knowing" that we'd finally found *the* singer, and that the career I'd always wanted could now be reality. With every line of that first verse, I knew we had a motherfucker of a hit.

> *I remember when all the games began,*
> *Remember every little lie,*
> *And every last good-bye.*
> *Promises you broke, words you choked on,*
> *And I never walked away. It's still a mystery to me.*
> *Well I'm so empty.*
> *I'm better off without you,*
> *You're better off without me.*
> *Well you're so unclean!*
> *I'm better off without you,*
> *You're better off without me.*
> *The lying! The bleeding! The screaming!*
> *Was tearing me apart!*
> *The hatred! Deceiving! The bleeding!*
> *It's over!*

Pure raw feeling. It was evident he was writing from an emotional place that was visceral and real. And he sang it with enough conviction that I knew then "The Bleeding" was going to change our lives forever.

12

I texted my girlfriend, Angel: "We found *the* guy. Remember the name . . . Ivan Moody. He's fucking incredible."

When he finished, he turned around with a look like a little boy seeking approval. "Was it okay?"

Okay . . . ? Hmmm . . . let me think . . . No! It was phenomenal. We all told him how awesome he was—that "The Bleeding" was a smash. His lyrics were authentic. This wasn't a bunch of emo pain or grunge angst. This guy had lived it. The combination of Ivan's voice and those lyrics was totally genuine—the real deal. I'd been waiting for this ever since I first arrived in Hollywood.

To celebrate, we shared the whole pint of lemon vodka. This was going to be a brilliant collaboration. After years of playing in shit bands with no chance, or good bands that came close but fell short, I was finally home.

That night, lying in bed, reliving the pure joy of hearing Ivan sing and feeling like we had a legitimate chance of "making it," I recalled the hundreds of hours of banging on my first drum kit, a kid's toy from Sears, pretending to be a rock star, dreaming that one day I'd be performing for thousands of screaming fans. Finally, deep down I knew it was only a matter of time.

It was like the stars had finally aligned in our favor. We had an awesome band, an incredible lead singer, and the beginning of an album that was strong enough to get the attention of a record label. The long journey that had begun in the strip pits of southern Indiana was finally reaching a destination I long dreamed about, but one fraught with problems I'd never imagined.

Everything, including success, comes with a price.

CHAPTER 2

IN EXORDIUM

1973–79

I share a birthday with Elvis, David Bowie, and Stephen Hawking: January 8. Apparently it's a day that produces pop-culture phenomena, amazing musicians, and the occasional alien physicist. The year was 1973 and the U.S. was about to withdraw its last troops from Vietnam. Nixon had just declared, "I am not a crook." A gallon of gasoline cost forty cents. And, most important, Jeremy Spencer Heyde made his first appearance to modest but enthusiastic applause.

I was born in Oakland City, a small town in southern Indiana. Unlike my sister, who tortured Mom during nearly twelve hours of labor, I popped out just minutes after the doctor arrived. Dad dressed in green hospital scrubs, feared he was going to have to deliver me, but Dr. Peters made it just in time. That's always been my way. Patience is not a virtue I've ever had or admired. Besides, I'd waited nine long months to make an appearance. Enough already.

Oakland City was a General Baptist paradise, where husbands and wives sat across from each other at the dinner table—silent and bored to tears—just waiting for the other one to die. This is the kind of town where the KKK had regular meetings to plot the next cross burning. My dad, Gary, who at twenty-five was editor of the local newspaper, wrote a front-page editorial condemning an actual cross burning at Wirth Park, and two days later the Klan sent a threatening letter saying to expect a "fiery cross" in our front yard. He turned the letter over to the FBI. They found forty-seven sets of fingerprints.

That meant that within forty-eight hours of the editorial's appearance, the KKK had held a meeting and had written and passed around the letter to the brotherhood. The local police wanted to assign a cop to watch our house, but Dad turned them down because the cop was a member of the Klan. What better birthplace for a potential hell-raiser like me?

My parents said I came into the world angry. As a toddler, if things didn't go my way I would fling myself on the floor, kicking and screaming. I've always had a hair trigger emotionally, always struggled with anger issues, always been fired up about something. I must have been pissed about some past life imposing itself on present reality. My feeling not good enough can trigger some explosive behavior, and when it comes to a power struggle, I'm in it to the bloody end.

My parents met at the University of Missouri in Columbia, when they were cast opposite each other in the summer musical, *The Boyfriend*. Dad always joked that after he "proposed" to my mom, Glory, onstage in front of four thousand people, he felt obligated to marry her. He was only twenty; she was twenty-six. He'd just finished his freshman year and she already had a master's degree and was a graduate assistant in the vocal music department. I didn't find out until I was a teenager that she'd been married briefly to a guy who was supposedly a musical genius.

Gloria Francine Kissel grew up in a St. Louis suburb and was outgoing, with a bigger-than-life personality. Dad said the first time he met her, he knew instantly she was the one. He said she was effervescent and a natural comedienne: "Carol Channing's eyes and Carol Burnett's physicality." Onstage, her theatricality made her a favorite with audiences. And in the classroom, students loved her.

Her public persona was really fun-loving and manic. But at home it sometimes felt like she'd burned up a lot of energy being "on," and it left her exhausted. She was a hard worker, so part of that was just being tired. (Looking back, I now recognize myself in her up-and-down emotions.) Some of it may have had to do with her father leaving when she was only four. It didn't help that he moved five hundred miles away, remarried only days after the divorce was final, fathered eight kids, and had little time for her.

All that contributed to her abandonment issues, her feeling not good enough—no doubt part of the reason she developed her please-like-me personality. Mom was a professor of vocal music for more than twenty years before becoming a professional actress. Now in her early seventies, she's still acting in various Chicago theaters. She's quirky and fun, and I love her to death.

Gary Austin Heyde was from a small town in northwest Missouri. He was an odd mixture of masculine and feminine energy. In high school, like both his parents before him, he was an outstanding athlete, lettering three years in basketball (still in the MSHSAA record book for eighteen assists in one game) and four years in golf, which he hoped to play at the University of Missouri before getting involved in theater. When the two conflicted, he chose his major, Speech and Drama—becoming the youngest member ever inducted into the theater's honor society. He's one of those people who could do whatever struck his fancy, even if he had no previous training or experience. He taught high school art and English for a year. Then he became editor of a small weekly newspaper, winning awards in editorial writing and photography, before becoming the director of cultural affairs at Mom's college. At twenty-three he founded a community theater, wrote a couple of full-scale musicals, and acted

in and directed a multitude of plays and musicals. When I was four, he became a copywriter at a large advertising agency in Evansville, began writing and producing jingles for radio and TV, and, within a year, became creative director—before opening his own music-production company and ad agency. At age forty-five he became a hit songwriter in Nashville, and then at fifty-two began an outstanding teaching career for the next decade. In his early sixties, as Austin Gary, he became a novelist and playwright.

Mom and Dad were married for thirty-five years but went their separate ways in 2002.

<hr />

From day one, Dad and I deeply bonded, because when I was born, Mom had the flu and couldn't be around me much for the first week. So he slept downstairs—with me lying on his chest. I got used to the beat of his heart . . . as he did mine. He's always been my best friend, someone I could turn to, and I can't imagine that ever changing.

But seven years into their marriage, in May 1975, he decided he'd had enough of Oakland City, the General Baptist College where Mom taught, the pseudo-Christians who peopled it . . . and her. He left a note and took off with eight dollars in his pocket. I know now his leaving had nothing to do with my sister or me, but at the time, his sudden departure flipped me out so badly I stopped walking and started crawling again. When I tried to walk, I fell and cut a big gash above my right eye. I looked like I'd gone ten rounds with a phantom weight.

Then, a few weeks later, while Mom was outdoors talking to a neighbor, my sister, Natalie, came downstairs only to discover Mom "missing." She walked out onto the back screened-in porch, quickly

scanned the backyard, but failed to see Mom standing in the neighbor's yard, less than thirty yards away. A caretaker by nature, she quickly determined that Mom, too, had abandoned us and that she was now in charge. Though she was only three and a half years older than me, I looked up to my sister and believed anything she told me, a belief which—as you shall soon see—could lead to big trouble.

I still remember exactly where we were and the expression on her face when she said, solemnly, "Jeremy . . . Mom's gone. I'll be taking care of us now."

That might seem funny or cute, but it was pretty heavy news to bust out on a two-and-a-half-year-old. Because I thought Natalie was an angel, I figured Mom's "leaving" had to be because of me. (Obviously, she hadn't left, but just thinking she had, if only for a few minutes, added to the psychological damage and the fear that loved ones could abandon me without warning.)

Dad's absence really took a toll on everyone. Many evenings, Mom sat out in the backyard with a glass of wine and talked to God, who apparently was not only the Creator of the universe but also—when needed—an understanding barkeep and therapist. Things got pretty twisted. After being gone three months, Dad returned. He said he'd missed us so much he cried every night, and his love for us was unbearable to live without. I was too young to understand much of it, but within twenty-four hours of his return, I was walking again.

No matter my parents' ever-changing dynamic, one thing was constant: MUSIC. There was always music in our home—lots of singing and dancing around the living room, crazy amounts of laughter and fun. However, many times I felt a little overwhelmed by how verbal both my parents and my sister were. Sometimes it was hard to get a word in edgewise. (I realize now the competition for

self-expression was good training ground for being in a band with highly opinionated members.) For whatever it may have lacked in stability, the Heyde household was always creatively stimulating and entertaining.

The downside of living in that theatrical atmosphere was being inundated with some music that made my asshole pucker—even at the age of three. I'm sorry, but Barbra Streisand records didn't thrill me in the slightest bit (though I thought *A Star Is Born* was a solid feature film). Instead they damn near killed my soul jamming her every day . . . that and fucking musical soundtracks: *A Chorus Line, Hair, Funny Girl, Dames at Sea, West Side Story* . . . the list was endless.

I never understood the fascination with that overacting, jazz-hands bullshit, singing and spinning around at the same time on the same cue. Everyone in my family loved musicals except me. Forced to endure them daily, it was an endless loop of musical hell. My ear holes were being bored out worse than the chicks who star in those fifty-guy anal cream-pie porn DVDs. Is it any wonder I later rebelled and started listening to metal? Try listening to the cast album from *Oklahoma* and tell me Slayer doesn't sound like the soundtrack to heaven. "Oh, What a Beautiful [Fucking] Mornin'" and "The Surrey with the [Goddamn] Fringe on Top" helped mold me into the contrary, cynical bastard I soon became. With a steady diet of show tunes, it was imperative for me to venture out into my own musical territory.

Speaking of venturing out, I once crossed the street—probably not even looking at whether or not cars were coming—just intent on getting there or getting away. At three years old, crossing the street, even in a small town, was a major accomplishment in itself—akin to

Joan Wilder traveling all the way to Cartagena to save her sister in *Romancing the Stone*: risky, but necessary to life's drama. (Have I mentioned that my whole family was brilliantly referential when it came to old movies, advertising slogans, and culture of a bygone era? To this day I have no interest in chicks who don't like movies or get pop-culture references.)

When I finally reached our neighbor's yard, I suddenly realized why I'd become the Prince of Adventure . . . it was to take a royal dump. Without hesitating, I pulled down my pants and proceeded to lay a hot triple-coiler on the front lawn. *Why*, you ask? Why *not!*

I might have made it safely back home undetected, had the neighbor not come outside and caught me in the act. Most people would be upset seeing a little kid pulling soft serve on their grass, but this guy was so awed by the ginormous rope of steaming excrement I'd deposited on his immaculately mown lawn, he didn't utter a word of protest: he just stood there slack-jawed, which I interpreted to be a sign of admiration.

At that very moment, Mom spotted me depositing the fecal lawn ornament, bolted out the door, and raced across the street. When she saw the monumental mound of manure, she was embarrassed but relieved that a car hadn't maimed or killed me. After apologizing, she carried me back home and upstairs to clean me off. I'd made a little mess in the process of delivering my "gifty" to the neighbor, who could be seen through the bathroom window removing it with a big red snow shovel. He appeared to be muttering to himself.

I never shat in anyone's yard again. Although I can think of a few people I would've like to have "gifted"—and still do to this day. If nothing else, the story clearly illustrates I've always been full of it . . . yet generous.

Just so you'll get the total picture of what a charming little three-year-old I was—with my shaggy hair, dimpled cheeks, and big brown eyes—here's an incident that became a family favorite, one that may have been an early indication of how I would become known as someone who could toss a verbal bombshell or two.

Everyone believed my sister, Natalie, to be the perfect angel; little did they know she often played the role of evil conniver. One evening Pastor Barry, from the Lutheran church Mom attended in a neighboring town, came to our house to see if he could encourage Dad to start attending, too. Though I didn't understand much of what they were discussing, I sat on the upstairs landing, listening.

Natalie sat down beside me and whispered something in my ear. She told me to go downstairs and repeat *exactly* what she said. I didn't think twice about doing it. After all, she was my older sister: a role model, someone I looked up to and trusted with my life.

Armed with an important message, I promptly descended the stairs, walked right up to Pastor Barry—chatting away on our living room sofa—and tugged on his shirtsleeve. He looked down at me and smiled. You know the one . . . that holier-than-thou, mouth-full-of-Chiclets toothy grin.

"Well, hi there, little guy," he said. "How're you this evening . . . uh . . . ?"

"Jeremy," prompted Mom.

"Of course! How're you this evening, Jeremy?" he repeated with a big ol' Lutheran shit-eating smile.

"I stuck my finger up Jesus' butthole!" I emphatically announced.

My parents gasped. The preacher was stunned. Surely, he hadn't heard me correctly.

"I'm sorry, honey . . . *what* did you say . . . ?"

23

Before my parents could gag me, I repeated, "I stuck my finger up Jesus' butthole!"

Boy, oh, boy, was I proud of myself. Pleased I'd remembered to say the words exactly like my sister had instructed, pleased they'd elicited such an emotional response. However, no one else seemed thrilled with my recitation. I couldn't comprehend why things suddenly got weird, but it felt like the barometric pressure shifted in the room.

The minister was speechless: gob-smacked. (Or should I say God-smacked?) The Spawn of Satan had spoken, and, as far as Pastor Barry was concerned, I'd morphed from Christopher Robin into Damien, the demon child. This was the house of Beelzebub, but obviously the good pastor wasn't prepared to perform an immediate exorcism. Instead he leapt to his feet and muttered something incomprehensible as he headed for the door. We watched as he sped away in his faded blue Ford Falcon with the I'm-a-Lutheran-and-unworthy-of-something-better rust spots.

Natalie sat on the stairs, looking on and giggling like Linda Blair in *The Exorcist* after she killed Father Merrin. She was really proud of herself . . . enjoying one of her finest moments. Looking back, I give her kudos. That was pretty kick-ass and creative for a seven-year-old kid.

I don't remember going back to Our Savior Lutheran Church, though I'm sure Mom persisted in trying to save my soul a little while longer. She'd long ago given up on Dad's.

———◆◆◆———

I could cajole you with more of my early-childhood tales, but let me skip ahead to how I ran the gamut of emotion the summer I was six—

and how it all pointed the way to my rock 'n' roll destiny. By then we'd moved from Oakland City to another redneck haven, Boonville, Indiana, sixteen miles east of Evansville. The only way our artistic family was going to fit into this burg was for Dad to buy an extended-cab pickup truck sporting a Confederate flag in the rear window—and that was less likely to happen than us winning the Powerball.

That certain summer I spent a lot of time at the home of one of my best friends, Brian, who introduced me to a life changer . . . the hottest band in the world: KISS! When I heard *KISS Alive!* I was mesmerized. It made my childhood favorites, B. J. Thomas and Paul Simon, pale in comparison. "Raindrops Keep Falling on My Head" and "Me & Julio" were lightweight fun, but this had a heavy fucking vibe. It rocked. I was instantly hooked—not only on the music but also on the record cover itself: the artwork, the gatefold, the weird and wild stylized makeup. All of it was the total shit!

For hours on end we jammed *Alive!* while pretending to *be* KISS. We were in Cobo Hall one minute, the auditorium of the local high school the next. We could draw this up any way we wanted: endless possibilities. With KISS, I discovered something way cooler than smoking cigarettes or drinking booze, both of which I'd already experimented with by age six (more, much more, on that later). This was my new life, my new identity: *being* KISS—Gene, Paul, Ace, and Peter. They'd formed the band in '73, the year I was born. Like Halley's Comet announcing Mark Twain's arrival, KISS affirmed mine. (Little did I know then that I would someday open for them when Death Punch toured Germany. Ain't life a kick?)

To his parents' dismay, Brian and I performed the entire album repeatedly: "Rock and Roll All Nite," "Cold Gin," "Strutter" . . . all of

them. I spent all day perfecting my air-drumming skills to "100,000 Years," which featured an eleven-minute Peter Criss drum solo (self-indulgent . . . of course, that's why I loved it). It occurred to me that this was what KISS got to do *every single day.* What a life . . . the life of a rock star. Not only did you get to be on a stage in a big arena with tons of people screaming, you also got to perform a solo and be the star of the show for one shining moment. What could be cooler than that? I returned home with one mission in mind: to collect every KISS record.

Around this time, the single "I Was Made for Lovin' You" was released off the *Dynasty* LP. I received the 45 for Christmas, along with what would be the most important gift I would ever get: a box containing something that would help define my role in life. It was a BIG box. I already had a bicycle. Whatever could it be . . . ?

I tore into the Christmas wrapping, mutilating the cardboard box. Was it? Could it be . . . in fact, it was: a seventy-nine-dollar drum set from Sears. Good ol' Grandma Evie, Mom's mother, had rocked me this incredible gift. Even though it was obvious she liked my sister more, and even though I would now have to let her kiss me without struggling to escape, it was fucking worth it. This must be what Picasso felt like when he got his first paint set; how Jordan felt when he got his first basketball; how Pee-wee Herman felt when he got his first pair of white bucks. I now had my own drums. Peter Criss . . . look out, baby, here I come!

All I did the rest of the day was bang on that piece-of-crap drum kit. It could have been two oatmeal boxes and a tin can—I didn't care. It was all *mine.*

When the day wound down from drumming, I wandered upstairs to the stereo where I put on my second-favorite gift from that

memorable Christmas of '79: the "I Was Made for Lovin' You" 45. I listened to it twenty times in a row. Excessive, I admit, but excess would be my "normal" for the rest of my life. I lay on the floor behind the stereo with my upper body pinned between the stereo and wall. What a great Christmas. A drum set and KISS. Both were like drugs to me, pushing my emotions to the extreme—way cooler than getting drunk or smoking stolen cigs.

<center>——◆——</center>

It wasn't long before Brian and I decided it was time to put on a KISS concert for my neighborhood buds. We dressed up like them, with borrowed stage makeup from my folks. Brian had an improvised costume, but Dad made me one with silver metallic material and red fur trim. Brian played the plastic KISS guitar I'd gotten for my birthday, and I banged the shit out of the Sears drum kit. I pretended to be Peter Criss—rocking at Detroit's Cobo Hall. In reality, I didn't keep time very well, but it didn't matter. It was all about the show. The guest of honor at the concert was none other than the wonderful lady who purchased the seventy-nine-dollar Sears special . . . Grandma Evie. Brian and I rocked through song after song, and when we finished, we smeared our makeup, thrashed the gear around, and ended it all with me throwing my drumstick into the "crowd" of eight—beaning Grandma in the head. How's that for appreciation?

Not long after, Brian called with some amazing news: KISS was coming to Evansville to play at Roberts Stadium! His mom was taking him, and hopefully I could come, too. I went home super stoked. My parents couldn't say no, knowing how much it meant to me.

"No. Absolutely not."

I felt like I'd been punched in the stomach.

"But *why*? Brian's mother is taking him."

"Good . . . he can tell you all about it."

You can bet I pitched a fit, but nothing I did or said would change their minds. To this day, I don't understand why they wouldn't let me go. Perhaps they were worried about me being around a bunch of rowdy teenagers who were stoned . . . who knows? You've read about how families get brutally slaughtered by one of their kids? The thought occurred to me. I figured I could bury their bodies in our shitty unfinished basement and no one would be the wiser. Instead I returned to school to break the news to Brian, who managed to show a little compassion (easier to do when you're the one going).

"Oh, man, that sucks."

I interpreted that to mean: "I'll bring you back a shirt and tour program—documenting what a great fucking time I had while your sorry ass sat at home."

The concert came and went. I couldn't believe I'd missed that incredible show. To make up for my disappointment, a few months later Dad bought concert tickets. Finally, a big stadium show.

"Who is it, Dad? AC/DC? REO Speedwagon?" Both were coming to Evansville.

"Hall and Oates."

Kill me fucking now! "*Who . . . ?*"

"You know . . . 'Rich Girl,' 'I Can't Go for That,' 'Private Eyes.'"

I'd missed the greatest rock 'n' roll show ever . . . but as a consolation prize, I was going to see something called Hall & Oates! Yippee-skippy-the-fuck-doo. To add another layer of shit icing to this inedible disappointment cake, I learned we would also be taking my half-blind, doddering Grandma Evie—yes, the same one

who bought me the drum set. (This may come as a shock, but sometimes I could be an ungrateful turd.)

When the big day arrived, we set out for Roberts Stadium, which I was surprised to see was still standing after KISS had reportedly annihilated it. This was going to be one of the longest nights of my life. Fuck!

Boy, was I wrong. The concert began with G.E. Smith strolling up and down the aisles through the audience, wailing on his wireless, scorching electric blues guitar. G.E. led the *Saturday Night Live* band for years. The atmosphere was electric, too. The stage lights were blinding. And the biggest surprise of all was that Daryl Hall and John Oates played and sang their asses off. Pop icons, they had some serious songs, lots of them—one big hit after another. It was a great show. It wasn't KISS, not by a long shot. But it was live music, *really* loud, with a huge stadium jammed full of eight thousand cheering fans, and I loved it.

I decided then and there: someday I'd rock a stadium full of admiring fans.

CHAPTER 3
THE WAY OF THE FIST
2005

Funny how childhood fantasies never quite square with eventual reality. And when it comes to being in a band, a cohesive and affable group of guys performing music they love, the fantasy is light-years away from what really goes on behind the scenes.

We went into the studio with Ivan to begin laying down vocals on the record. Having had all the music tracks completed, we needed his vocals and his lyrics to finish them. It's not that we were incapable of writing lyrics, but for this to be what we needed it to be, it required Ivan to sing things that meant something to him personally. And, believe me, he had an infinite well of pain, a seemingly bottomless pit from which he could draw on experiences that would resonate with other like-minded souls—deep enough to keep feeding his creativity through dozens of great songs to come.

He started banging them out one by one, and, right from the start, he was killing it in the studio. We canceled his plane ticket back to Denver, holding him hostage till he finished the record. It had taken some real coaxing just to get him to LA for the audition. Now that we had him, we weren't letting him go. We decided to keep the magic flowing.

Many times he would write on the spot and lay the stuff down. There were only a few times he got stuck and needed help on a line. This dude was fucking incredible and nailed everything. He was so passionate about perfecting his vocals that if he messed up, he'd scream "Fuck!" ten times and punch the stool.

We made sure there was no short supply of booze while we watched him record. Matt and I always managed to knock back a few: beer, vodka, you name it. Ivan wasn't opposed to drinking—far from it. However, Zoltan always hated it and was pretty vocal about it.

The exception was one night, after finishing recording vocals, when Matt and Ivan went back to Zo's apartment. The three were listening to the day's recording and getting hammered—even Zo. That led to them flipping the furniture and moshing in his apartment. It was an important moment of bonding, but it was also a preview of what would become the band's standard operating procedure. The old saying is: what doesn't kill you makes you stronger. That old saw doesn't apply to booze, because whatever bond was formed that night would later be torn apart by the same alcohol that fueled it.

When we finished recording what would become *The Way of the Fist*, we added another guitar player to round out the lineup: a nineteen-year-old kid named Caleb Bingham, a real prodigy who could shred on drums and sing, as well as crush the guitar. Not long after we started rehearsing with him, the age gap between him and us older, jaded farts became too big to ignore. Caught up in what a great player he was, we'd disregarded a potential problem: Caleb wouldn't be able to hang in the venues we'd be playing in on tour, since he wasn't old enough to be in them in the first place. Plus the disparity of life experience, in general, was also too great to ignore. No matter how much we wanted him to be part of the band, it simply wasn't going to work.

We decided to address the situation before we got signed, and I knew just the guy to call: Jason Hook. Jason and I had been in another band together. A Canadian without a green card for his first decade in the States, he was an incredible guitarist. Unfortunately,

33

he was touring with Alice Cooper and wasn't available. So I turned to the best guy I knew who *was* available: Darrell Roberts.

The one good thing I got out of the W.A.S.P. experience—the "sting" of which I've already explained—was my connection with Darrell. He was a seasoned vet on guitar, having made numerous tours with W.A.S.P. The timing was right, too, since he'd recently ended his association with them and was looking for another gig. I'd helped get him a construction job with me, so we were hanging out every day at work. I played him *The Way of the Fist* record, and he loved it. When I asked if he'd be interested in joining, he leaped at the chance.

I called Zo and told him I had the guy: someone who'd been in the trenches and knew what to expect, not to mention a good guitarist with good stage presence. Turned out Zoltan had always liked Darrell, so it was an easy sell.

Now part of the fold, we decided to write one more song with Darrell—swapping it out for one we'd written with Caleb. It was important for him to feel like part of the record we'd recorded. He gave Ivan his song idea on a cassette tape. Remember, it was 2006, but Darrell was still into cassettes. (I always thought that was funny, but it was so like him.) The song, "White Knuckles" ("I'm taking back control with my knuckles"), was a hard-edged rocker and it turned out great. That was the final piece of the album, which we sent to our friend, Logan Mader, to mix. Logan was the former guitarist for Machine Head on the first couple of records back in the '90s and toured with Soulfly in '98. His name would lend even more legitimacy to the project.

We were now close to having a mixed and mastered album, but the band still needed a name. It seemed all the good ones were

taken. We came up with a long list of candidates. Wish I could remember some of them, but believe me when I say they shared one thing in common: they were beyond lame. We finally decided on Five Finger Death Punch, a reference to the Touch of Death—the Five-Point Palm Exploding Heart Technique that appeared in the Tarentino flick *Kill Bill*. With Zo's martial arts background, he really pushed for it . . . so FFDP it was.

Our first gig was at the Wiltern Theatre, a landmark art deco building on Wilshire Boulevard in LA. The British metal band DragonForce was scheduled to be the headliner, and because Darrell was friends with one of the band's members, we got an invite to appear on the bill—along with All That Remains and Horse the Band.

It was a pretty big deal, since we were not yet signed and no one, except people on MySpace, had heard any of our songs.

Dad flew to LA for the gig and I invited a bunch of friends—including an older Mexican guy I'd met while drywalling, a guy I'll call Fernando. He was a really fun guy who'd invited me to his house for dinner several times, and I couldn't wait for Dad to meet him. We were standing out behind the venue when Fernando showed up with his nephew and a few other relatives. Unfortunately, he was falling-down drunk—literally. When Dad went to shake his hand, he staggered and would have done a face plant, but his nephew caught him in time. I was embarrassed and disappointed.

His nephew said Fernando needed to use the john. When security saw his inebriated condition, I had trouble convincing them to let him into the backstage area so he could take a piss in our bathroom, which was up two flights of stairs.

While Horse the Band performed, our band hung around outside before heading up to the dressing room for a last-minute pep

talk. Ivan led the way, and I heard him yell, "Who the fuck barfed in here?" Of course it was Fernando. Ivan was so pissed I thought he was going to explode. The rest of us tried to keep from gagging while the custodial staff scooped up the mess.

An assistant stage manager stuck his head in and informed us that we had twenty-five minutes from the time we hit the stage.

"That's twenty-five, *not* twenty-six. Got it?"

The policy was that even if we were in the middle of a song, once the twenty-five minutes were up, they'd pull the plug. No exceptions. We quickly regrouped and decided to cut one of our songs just to be safe.

Ivan gathered us together and went into his pump-us-up mode: "Let's go show these motherfuckers we mean business."

We were psyched.

I sent Dad to the lobby to hang out with Jason Hook, who had just gotten off the road from touring. They knew each other from a previous visit a decade earlier. Jason was there with his girlfriend, and the three of them stood on the mezzanine to watch the show. Though we'd practiced, it was our first real gig, and we were a little shaky. The eight hundred people in attendance were there to see DragonForce. It wasn't until the third song that some of them actually started to get into our music. Ivan demanded they start a mosh pit, and though it was the smallest, most ineffectual mosh pit in history, a dozen or so began circling while he sang "A Place to Die" and cursed the others for not joining in. We managed to end our last song with the assistant stage manger waving wildly at us—pointing to his stopwatch. Though the gig was a mediocre success at best, we buried Horse the Band and got at least as much reaction as All That Remains.

I tracked Jason and Dad down in the mezzanine lobby. Of course,

Dad said we were great, and surprisingly, Jason said, "Man, I wish I could have been part of that. That's the kind of music I love. I'm a little jealous." (As the old saying goes, "Be careful what you ask for!")

We decided to stay and watch DragonForce, because we wanted to see their guitarists, Herman Li and Sam Totman. The duo was renowned for their long and high-speed solos. Their whole shtick was like a page from the *Guitar Hero III* soundtrack.

Later that night, I overheard Dad talking to Ivan, who needed plenty of reassurance that he didn't suck. "I've been around the music business and theater for decades, I've seen the best, and I'm here to tell you that you're a born stage performer. You're fucking awesome." (In keeping with his dual nature, my dad's vocabulary could be either sophisticated or street. He always said, "I don't trust anyone who doesn't say 'fuck.'") He was dead serious when he told Ivan, "You're the real deal."

"Really?" said Ivan, who seemed to become a respectful, less angry version of himself when confronted with a potential father figure.

"You're a natural . . . incredible charisma. You controlled that crowd like a lion tamer. And another thing . . . you don't need to hide behind makeup or a mask . . . ever."

Ivan had worn both when he was the lead singer for Motograter, and he'd recently been talking about doing it again. Dad's encouragement ended the makeup-and-mask conversation then and there.

Ivan gave my Dad a hug and kissed him on the cheek. He whispered something in his ear. I found out later he said, "I don't know about this band yet, but if it doesn't work out, I'm taking Jeremy with me. He's my man."

Oh, how things would change . . . like the volatile weather.

———◆◆◆———

*Not long after the gig at the Wiltern, we received an offer to fly to Seda-*lia, Missouri, to play a show. A promoter had contacted me through MySpace, and I put him in touch with our then manager, who shall remain nameless but not blameless. They worked out the financial end of the deal. It didn't pay a lot, but it was a chance to get away, not only from LA but also from my girlfriend, whom I had been with for almost two years.

We'd originally met at a party. I really didn't like parties, because I'd been clean and sober since I was sixteen (way more on that later). So there I was, sober and insecure, trying my best to hang but failing miserably. I was just about to leave when I walked past this sexy brunette who was wearing a little jean skirt. I paused in front of her, and we started talking.

She was originally from New Jersey . . . and Italian. This was long before *Jersey Shore*, but you get the picture. Little did I know then, but she came with a lot of baggage and a couple of aliases. Jersey, Italian . . . get it? Relocation had been a big part of her adolescence. For the sake of protective custody, I'll call her Angel.

I thought Angel was attractive, so I put on my most charming self. I said a bunch of funny shit and she seemed to dig me. When I mentioned I was a vegetarian, she said she was into health food and was a vegetarian cook.

"You have ADHD, right?" she asked, matter-of-factly.

I'm betting the fact that I was bouncing all over the place was what gave me away. I've always been a hyper, spastic dude who could never sit still or focus on anything for very long without my brain

moving on to something new. Unlike me, she was completely calm and chill, almost hippie-like.

I thought, She may be the type of person I need in my life. Someone who could help ground me and focus on positive things.

She gave me her number, and I walked her to her friend's car. I went home that night more excited than I'd been in a long time. I'd been asking the universe to send me a different kind of relationship, and it hadn't taken long to appear.

We started dating. For the first few weeks, it was great, but it wasn't long before things got a little sideways. I soon learned that she was used to being treated like a princess. If my attention deviated from her one little bit, she'd vibe me out.

At the time, I was playing in a band with some friends. After shows, if I walked around talking to people, Angel would get all fucking weird. If I turned away from her to talk to someone, she'd make a big deal about me "ignoring her." What was really being ignored were signs that she was as insecure as I was. Early on, she appeared so self-confident that I thought *I* needed to change—needed to become someone I wasn't in order to be worthy of receiving love from someone I assumed was out of my league. It didn't take long for that facade to crumble.

One weekend, we went on a mini-vacation to San Diego. My focus was completely on her, and that was the way she liked it. We had a good time until, on the way back, we stopped for lunch. The topic of my sobriety came up, and it was obvious that something was bothering her.

With a look of stony seriousness, she then delivered her own death punch. "I don't think I can be in a relationship with someone who can't even have *one* glass of wine."

I literally felt a sharp pain stab my heart. I couldn't respond.

"You were young when you partied before. You're a man now. I'm pretty sure you can handle having a glass of wine."

I let that thought sink in. The more I considered it, the more it seemed to make sense. She's right, I thought. I'm not some fifteen-year-old kid. I could have a glass of fucking wine without losing it. I was tired of feeling like a victim. Everyone I knew could party and numb themselves from uncomfortable feelings—everyone but me. I wanted to be able to enjoy social situations. All I knew was, I was tired of being miserable and ready to have "fun."

When I got home from work the next Friday night, two bottles of wine were sitting on her dining room table. The bathroom was aglow with candlelight. While she ran a warm bath, she poured us a glass of red wine. I lifted the glass and stared at it like it contained the answer to some ancient mystery.

"You think I'll be cool, right?"

"Your choice. But you're in a totally different place now than you when you were fifteen. You'll be fine."

Truer words were never misspoken. When I pressed the glass to my lips, the familiar bouquet swirled up into my nostrils. The fragrance was, if you'll forgive the pun, "intoxicating." I took a sip. And, with it, I ended fifteen years of sobriety. *Fifteen years* when I'd never relapsed even once . . . not even when I had nothing or no one, even when the career I'd pursued since high school had fallen apart. Over 5,500 days of resisting the temptation to medicate my feelings—all that ended with that first *little* sip.

That August night in 2004 changed my life—or redirected it. And, though I was oblivious to the consequences of that first innocent sip, it reactivated my descent into hell. I didn't just ease into my

old addictions, I was propelled into them like trampolining into a whirling helicopter blade. As my drinking accelerated, my intolerance of Angel's codependent behavior did, too.

To add to our problems, only a few weeks before the Sedalia gig—while we were still mixing our record—I found out she was pregnant. We decided the last thing either of us needed at that point was the responsibility of taking care of a kid. That most certainly added pressure and strain to an already rocky relationship. Selfishly, I was so wrapped up in our album and getting signed that I didn't really care about anything else. She said she needed $700 for some kind of pill that would "magically" end the pregnancy. At the time, it might as well have been $1 million. (Thank God for credit cards.)

So when the gig in Sedalia materialized, I couldn't wait to get the fuck out of town and away from Angel and our confining relationship. All I wanted to do was play music . . . and party! However, I had no way of knowing that America's heartland would turn out to be its anus as well.

We flew to Sedalia, the home of the Missouri State Fair, on an airline a pilot friend of ours had worked for. He let them know we were personal friends, which meant "perks"! The stewardesses immediately made us feel welcome by opening the minibar. No sooner was the seat-belt sign off than we took full advantage. I grabbed a fistful of vodkas and the party was on. Matt walked up and down the aisles serving drinks on a tray to total strangers. Within minutes, everyone went apeshit. The flight was quickly out of control. The only thing missing was Denzel Washington as our coked-out pilot.

I sat with Darrell and got so blotto I nearly blacked out. In my drunken haze, I ended up in the back of the plane with a stewardess.

41

As they say, one thing led to another. Zo said that when he looked back, all he could see were legs sticking up in the air, and it wasn't a demonstration on how to buckle a seat belt or secure an oxygen mask. I'd never cheated before, but I was so messed up, I wasn't aware I did it until he informed me later. Had I not been so miserable at home, it might not have happened, but the alcohol removed any restraint. Booze soon became my default excuse for any fuck-up.

By the time the party plane from hell landed, we were all destroyed—except Zo. Cars were waiting to take us to the hotel; I passed out in the backseat. We got to the hotel and someone shook me awake. I staggered inside. Darrell, also shit-faced, fell *up* the stairs while carrying his guitars. I dumped my stuff in the room and headed for the bar. With no thought about how being hungover might affect my performance, I was hell-bent on getting even more blitzed.

Darrell and I shared a room. We drank all night. At some point he wandered out into the hall—ending up in the wrong room. After I retrieved him, he fell out of his bed and passed out. A few hours later, he was awakened by a phone call—from his roommate back in LA—informing him that his dog had to be put down. Devastated, he hung up and burst into tears. I felt terrible for him. We were both wrecked and in no shape to play that night.

It was hotter than the sixth level of Dante's Inferno. The combination of a 95-degree temperature and 100 percent humidity, plus hangovers from Hades, did not bode well for a sterling performance. The venue, a deserted midway and the perfect setting for a zombie invasion, was a vast fairground that made the tiny crowd look tinier. Those who stopped milling about to honor us with their presence were restless and unimpressed. No one had any idea who we were,

but they made it pretty clear who *they* weren't: fans. Heavy metal wasn't exactly the genre du jour in Bumfuck, Missouri. Besides, we only knew five of the songs on our album, and our lack of enthusiasm was pervasive.

Fortunately, the gig was over almost as soon as it began. Had you polled the indifferent crowd, Five Finger Death Punch would have received only one finger, and it wasn't the pinkie. No one could believe we'd come halfway across the country for this shitful disaster.

The whole weekend ended up being a total bust, a page right out of a hideous soap opera (wait, that's redundant). The promoter, who may have been the inspiration for *The Biggest Loser*, lost his ass on the show. (As it turned out, we were one of the few bands who got paid, as our manager would not let us go onstage until he forked over the cash. Credit to our manager for the one good thing he did before we fired him.)

The promoter came to our hotel to deliver the pitiful news—perhaps hoping for a refund. When that wasn't forthcoming, he promptly had a heart attack. While the medics, risking hernias, hauled him down the stairs on a stretcher, they dropped the behemoth, who landed on a chick—fracturing her leg.

We'd entered the musical Twilight Zone. Following the barf-a-rama gig at the Wiltern, Sedalia was chapter two of what I like to call the Death Punch Curse. Anytime we're around, so's the potential for major drama. At least that's how it's been so far. When the Death Punch is a-comin', it's like death in *Final Destination*—inescapable!

Once back in Hollywood, we played a local venue called the Knitting Factory. One of Angel's girlfriends from out of town was staying at our apartment, and the two of them were excited about

coming to the gig. The last thing I needed was someone I barely knew added to the mix.

I was over feeling trapped in a lame domestic situation. Angel was way too vibey. I didn't like the way I felt around her. The more I endured it, the worse I felt about myself. I'd been numbing myself as much as possible. I didn't need any reason to drink and clock out; however, this relationship made it seem totally justified, and I took full advantage.

After we finished our set at the Knitting Factory, I came off the stage and went to talk to some friends. Angel had been drinking, and when I failed to acknowledge her first, she went completely psycho. She stepped in front of me—blocking me from my friends, who were complimenting me on the show. I was pissed and I let her know it.

She and her friend left before I could finish loading gear. Once home, no sooner had I walked in the door than I became the focus of a nuclear meltdown. She went ballistic—accusing me of ignoring her. I was over her neediness and tired of the fucking drama. Since I had to get up early for my construction job the next morning, I decided to go stay at Jason's pad. I hurriedly packed a few things. When I headed for the bedroom door, Angel tried to stop me from leaving. I managed to push past her, but she grabbed me from behind and started crying hysterically.

I needed to get out of there, but every time I tried to leave, she'd grab hold and pull me back. I finally flung her off onto the bed, but she came back at me, punching me. As I turned to leave, she jumped on my back. I finally managed to yank the door open, and there stood her girlfriend—staring at us. I held my hands straight up to show I wasn't fighting, that she was punching me.

44

I finally calmed her down, pretending everything was okay so I could fall asleep. The next morning, while at work, I texted her saying I was turning off my cell phone, but we needed to talk when I got home. I'd already made up my mind we were through. That night I told her I couldn't do this anymore. Though she was predictably dramatic—big tears and promises—I was over it. Fucking done!

That is . . . until the next time.

—————◆◆◆—————

Josh, a friend and an independent construction contractor I'd been working for part-time, agreed to let me move into his two-bedroom apartment in Burbank. It didn't take long for the two of us to start getting drunk almost every night. When we got home from a job, we'd be up until four or five in the morning, plastered (construction pun intended).

In a drunken stupor, I'd ask, "Why the fuck are we up drinking at four in the morning?"

His stock reply was, "Because it's Tuesday!"

We'd laugh and keep drinking until I'd finally pass out. Up early, I'd struggle to pull myself together so I could go back to work. Somehow I always managed to shake it off and do my job. Though I was probably kidding myself about how well I handled it, it was just the beginning of a routine I would perfect once we hit the road.

In addition to being drunk every night, I began to hook up with several different women—including a porn star. Angel and I were still speaking, but since we spent less and less time together, I took full advantage. That first little fling on the airplane ride to Sedalia made me realize I never wanted to be in a monogamous relationship again. Like anyone who's repressed a desire, once freed . . . I went apeshit.

45

———◆◆◆———

After **The Way of the Fist** *was finally mixed and mastered, we threw* some songs up on MySpace, and right away started getting tons of fans. It was surprising to us, considering we didn't have a record deal. There was so much traffic coming to our page that it caught the attention of what was then one of the most powerful management companies in the business: The Firm. Once a major artist- and talent-management company—at one time representing Kelly Clarkson, Korn, Ice Cube, Backstreet Boys, Snoop Dogg, Dixie Chicks, Linkin Park, Jennifer Lopez, Audioslave, Limp Bizkit, and other major acts—they'd undergone catastrophic departures and now represented only Korn. They also had a record label: Firm Music. Rather than question why they'd dramatically downsized or been dumped, we were eager to be on their roster, or anyone's for that matter. It's called getting in the game, and it usually comes with a high price tag. (Permit me to translate: we were on the verge of getting fucked without the benefit of a full-metal jacket or the courtesy of a reach-around. Too obscure? Get with the program!)

One of The Firm's employees, a specialist at radio promotion, loved our band. She'd been following what was happening through our MySpace page. She was so into the band that she contacted us to request an invite to a show we were playing at the Whiskey. She came and was blown away. She told the bigwigs at The Firm they needed to sign us, because we were gonna be fucking huge. As a result, they sent more representatives to come out and see a show.

We were now a tight-knit group, and our set was impressive. Several of her coworkers got excited with what they saw and decided to schedule a private showcase for the honchos—including one of

the head honchos, Peter Katsis—at the Viper Room. We knew this was our shot; if we nailed it, we'd get signed and be in the Game. Though we'd played only five shows, things heated up fast and we were just rolling with it.

Try to imagine the feeling of knowing you're *this close*. I'd never been so excited and innervated. The anticipation was filled with equal parts delight and dread. If this didn't work, I'd be back in fucking Tennessee—where the men are men, the women are women, and the sheep are nervous—installing drywall or drumming for some lame pseudo-country act. The days preceding the showcase were torturous. True to my ambivalent nature, I was both certain of success and plagued by the thought of failure.

The night of the showcase, we slayed! I mean, the place was electric and we were on fire. It was obvious to everyone we were going to get signed. I celebrated the evening by going with the rest of the band to the Rainbow.

I'd invited the porn star I'd been banging. We started tossing back drinks the minute we arrived. She quickly got buzzed and began asking about our "relationship" status. Gimme a fucking break! Relationship? I'd just gotten out of one nightmare situation, and I most certainly didn't want to get into another, especially with a chick who got railed out every day on camera by huge fucking black dudes with massive Louisville Slugger–sized cocks. Just hearing that tone put a damper on a terrific evening.

The day after the show . . . it came: THE PHONE CALL. They wanted to sign us! This was what I'd waited for my whole life, and now—after more bands than I could count, sleeping on floors, in closets, in ghost-infested crack houses, making millions of boring data entries, drywalling and enduring years of utter loneliness—

it was happening. My dream was finally coming true. We were all sky-high.

When The Firm got the contracts together, we went to our newly hired lawyer's office to sign on the dotted line. This is one of those moments you envision for years, and one you know you'll never forget. How true. We hadn't been there five minutes before Ivan started being an asshole and causing a ruckus.

"Hold everything! I ain't signin' nothin'!"

We looked at him in disbelief. He was adamant. He wanted *his* lawyer to look the contract over before he'd sign. He'd been fucked over in a previous band, and he was scared of it happening again. We were incredulous.

This close! Another roadblock, and one that could have been avoided had Ivan alerted us to the fact before we all gathered to ink the deal. But no, that would have been too convenient. Little did I know it was a sign of things to come, the beginning of how things would always have to be: pushed to the limit and as dramatic and traumatic as possible.

To be fair, Ivan didn't really trust Zo—or any of us, for that matter. We'd only known each other a few months. But, man, he started in on Zoltan and the verbal sparring accelerated; they really went at it. I was pissed they were fucking up this special day—one that was supposed to be the happiest we'd known. Our memorable day would be forever memorable for all the wrong reasons.

When the yelling looked like it was going to turn physical, Matt and I went to a bar and got shit-housed—my default for anytime I needed to escape. I always had plenty of excuses: insecurity, anxiety, relationships, no job, horrible job, no recognition, lack of success, pressure, expectation and ego: you name it. All I knew was, this

band had barely been signed, and I was already fucking miserable.

Bottoms up!

<center>—•◆•—</center>

We invited everyone we knew to our record-release party at the Roxy. There were tons of industry people in attendance. At least four of the chicks I was fucking all showed up, so I had to scramble around and do my best to juggle time between them and not get caught. Like the flimflam man I'd become, I pulled it off beautifully.

Booze was flowing freely, and before I knew it, Angel and I hooked up. (My inability to say no and mean it was, once again, proudly on display.) In a matter of minutes, we found ourselves upstairs with one of her friends. They began dancing and rubbing around on each other. Her friend's boyfriend was off drinking somewhere in the club, and she started flirting with me, telling me how hot I was. At this point, I still had an ounce of integrity; I wasn't the complete pile of shit I would soon become. I knew she was drunk and could have easily pushed that envelope, but I opted to play it cool.

Following the signing, we shot a music video for our first single, "The Bleeding" (more on that later). We were all excited about getting Death Punch launched. We'd rehearsed our asses off preparing for the start of the first tour. Our management had arranged for us to go out on the Family Values tour featuring Korn, Evanescence, Hellyeah, Flyleaf, and others. It was far from my dream line-up, but I was stoked, as this was my first real tour. Management sent us an e-mail saying, "Do any of you guys have a van?"

A *van*? Did they actually think we'd agree to tour in a fucking van? We were jaded, angry, and set-in-our-ways motherfuckers

who'd been disrespected enough. No fucking way were we going to sink that low.

Zo replied back, sarcastically, "Why . . . is somebody moving?"

We basically forfeited any money we might make for the next year and a half by getting a touring bus, but we wouldn't have survived a week without it. I had to sell my truck in order to have enough money to exist, but at that point I was willing to do whatever it took.

The big day finally arrived. We were at our rehearsal space, rounding up all our gear, ready to leave for the tour. We heard a horn blowing outside. Our tour bus had arrived! Man, were we pumped. We all ran out to see it. In unison, our jaws dropped: we stared in disbelief. The ugliest, most embarrassing-looking bluish-purple tin can on wheels greeted us. It looked like something for the Wisconsin Gay Men's Bowling Association or *Priscilla, Queen of the Fucking Desert*! A Dodge (Dead or Dying Garbage Emitter) minivan might have been preferable after all. This was my first taste of the big time. I shook my head and laughed in disgust. Even greater indignities awaited us . . . as anyone who's ever toured can attest.

Resigned, we loaded our gear into the Purple Placenta. Matt had gone to Costco and purchased ten industrial-size barrels of booze. Of course, Zo had a shit fit over that. He knew we'd be drunken 'tards, partying our asses off. How right he was! After pulling out of Burbank, we'd barely made it down the road ten miles before we busted out the vodka. We weren't playing the next day, so why wait? Anytime there was a day off, massive quantities of booze were consumed. It wasn't long until—show day or no show day—the party was on.

No doubt about it . . . touring was gonna be EPIC!

50

CHAPTER 4

INFLUENCES
THE '80S

I f there's a body part that best defines me as a musician, it's my . . . (fooled ya) . . . foot. Or, more accurately, feet. From the moment I started playing double bass, it's been my ability to coordinate two alternating foot petals at speeds reaching 210 beats per minute. That's pretty fast, unless you're comparing it to a hummingbird flapping its fucking wings. And if one characteristic best describes why I'm the musician, songwriter, and producer I am, it's my childhood love of all kinds of music and groups whose emphasis was the song. It didn't hurt if they were visually exciting.

First, a closer look at some of my early musical influences. Then, a couple of horrific stories about my tootsies.

Fans who follow me on Facebook know that growing up, my musical influences were vast and varied. One of my favorite songs was "Whip It," by a band called Devo. Not a lyrical gem by any means, but rhythmically, it killed. My parents purchased the 45, along with a Devo picture disc. It was rad and bizarre. I'd stare at it, thinking, Man, these dudes are cool!

Though they were weirder than KISS, like that face-painted quartet, Devo was character-based, and I was really into their trip. Though they didn't realize it at the time, they made an indelible impression as far as what a live presentation should be: over-the-top and visually spectacular. Hall & Oates had cool shit on stage, but KISS and Devo were whole different animals. It was about more than just the music,

it was about spectacle. (In his *Poetics,* Aristotle lists "spectacle" as the least important of six theatrical elements. Had the Greek philosopher and polymath seen Devo and KISS, I'm sure he'd have moved it to second, right behind "sound"—not to mention gotten off on "Whip It" and "Detroit Rock City.") The music from those two bands was constantly blaring from my room, while the rest of my family was still jamming those goddamn musicals.

These years coincided with the best time on the radio: the '80s. Though I still admired KISS, I began to branch out in my musical taste. And what incredible songs populated that magical musical decade: everything from new wave to Madonna to "Puttin' on the Ritz" by Taco; pop groups like Duran Duran and the Cars. Bryan Adams and Phil Collins fucking ruled. I relished all kinds of amazing pop culture.

My next-door neighbor, Harvey, turned me on to some incredible music—introducing me to rap (not gangsta—this was good old-school shit). And he turned me on to break-dance music. Suddenly everyone was into break dancing. We flattened out cardboard boxes—sprinkled them with talcum powder and perfected our back spins. We spent hours practicing our gravity-defying moves. It wasn't enough to bust a groove—you had to look "fresh and fly." We sported nylon vests and parachute pants. Replacing our Walkmans with jumbo jamboxes, we blasted the *Beat Street* soundtrack: LL Cool J, Run-DMC, Grandmaster Flash, and the Fat Boys.

This was also around the time Michael Jackson was everyone's idol—long before the accusations of child molestation, bariatric sleep chambers, chimpanzees, and other weird shit. MJ was the most popular thing since the Beatles. I persuaded Mom to buy me a red leather jacket like the one he wore in the "Thriller" video. *Off the*

53

Wall and *Thriller* dominated my cassette player. Soon, another pop icon would rivet me way more than Wacko Jacko. This guy was the absolute shit in every way. He wrote, played, and produced everything on his records. I'm talking about none other than Prince.

Prince Rogers Nelson was an incredible, multitalented artist. I thought his edgier material and stage performances were way cooler than MJ's. I still liked Jacko, but Prince and the Revolution was more my vibe. I was obsessed with all things Prince.

Purple Rain was an iconic album and film. Of course, my parents wouldn't let me see the movie or permit me to have some of his albums, because they thought his lyrics and some of the titles were too explicit—the prudes. At eleven, I found nothing obscene about "Head," "Jack U Off," and the earnest lyric "I sincerely want 2 fuck the taste out of your mouth," from "Let's Pretend We're Married." (Okay, even I knew they were indecent . . . but that's why I wanted them.) Forbidding it only made me want them more. Like most people with an addictive personality, tell me I can't have something, and it becomes an obsession. As a result, I sought out each and every one of his records and secreted them away. I also tried to sneak into the film—after purchasing a ticket to a Muppet movie—but I got nabbed.

I couldn't wait for the follow-up to *Purple Rain*. The night before its release, I was so wired I couldn't sleep. It wasn't until daybreak that I suddenly realized I'd have to wait, because I was being forced to go to VBS. (That's Vacation Bible School for all you Philistines.) I begged not to go, but Mom insisted. To appease me, Dad said he'd buy the cassette and it would be waiting for me when I got home. Rather than throw my typical tantrum, I chose to be grateful I'd only have to wait a couple of hours.

INFLUENCES

Forget prayer, scripture, and singing the B-I-B-L-E—I couldn't concentrate on anything but getting that new Prince record. The first one out the VBS door, I sprinted all the way home. But when I arrived, breathless, Dad wasn't there and neither was the promised cassette. Jesus Christ! Now I could justifiably have a shit fit. However, before I could get too worked up, I spotted his car coming down the street. I rushed to meet him curbside. I didn't even bother to say thanks. I grabbed the cassette out of his hand, raced back inside, bounded up the stairs, and popped it into my jambox.

My heart was racing. Then it hit me: what if it sucked? I wasn't prepared for a letdown. With trepidation, I hit the play button. The intro to the first song was the title track. It began with a weird flute sound that caught me off guard; however, within seconds, I already loved it. Next up, "Paisley Park." To this day it remains one of my all-time favorite Prince songs—so unique and cool. It was a serious fuck-you to everyone anticipating *Purple Rain II*.

What a brilliant move, I thought. Little by little I was forming an idea of how I would approach the music business: never give 'em exactly what they're expecting; keep it interesting; have solid songs and don't forget the spectacle!

I jammed Prince even more than KISS; I was seriously mental with everything about him—a true fanatic. I acquired every Prince album and every twelve-inch he released: imports, colored vinyl . . . everything. One of my most prized possessions was a life-size cardboard stand-up of Prince on his purple Harley (which I kept for years, to the dismay of several girlfriends). It stood like a shrine in the corner of my room.

What an incredible time in music. These were my musical favorites—or they would be, until I discovered METAL!

And now, how I developed a world-class foot phobia. (That's phobia, not fetish!) This is significant not only because it's affected me for years, but for a drummer known for his rapid-fire double-bass playing, having a foot phobia's akin to a competitive swimmer being terrified of getting wet.

This particular incident occurred several years before I discovered Prince. It was a typical Midwestern summer, filled with humidity thicker than a redneck's skull and infested by swarms of bloodsucking mosquitoes. Had the mosquitoes known how my blood was about to flow, they'd have been lying in wait, ready to feast.

I'd been playing in my room when Dad called me downstairs. A writer, he'd run out of typing paper, and because Mom had taken our only car to the rehearsal of yet another musical, he would have to tote me on his bike to get more paper at X-Market, our local grocery store.

When he saw my bare feet, he insisted, "Put on your house slippers."

I ran upstairs and slipped on my thick brown leather cowboy boots, which looked retarded with my pajamas, but I didn't care. (It's like my higher power knew something I didn't.) I came back down with my boots on and Dad frowned. "I told you to put on your slippers."

I'm not sure I understood why the fuck it mattered what footwear I wore, but this is a prime example of the super-critical bullshit I would be subjected to my whole childhood. I was still wearing my royal-blue pajamas, but *that* was no big deal. Apparently the big

deal was all about having proper, stylish footwear to wear to a shithole convenience store. I ran back upstairs and slipped on my little brown house shoes.

There were some steep hills to deal with, which made the bike ride challenging. I hopped onto the back of his Schwinn, wrapped my arms around him, and we took off, my feet dangling by the spinning spokes. We hit one of the major hills, descending at a pretty good clip. Though Dad kept braking, we were still flying down the asphalt. I was a little freaked out, but it was also kind of fun.

We'd just reached top speed when all of a sudden . . . bam! We stopped like we'd hit a brick wall. Both of us went flying off the bike, then tumbling onto the pavement. Neither us understood what had happened, why we'd gone from twenty-five miles an hour to a complete halt. That's when Dad noticed some of the spokes on the rear wheel were bent and broken. He quickly examined my right ankle and it was skinned, but not bleeding. Instead, it was as white as cottage cheese. Though my foot had caught in the spokes—bringing us to a sudden halt—I'd somehow survived being seriously injured.

No sooner had he breathed a sigh of relief than the white patch on my ankle, which was fat, not skin, started gushing blood. The skin had not only been completely scraped off, it had been shredded like Big League Chew along with a huge chunk of ankle meat. I was in instant shock, and so was Dad. We needed to get to the emergency room at Warrick Hospital, and fast. He pulled off his shirt, wrapped it around my foot, picked me up in his arms, and took off running.

We made it to a gas station and spotted a couple filling their tank. JUST MARRIED and HOT SPRINGS TONIGHT adorned their car windows. Dad frantically explained to the newlyweds what had

happened and how serious the injury was, and they agreed to give us a ride to the hospital.

Dad's T-shirt was already blood-soaked, but the groom handed him a rag he pulled from under the front seat. Nothing like using a stranger's dirty rag—probably infected with Dutch elm disease or his bodily fluids—to cover an open wound. In the process of replacing the T-shirt with the rag, blood dripped everywhere.

When we finally made it to the hospital, the driver, who couldn't have been more than twenty, pulled into the circle drive and up to the emergency room doors. Dad thanked them and we hurried inside. (I'm sure the sight of minced ankle meat made their wedding night a more joyous affair.)

The whole concept of an emergency room is a fucking joke—like the express checkout lane in most grocery stores. Usually the cashier in the express lane is there because she's too inept to handle a regular checkout lane, so she's slower than molasses in the dead of winter, which pretty much fucking defeats the idea of "express"! Likewise, emergency rooms are often staffed by mental midgets, stuck behind the admission desk with a huge stack of forms that *must* be filled out *before* a doctor can tend to the "emergency." (Judgmental, yes . . . but all too true.)

"Gonna need to see yer insurance card," said a woman who could have subbed for Jabba the Hutt's kid sister.

"I don't have it with me right now . . . I was riding a bike. We had an accident. My son's hurt. He needs a doctor immediately—his foot's—"

She silenced him with: "Hold yer horses . . . gotta make a call."

"Please *hurry* . . . my son's bleeding to death."

"Be patient, sir . . . this will only take a . . . Hello . . . this is Fern

in admissions. Uh-huh . . . it's packed as usual. Is Joan there? Lunch, huh . . . ? Know when she'll be back? 12:30. [*checks clock on the wall: 12:10*] Hmmm . . . maybe you can help. Appreciate it. I have a man here . . . Yer name, sir?"

"Heyde."

"*Heidi*. Love that story! [*back to the phone*] Name's Heidi. No . . . it's a gentleman. . . . that's what I told him. What's that . . . ? I think so . . . That's right, the Alps . . . Swedish or one of them. Uh-huh, yer right . . . Swiss. Anyway, he don't have his insurance card with 'im. No . . . his son. . . . I'll ask 'im. Been here before, sir?"

"No!"

"[*Into phone*] That's what I told 'im. She wants to know if you *have* insurance."

"Yes, of course. Look . . . my son needs a doctor *right now*!"

"Don't be raisin' yer voice. We got us some real sick people in here."

"Sorry, I just—"

"Said yes, he has. Oh . . . all right, then, I'll tell 'im. [*hanging up*] She said all I need fer now is the *name* of your insurance company. Just call us with the policy number later . . . okay?"

Jesus Horatio Christ!

It went on like this for another fifteen minutes: address, phone number, occupation, place of birth, weight, height, birthmarks, hair color, eye color, emergency contact, and next of fucking kin—while I sat there, still in shock, bleeding another pint.

At long last we were directed to one of the patient stalls. You know the ones: examination table, metal cabinet topped with an antique autoclave filled with stethoscopes, needles, bandages, and cotton balls, and a sliding curtain—the only thing separating you from

the screaming man whose leg's been amputated in a car wreck. A curtain *sooo* thin you can read a fucking newspaper through it. Ironically, it's called a *privacy* curtain!

The doctor, who was probably banging one of the candy stripers in the utility closet, finally showed up. He examined my foot, then instructed a nurse to start cleaning me up. She poured what felt like battery acid on the wound.

With a very concerned look on his face, the doctor explained the severity of the injury to Dad.

"Jeremy's lost a lot of skin, so I'm not able to stitch it. If I did, it would most certainly tear apart . . . and that would greatly complicate matters."

He said it would probably require a skin graft sometime in the future, but first it needed to heal, and that process would take weeks. He instructed Dad on how the antiseptic medication had to be applied and how often the wound had to be cleaned. And then he leaned forward and whispered (like I couldn't fucking hear), "If gangrene should set in, Jeremy could . . . " Realizing I was hanging on his every word, he made a pitiful face—indicating they'd have to chop off my foot!

I liked my foot and I needed my foot: to walk, to run, to pedal my bike. And, *someday,* I would need my fucking foot to shred double bass. Little did I know then that in five years, the drummer for Def Leppard would lose his entire left arm and still be able to play using foot triggers for snare and toms. Even if I *had* known, this information wouldn't have cheered me up one fucking bit. I wanted both arms to play drums and cymbals. And both *feet* for more than cosmetic reasons. Without my left foot, I guess I'd be forced to use my dick to trigger one of the double-bass petals!

Dad finally reached Mom, who rushed back from rehearsal to pick us up. She was hysterical. With the Heydes, especially my mother, there was always more drama offstage than on. I was too drained to join in with explanations or answer a ton of how-are-you-feeling questions. Once at home, Dad carried me to the couch. Mom got me some ice cream, and I eventually passed out for the evening. What a piece-of-shit day!

I would be shackled to that couch for much of the summer. The gaping wound took forever to heal. Dad, feeling majorly responsible, cleaned it and changed bandages three or four times a day. The doctor said, weeks later, that if I hadn't received such good home care, I might have lost my foot from just above the ankle.

It finally healed enough so I could be up and around on crutches. Boy, did I suck on those things. First time out, I took off too fast around the dining room table, lost control, and stepped down hard on my fucked-up foot—collapsing in pain. From then on, I took things a little slower.

Most of my summer had been consumed by this unfortunate injury. Now that I'd finally healed, I was hell-bent on making the most of what remained. I couldn't wait to get outside and play. It had been over six weeks, and I was determined to have some fun before returning to school.

It was a perfect summer evening in Indiana—twilight, that magical half hour before total darkness. The lightning bugs were just starting to appear, flashing on and off like stars in the distant heavens, and the locusts were just beginning to drone away like sonorous bagpipes at a Scottish funeral.

I sported the same blue pajamas I'd worn when I got my foot caught in the spokes. No shoes. Complete freedom . . . at last. I loved

being connected to the earth. I was running around the backyard, having a great time, ecstatic to be on my feet again. That's when I decided to practice my long-jumping abilities.

I spotted a big ol' garden rake lying in the grass, barely visible. (Good thing, too, 'cause it was a big, scary-looking mofo!) The rake's metal tines were pointing up, rusty from being left out in the rain. Ah-ha! thought I. I'll run and jump over it . . . no problem.

I took off, sprinting as fast as I could. When I got to the rake, I launched myself into the air: great distance, nice form, perfect landing. For a second, everything seemed normal. Then, suddenly, my leg gave out and I tumbled to the ground. Excruciating *pain*. (Way more than when my ankle got mangled). I hadn't cleared the rake after all; I'd used it as a launching pad!

I'll spare you the particulars, but let me just say there was a huge puncture wound right between my second and third toe, right where the middle cuneiform bone joins the metatarsals. (Looked it up.) The *Peroneus longus* tendon was pierced, and there was a perfect rake pattern of smaller puncture wounds piercing my foot meat. I screamed my ass off.

Dad ran out and—spotting the rake—quickly surmised what had happened. He picked me up and rushed me inside to the upstairs bathroom, sat me on the edge of the bathtub, and rinsed my foot under running water. Blood mixed with H_2O, like tomato juice in vodka, circled the drain. I watched in agony as my Bloody Mary refused to coagulate. He continued to clean out the puncture wounds while I continued to cry nine kinds of hell.

Because he couldn't stanch the bleeding, I was rushed to the emergency room again. Since I was a returning patient, things went a bit faster. I should say now that over the course of my childhood,

extending into early adolescence, I became such a frequent visitor to the ER, I'm surprised they didn't hang up my picture in the lobby.

Once again I was installed in a "stall" behind the "privacy curtain," this time next to a hefty old lady who was groaning and moaning like a manatee in labor. Turned out she had an impacted turd. (For you lightweights, that's a petrified-shit butt plug.) Apparently, this woman hadn't taken a healthy crap in a week. A nurse with a finger cot was trying to dig the brown boulder out of her rectum and wasn't having much luck.

"Push!" the nurse kept saying through the major-league moaning. It sounded like she was trying to shove a watermelon through a garden hose.

When the nurse finally loosened the enormous bunghole cork, it was like an atomic shit bomb exploded. The hideous, gray-green gaseous odor filled the entire ER. Patients—and also the staff—were gagging and making cat-puking sounds. A room full of teargas would have been preferable. The nurse who'd excavated the encrusted turd looked like she'd been mixing brownies in a Cuisinart without a lid. Splatter city!

Not only was I wanting to die from my Swiss-cheese foot, I was now engulfed in ass cancer that was floating into my bloodstream from the seismic shit storm in the next cubicle. If I could have opted for a quick death, I would have. (Too dramatic? C'mon, you should be used to it by now.)

Like Marty McFly, it was back to the . . . sofa. The upside of all this recovery time on the couch was that I developed the ability to do nothing and chill. This would be useful later when I morphed into an ADHD-addled teen, and, more important still, when I needed to come down from the adrenaline rush of a rock concert.

(Side note: The combination of these traumas has me mentally fucked—even to this day. If somebody comes near my foot, I'll karate-chop them in the fucking face. Ask anyone in Death Punch: they'll confirm that I continue to manufacture foot injuries like Lindsay Lohan does court appearances.)

Anyway, that explains some of the trauma that plagued me in those early years. Daniel Day-Lewis got a Best Actor Oscar for *My Left Foot*. I got a permanent fucking phobia!

CHAPTER 5

FIRST TOUR
2007

he first stop on the Family Values tour was St. Louis. After nearly three grueling days on the bus ride from LA to the Gateway of the Midwest, we arrived looking and feeling like refugees fleeing a Middle Eastern dictator. The only thing that made that exhausting journey worth it was knowing we were just hours away from our first performance in front of a really big crowd. That, and fulfilling my teenage dream of becoming a true "cocksman." I had recently read an Internet article entitled "A Guide to Good Cocksmanship." Its opening line clearly stated: "The Cocksman recognizes that vaginas can be found all over the world in a variety of situations and he must press his way into that new vaginal territory."

I was determined to waste little time in claiming my membership in this sacred fraternity. And, knowing the crowds would be huge, I was hopeful I'd find safe passage to Vaginaland post haste. I'm now ashamed to admit that I was on my way to becoming a total man whore. Let the festival begin!

Although confined to the second stage, we were told they were anticipating about twenty thousand attendees and that we could count on a screaming throng. I knew this to be true because my stomach was a burning fire pit. I'd spent most of the morning in a Porta-Potty with faucet ass. When I wasn't spraying out toxic waste or barfing up stomach lining and bile, I was nervously pacing like a caged tiger on amphetamines. My first tour and my nerves were

completely fucked. As always, I was building things up in my mind as being more of a big deal than they actually were. But try telling that to my raw sphincter. After dry-heaving and shitting my soul, I baby-wiped my ass and brushed my teeth (thankfully, in the right order).

Before the show, Ivan and I went outside to distribute Death Punch stickers. This was a routine he and I would repeat every show day. We'd hand out hundreds of stickers and introduce ourselves— inviting people to be sure and come see us on the B stage. At first, it was an opportunity to meet girls. Later on, I developed a more successful way to pick up chicks. I'd stroll up and deliver what I thought was an irresistible line: "Hi, I'm Jeremy from Five Finger Death Punch. You probably don't care who I am right now, and that's cool. But after we play in a couple of hours on that stage, *you will.* I'll check back with you then." In spite of how cheesy it now sounds, it worked almost every time.

Finally, we were alerted to hit the stage. Man, were we pumped! Like a football team, we huddled up and Ivan glared into our eyes like a crazed Ray Lewis giving us a fiery rally speech. As the intro rolled, we broke the huddle. At a specific moment in the intro, I ran out on the tiny B stage, raising my arms to the enthusiastic cheer of about a thousand beer-soaked fans. It was two o'clock in the afternoon and the sun was a blazing inferno. We didn't give a fuck about production values or lights or any of that. We came to own the fucking thing, and that's what we did. We blistered through our twenty-five-minute set and leveled the place. That hot scorching St. Louis heat was a killer, but it paled in comparison to our blistering set.

Drenched to the bone, the minute I exited the stage I bought a beer from the venue . . . for *eight bucks.* (I totally get why some fans

complain about the prices at these festivals.) The headliners gave the B-stage bands nada: no water, no towels, no catering, no place to shower. Great way to treat other bands, right? Everyone needs a meal and a shower, or at least a bottle of fucking water. We vowed then that when we became the headliners, we'd treat the other bands with more respect.

I managed to scrounge up plenty of booze, and in no time I was buzzed. I hit up the stripper I'd met the night before. I informed her that my bunk on the bus awaited her, and she suddenly turned into Vicki Virgin.

"Oh, but I can't leave my friend."

Say what? "No" to me then was just a temporary setback. Though I can't imagine how, I finally persuaded her. We headed back to my small-ass bunk—like the inside of a modest-size doghouse—and began making out. I use the doghouse simile because it also smelled like wet fur. It was a steam pit, and the intense heat was a downer . . . I mean that strategically. I'd consumed enough booze that I was totally numb above and below the waist. It was as if a dentist had given me a half dozen Novocain shots in my love muscle. It took some major effort, but with her magic mouth, she was finally able to arouse my skin flute. To keep this sad musical metaphor going, I hurriedly mounted the maestro's platform, but before I could deliver the downbeat with my conductor's wand, she halted me with that most dreaded of words: *condom*. (Okay . . . I lied. *Pregnant* is, hands down, the most dreaded of words.)

Fuck! I'd barely gotten it up with seventeen minutes of intense fellating; now I had to put a Ziploc storage bag on my cock. I held on to my nearly flaccid trouser snake, hoping to keep as much blood flow as possible, while I fumbled for a rubber strait-jacket. Inept at

opening a bag of potato chips, I needed help unwrapping the dick sock, which required all my concentration to just unroll it on my now nearly limp beef stick. Trying to penetrate the enchanted forest with a droopy love glove was like trying to thread the eye of a needle with frayed thread. Poke. Poke. Not happening . . . (Better get used to the juvenile nicknames for my penis; same goes for the vagina. I'm into low-brow humor and puns. I prefer "reptile dysfunction" to erectile dysfunction. Besides, it's not the size of the pun, it's . . .)

After several failed attempts, I finally mashed my drooping dick in there, but by then I was completely, dare I say it . . . petered out. After several halfhearted attempts, we finally admitted it was a failed experiment. We got dressed and I walked her back out to her friend. After she left, she texted me and said that she couldn't talk to me anymore because "it's causing too much of a problem with my boyfriend."

I would later detect this pattern: fuck the rocker and then get all sanctimonious. But to be fair, it probably had at least as much to do with the disgusting locker-room ambience and limp-dick syndrome.

A further irony of the laughingly titled Family Values tour was the continuous consumption of alcohol and plowing our way through chicks in every city. It's crazy how many girls gladly give it up for a guy in rock band. One's star doesn't have to be very luminous to find star fuckers. I must admit, back when I was dreaming of being a rocker, I'd hoped to add a few notches to my three-row pyramid stud belt, but I hadn't anticipated an endless line of groupies willing to do virtually anything sexually just to be "up close and personal." As stated previously, the life I'd once imagined had little in common with the reality of touring. It didn't take long to realize

the fantasy world I'd created in my youth was just that: fantasy. With my inherently addictive personality, I'd been easily seduced by the lifestyle and was already on the road to self-destruction—even though I thought I was just living the life and having a good time.

———◆———

Somewhere in Virginia, an exceptionally "eager beaver" hit me up on MySpace. We exchanged numbers and, after our set, I texted her and told her to meet me at the gate by the buses. I'd power-slammed several beers, and though I was a little woozy, I was ready for some action. She met up with me and asked where we could go. I knew the bus was off-limits because it was already in use.

"Did you drive?" I asked, hoping we could do the deed in her car.

"I came with friends."

Fuck! It then occurred to me we could use the restrooms. Okay . . . I said I was buzzed.) As pathetic as that suggestion sounds, it didn't take much to convince her that sex in the john was a fantastic idea—providing a story she could share with her like-minded MySpace friends. We walked into the men's room and dudes started making all kinds of a fuss about her being in there, so we quickly exited.

Next, we tried the ladies' room. She went in first to make sure the coast was clear, then signaled me in. When I entered, I was surprised to find a bevy of females lined up at the stalls, or pushing and shoving for a quick makeup check in front of the mirror. Ignoring them, we squeezed past a girl who was too shocked to protest and into a stall just as it was being vacated. Within seconds, we were fucking like rabid dogs.

Like an idiot, I continued my practice of fucking complete strangers without a condom. These were random hookups, one-day and -night stands—unprotected. As previously illustrated, I hated wearing them. It was like devouring a juicy filet mignon with Saran Wrap on your tongue.

So here I was . . . pounding away. I've never been that fond of girls who sound like they're being assaulted during sex. It's not like I'm endowed with Cockasaurus Rex. But for some reason this particular chick, let's call her Mona, turned out to be louder than an opera singer hitting ear-splitting high C's. Following a glass-shattering wail, her voice would drop three octaves into James Earl Jones territory. It's was weird and more than a little annoying. I covered her mouth because Mona was moaning like a porn star and screeching like a banshee. The john was now filled with curious fans, as well as those who just needed to pee, and it pissed me off that she was serenading them on purpose. I quickly came, pulled up my pants, and announced, "Let's get out of here."

Our exit through what was now dozens of onlookers caused quite a stir. But all I cared about was "The Conquer."

When we got outside, she asked if we were going to be able to hang. I used my standard line: "Oh, man, I'd really like to, but I have to do all this press," which of course was a fucking lie.

I'd gotten what I'd come for, and all I wanted now was to go find more booze and get smashed. The last thing I wanted to do was cater to some stranger who was not looking half as good now as she'd looked fifteen minutes prior. With apparent ease, I'd managed to put my conscience in a bulletproof compartment. This was the life of a rocker, and I was going for it with gusto.

———◆◆◆———

As the tour continued, we started hanging out with some of the other bands. Since we were on the second stage out in the parking lot, all the bands congregated and drank there. It was like summer camp. Every day after we played, we all sat around drinking, smoking pot, and acting like idiots.

I met Will, the drummer from Evanescence, who also played with Bloodsimple, another second-stage band. He was a cool cat who'd sneak us backstage on the main stage and let us watch the show. He'd also take us into Evanescence's dressing room and supply us with booze. We did shots of Jägermeister and whiskey—basically anything to get hammered.

The Hellyeah camp was out of control—mainly their techs, although the band seemed to enjoy lots of partying as well. They gave me shit all the time for looking like Trent Reznor of Nine Inch Nails. It was "What's up, Trent?" every time they saw me. Funny at first, but like anything, after a while it failed to amuse. Booze has a way of making groups feel like they're bigger and more important than they are. There was plenty of that on display, and to see it, all I had to do was look in the mirror. Everyone took himself so seriously, me included.

I needed to hang with someone who could just goof around and have fun. I hadn't had a friend with a super-grade-A, goofball sense of humor for quite a while. But then I got lucky one morning when a commotion outside woke me. My head throbbed—like big-ass subwoofers in a car trunk—from the night's previous binge. To add to the headache, I heard someone outside messing with my drum kit; I went to check on it. At the time, we didn't have a drum tech in

our camp, only two all-purpose techs who did everything—including setting up my drum kit wrong every day.

Still groggy, I stumbled outside only to discover a kid with spiky red-and-black hair tuning my drums. He was really going at it in earnest. I observed him for a few moments, until he spotted me.

Startled, he blurted, "Oh, hey! Uh, hope you don't mind me tuning your drums. Name's Bobby."

"No, awesome . . . have at it."

I found out Bobby Watson worked for another band that had fallen behind in paying him. He said he'd had enough of that gig.

I'd been wanting to use drum triggers, and I asked if he knew anything about them.

"Yeah," he answered with no hesitation. Of course, he didn't know a fucking thing about triggers, but that was Bobby, who said "Yeah" to everything.

"Do you like chasing girls and partying?"

"Yeah."

"Wanna job?"

"Yeah."

"Are you totally full of shit?"

"Yeah."

Though I just made him sound like Rain Man, Bobby Watson, who'd honed his comedy skills during a brief stint at Chicago's *Second City*, was quick-witted and funnier than a retard eatin' hot wings, as we Hoosiers liked to say.

I talked about it with Zo, and we hired him later that day. Life hasn't been the same since. I've never met a crazier, more energetic buffoon than Bobby Watson. He'd happily throw himself down a flight of stairs for a laugh. He reminded me a lot of myself at that

age. At twenty years old, he was full of piss and vinegar. His wit could go toe-to-toe with anyone, and, as a special bonus, he was a chick magnet.

I'd been looking for a running partner on tour, someone who could match my weird-ass sense of humor and party-till-you-drop attitude. We christened him Rockshow, because before every show—as the intro was rolling—he'd try to pump us up by yelling, "Are you ready for a *rock show*?"

From the minute he was hired, we hung out all day, every day. Like two annoying chimps, it only took a few raucous days until we were on everyone's last nerve. Not only did we have a blast partying together, making up stupid bonehead jokes and pranking everyone; I could also count on Bobby to help me get out of any sticky situations I managed to get myself into. And if it involved handling the overflow of chicks, he was always willing to be of assistance.

While Rockshow and I got along famously, that wasn't the case with the other band members. They thought he was an annoying fuck and looked for reasons to get rid of him. Happy to accommodate, he gave them plenty. A perfect example was the night Bobby found some chick he wanted to bang. He pulled her back to the bus and asked me where they could go.

"Zo's gone tonight, so use the back lounge," I told him.

"Thanks, man," he said, disappearing with the chick.

I went outside to drink a beer and smoke weed. A few minutes later Darrell came charging up to me.

"I want that goddamn Bobby to pack his shit. He's fired. I walked in on him and his pants were down around his ankles and he was fucking some chick in the back lounge."

"So?"

That cavalier response really hacked Darrell off, and then Matt got all pissy, too. It was obvious they were angry because the new kid I'd hired was getting laid in our bus when it should have been them. I explained that I'd given him permission. They finally calmed down and agreed to let me keep him on. Like a cat with nine lives, that was just the prelude to the first of nine times Bobby was actually fired.

Bobby aside, mixing personal and professional rarely worked out. A perfect example was a friend of Ivan's—one he'd always wanted to hire—who was reluctantly given the position of tour manager. He was this pseudo-hippie dude who smelled like ass and looked like he'd slept in his clothes for weeks. He'd barely begun his new duties when we got a call from our management.

"Jonathan Davis [Korn's lead singer] wants to send you guys home."

"What? *Why?*"

"That guy you hired as your new tour manager was caught scalping tickets out in front of the venue."

No fucking way! We were allotted ten comp tickets for our guests for every show, and this dumb fuck was outside scalping them. Though he'd just come on board, he was already taking full advantage of us. We had to go apologize to Jonathan Davis and the guys from Korn. (That's actually how we first met them.) We told them we'd already fired the asshole and asked them for another chance to stay on the tour. They agreed, but not before making us grovel. Our burgeoning career almost came to a grinding halt that day. We learned that friendship and business could be a deadly combination. Add booze to the mix, and it's a wonder any of us survived that first tour. I certainly had some close calls, and all of them were alcohol related.

In any case, as long as I could get drunk and have sex, I wasn't particularly selective either way. At one of the radio promos, I spotted "promo girls," hot chicks who worked for the station, being "pitched" by guys from other bands. I singled out this super-hot chick, probably the hottest of all those working that day. I always got off on the challenge of talking to the hottest one. I marched up to her like I was the only guy in the room. Admittedly, I look like every other generic rock guy, but my attitude and confidence set me apart.

I pitched this chick, convincing her to come back to my bus and drink with me. We started drinking and making out, and then we went to her car to seal the deal. Once inside, she told me she was married and her husband was a crazy UFC fighter. I didn't care. Like a dog pissing to mark territory, I actually got off more on doing it with her in *his* car. When it was time for her to leave, she gave me her phone number.

I was so hammered I started texting her and calling her. Later that night, my cell phone rang. It was her number, so I picked it up and said, "Hey, girl."

"Did you call my wife?" The voice on the other end was fucking steamed. I held the phone at arm's length as if it had a deadly virus. Finally, I asked, "Who is this?"

"Yeah, play dumb, *motherfucker*. If I ever catch you, I'll fucking kill—"

Click. No reason to listen to empty threats. I powered my phone off.

She hit me up the next day and we kept flirting back and forth; however, I eventually shut it down because she was married to a crazy bonehead fighter.

Booze always altered my judgment. However, as long as I got The

Conquer, I got the validation . . . and it didn't matter what I had to do to get it.

Sex was random and rapid, and when I was drunk, which was almost all the time, it was reckless. After one such encounter, I called Angel. Even though I'd told her we were through before going on tour, I still called her occasionally. She knew what I was doing, but she was hoping we'd get back together. I was still ambivalent about what I wanted. I had her to take care of me when I needed someone to, but I loved getting drunk and having random sex in a different city every day. I was in no hurry to make a decision about getting back with her, because I could do both, and she went along with it.

I was on my first tour, sucking up as much of the rock-star life as possible—all the while sinking deeper and deeper into my alcoholism.

Family Values . . . yeah, right.

CHAPTER 6

THE AWAKENING

1986-87

I come from a long line of alcoholics. My great-great-grandfather Heyde's family owned a brewery in Kassel, Germany. Really bad karma ... apparently.

I was six and a half when I'd watched my grandparents, the Heydes, down a water glass full of rotgut whisky—with a water-back chaser—for *breakfast*. At one time, this was a way to celebrate being on vacation. It was called a Minnesota breakfast. But somewhere along the line, this fucked-up ritual found its way to most Saturdays ... then to Sunday mornings. I looked forward to sampling it myself.

I was always curious about their booze. Both sides of the family were drinkers. Dad was afraid of becoming an alcoholic like his parents, so he rarely drank. However, this was the period when Mom would have her nightly one or four glasses of wine "to relax." I always made sure I was by her side, taking sips of the cheap-ass wine that came in a green gallon jug. She was part Italian, so it was normal to let kids have a little vino. I nibbled cheese and washed it down with a few sips, more than a few if she wasn't paying attention. What she didn't know was that I'd started chugging gulps from the bottle in the fridge.

Anyway, back to my first drunkfest ...

I was spending a week, alone, at my grandparents' house, the wonderful home of Dutch and Helen in Stanberry, Missouri. As Carl Sandburg once said of such places, "It's a slow burg—I spent a

couple of weeks there one day." With nothing else to do, I decided to help myself to a Coors original.

While they were in the living room captivated by *Wheel of Fortune*, I snuck into the kitchen, grabbed a cold one, scampered past the doorway, and disappeared outside. Cowering behind some lilac bushes in the backyard, I power-slammed the beer. The minute I finished it, I felt *that* feeling . . . and I dug it. I enjoyed it so much, I decided to keep it going.

After stealing and power-slamming beer number two, it really hit me. It felt like someone had pushed me down a staircase and then shoved a Craftsman tool chest on top of me, crushing my little lungs. Fucking smashed, I struggled for breath. On my way back to the house, I noticed my shadow on the ground and was surprised to discover that I had not one but two.

To cover up my crime, I got the bright idea of throwing the beer cans away in the kitchen trash can, under the garbage. A couple of beers and I'd become a miniature Einstein. As I walked out of the kitchen on my way to the bedroom, Grandpa yelled at me.

"Hey, Jer . . . bring Grandpa what you just threw away."

I stood, frozen.

"Bring what you threw away to Grandpa," he repeated.

Holy shit! I was *so* busted. I've failed to mention that Grandpa Dutch was a big mother. His hands looked like baseball mitts, his fingers like fat sausages; if he thumped you on the noggin, it rattled your brain . . . for hours.

What to do? How to get out of this one? I went back into the kitchen and spotted a six-pack of Mountain Dew beside the fridge. This could work! Ah, shit . . . it was a six-pack of glass bottles, not cans. My choices were limited, so I grabbed a bottle and staggered

into the living room. Grandma sat on the sofa. Grandpa was hunkered down in "his" recliner. I handed him what I hoped would be an acceptable end to this drunken nightmare. He looked at me with that all-knowing gleam in his eyes.

"There's no reason to lie to Grandpa. Go get what you threw away."

I was fear-stricken . . . and hammered. I stumbled back into the kitchen, dug a beer can out of the trash, and brought it to him. When I held it out, my hand was visibly shaking.

"You don't have to lie to Grandpa . . . it's okay."

Jumping up from the living room sofa, Grandma Helen chimed in, "There's nothin' wrong with takin' a snort now and then."

I followed her into the kitchen, where she removed a bottle of Jim Beam from the cabinet and poured the whiskey over ice. Grandma Helen had grown up on a farm and, at times, could be pretty country. "Here ya go," she said, handing me the glass and repeating, "Nothin' wrong with a little snort."

Who *were* these people pretending to be grandparents? How did I get so lucky?

Predictably, I did what any normal six-year-old with a major-league buzz would do: I took a big-ass sip and, like a gasoline-fed forest fire, it blazed its way down my throat and into my stomach until it completely obliterated my breath. I couldn't breathe . . . *or speak* . . . which was good, because I couldn't have formed an intelligible sentence if I'd tried.

Whiskey was absolutely revolting, a way different vibe from beer. It tasted like kerosene smelled. But, not wanting to disappoint, I managed to down it all. By now I was absolutely shit-house hammered. I staggered out of the kitchen and into the guest bedroom

and collapsed onto a twin bed. The room was spinning like a carnival ride on acid. I passed out and woke up many hours later. I could try to capture how I felt, but mere words aren't adequate. Let me just say that experience quenched my desire for alcohol . . . until 1986, the year I turned thirteen.

The summer of '86, my parents were involved in yet another musical—this one written by Dad and based on the life of the famous French actress Sarah Bernhardt. He wrote it as a gift to Mom, who played the title role. It was being produced at the University of Evansville, and it was a pretty big deal, involving a cast of thirty and more than one hundred costumes, and it totally consumed them.

Most nights, I was forced to go along to rehearsal. Sitting in the dark theater, hour after hour, was pretty much a drag until the final weeks of rehearsal when the band was added. That's when I met the percussionist, a person who would help facilitate my journey to Addiction Hell. Let's call him Rob.

Three years older than me, Rob wasn't just some guy who played timpani and glockenspiel (though he did with a nearby symphony orchestra): he rocked on the drums. He let me sit behind his drum kit and showed me some incredible chops. I was seriously impressed with his playing. Plus he seemed like a cool guy. Going to rehearsals became instantly more fun, since I could now hang with the band. As a bonus, he smoked cigarettes. I was scared of getting caught by my parents or someone who knew them, so he would let me take furtive drags off his cigarette.

We started hanging all the time. A few weeks passed before I convinced my parents to let me stay overnight at Rob's. It helped that he could lay on the charm when necessary. He'd been adopted by this really straight couple who worked at the university, which helped

convince my folks it was okay. Rob's parents didn't suspect that their son possessed a dark side—insecurity issues that he medicated in a variety of ways. Like the cone snail that appears to be a pretty seashell but is armed with venom, Rob was about to inject my life with a poison that would eventually prove to be deadly . . . almost.

With my new buddy, life was on the upswing, and we didn't waste any time going for the gusto. Rob had older friends who drank and could get us booze. He picked me up and drove straight to the home of one such friend, who agreed to buy us some thirty-two-ounce Colt 45s—the equivalent of two and half beers in each bottle. The three of us tooled around in Rob's car jamming the David Lee Roth album *Eat 'em and Smile.* guzzling our Colt 45s and smoking Marlboro reds. I was in fucking heaven.

Being a skinny-ass eighth grader, it didn't take much to get me completely shit-housed. I killed my first beer like it was lemonade, and within minutes I was totally drunk. Halfway through my second beer I became aware that the earth was spinning wildly—requiring my complete concentration to keep from spinning with it. I also became aware I had to barf. Rob must have recognized the signs, because he pulled the car over and said, "Hurry, get out." I flung the car door open and staggered out—tripping and falling onto the pavement. I struggled to my feet but fell forward again. I wavered back and forth—waiting to toss my cookies—but when nothing happened, Rob yelled, "Come on, let's go."

No sooner had I reached his car door than I began to projectile vomit like Mount Vesuvius erupting carbonated gravy. It looked nasty but smelled worse. Though I felt bad because I showered the outside of his car, what made it really embarrassing was that I'd up-

chucked like a rookie. This was my first night as a member of the Big Boys' Club, and I quickly proved I was unworthy of membership.

How could I be such a lightweight? Oh, yeah, I only weighed eighty pounds, not very big for someone who'd consumed five beers—especially when I downed them at warp speed. Cigarettes didn't help either. It was like Tattoo from *Fantasy Island* power-slamming five beers and chain-smoking half a pack of Marlboros. Nothing like ingesting shitloads of nicotine—on top of booze—with a body as skinny as a vegan's on a diet of bean sprouts and wheat-grass.

I stumbled into the backseat. My mouth was a toxic waste dump, and no matter how hard I tried, I couldn't make things stop gyrating. I grabbed the edge of the seat and tried to hold on, praying I wouldn't upchuck again. Rob and the older dude were making fun of me. I'd hoped to make an impression, to show them I could hang and be a badass. I'd made an impression, all right, but one that proved I was a neophyte among pros. Still, you know what they say . . . if you get bucked off the horse, you gotta get right back on it. Believe me, I hopped back up on that motherfucker and rode every chance I got.

I soon discovered that all of Rob's friends were equally fucked up, dysfunction being the glue that held the group together. I loved this new cast of misfits; however, it's probably not a good idea to judge people's character while in a perpetual alcohol and drug haze. That being said, I thought Rob was the shit. I began spending as much time as I could with him and his buds. When I wasn't there, I obsessed about being there. When I wasn't drinking, I anticipated the minute I would be.

Besides booze, Rob turned me on to a lot of different music—the band Rush, for one. Neil Peart's drum solos definitely resonated with me. Alex Van Halen had some nasty shit going on, too. "Hot for Teacher" was a serious drum song. We'd jam Rush and Van Halen's *1984* while driving around drinking. How we managed to keep from getting in big trouble, I'll never know.

In addition to beer, I started drinking Jim Beam and Coke, Bacardi and Coke—anything we could get our hands on. Most of Rob's friends were of age, so we could get anything. One, a guy named Roy, was a crazy meth head. We'd sit out in back of his trailer and get hammered. Roy, who had to be thirty, seemed to dig the fact I was so young. Knowing he could mess with me, he took full advantage.

"Boy, you ever been laid?"

Sheepishly, I answered, "No."

He started laughing, which made me feel really insecure. Then he yelled to his girlfriend. "Rachel . . . get out here and give this boy his first piece of ass!"

I laughed, but I was terrified. I looked to Rob for help, but he was already a goner. What was I supposed to do? Stupidly, I wanted to impress these older people. But clearly I was out of my element when it came to being a full-fledged fuck-up, even though at the rate I was going, it wouldn't be long until I could say I'd succeeded.

Roy was relentless. "Rachel, I *said* get the hell out here right now! This boy needs to dip his wick."

Thankfully, she wasn't digging it, so the addle-brained asshole finally let it slide. Next, the topic turned to food.

"Boy, yer hungry, ain'tcha?"

I said I wasn't because I didn't want to impose, but I was totally wasted and actually needed to eat something to absorb some of

the alcohol. How drunk was I? I was so drunk I couldn't have hit the floor with my hat. Everything seemed to be whirling, and it was all I could do to stay upright in my lawn chair. I gripped the armrests like a passenger in an Indy race car, rocketing around that brickyard track at two hundred miles an hour. Ol' Roy could see I was trashed, and he was determined to fuck with me as much as possible.

"Jeremy, don't be tryin' to fool ol' Roy now. Yer in need of some grub, and by God yer gonna have some."

I started to protest, but there was no stopping that sadistic bastard.

"Rachel, you fuckin' cunt . . . fix this boy some spaghetti." He sure had a way with words and women. As my grandma Helen liked to say, he was slicker than a bald-tire semi on a mile of wet asphalt and dumber than a box of rocks. And he happily played abuser to Rachel's victim.

All I wanted to do was disappear and find someplace to pass out. I kept trying to get Rob's attention, but he was toast. I ended up eating some of Rachel's home-cooked trailer spaghetti, which elevated Chef Boyardee's ABC's & 123's with Franks to gourmet status.

Surprisingly at first, the pasta seemed to lessen my inebriation. However, I'd barely choked down the last of this slop when I felt the first rumblings. I grabbed my belly, trying to settle the boiling cauldron and hoping to prevent the inevitable. Too late! Before I could get to my feet, the vomit volcano began erupting, spewing undigested greasy ground beef, toxic tomato sauce, slimy noodles, and all. Some stomach-acid-infused sauce shot out of my nostrils, followed by a violent discharge that exploded everywhere: landing in my hair, on my shirt, and all over Roy's trailer-park patio.

Once again, I was embarrassed that I couldn't handle my party. I was a skinny little rookie who had no business drinking and smoking. But in my fucked-up condition, that much was obvious to everyone but me.

Like they say: you can always tell a drunk, but you can't tell him much.

Rob turned out to be my personal perfect storm, a disaster of epic proportion. He finally confessed that his birth mother had been a junkie. Looking back now, I realize he probably suffered from fetal alcohol syndrome, in addition to whatever damage he suffered from her addictions. His adoptive parents had done everything to give him a stable home life. But with his genetic road map, he was headed for destruction. (Not long after I left for the West Coast, following high school graduation in 1992, I heard he got arrested for dealing crack. He spent several years in prison. I hadn't seen or heard from him for nearly two decades; however, ironically, the same week I wrote this chapter, he died of heart failure, brought on by a deadly mix of narcotics.)

Meeting Rob was no accident. He played an important role in helping me understand that life can be fragile . . . and fleeting. I was destined to find my way to self-destruction. With his help, I just got there a little faster.

———— ❖ ————

Later that same summer, with our parents out of town, my sister decided to host a house party. She had always been the responsible one, so they'd left her in charge. Natalie would soon be leaving Boonville to finish her senior year of high school at the Cincinnati School for the Creative and Performing Arts. As a gesture of goodwill, she decided to include her little brother.

Natalie was a talented triple-threat stage performer. When only twelve, she'd won a full scholarship in ballet to the National Academy of Arts in Champaign, Illinois. She'd had major roles in Evansville Civic Theatre musicals for several years. She'd recently played the silent-screen film star Mary Pickford in the U.S. premiere of *The Biograph Girl*, with screen legend Lillian Gish in the audience.

Even then, everyone thought of her in glowing terms. She was on a path that would lead to a distinguished career as a stage director: as Rachel Rockwell, she would be named 2012 Chicagoan of the Year in Theater. Unlike her, I was on my way to becoming a prime-time addict and a certified juvenile delinquent. Though I loved her, my sister's successes were a little hard to take. I felt I couldn't compete. Truthfully, I looked forward to her going away to Cincinnati for that reason. This party would be her send-off, our last chance to "make some memories."

During the summer of '85, Natalie worked at a bizarre theme park in Nice, France. The summer of '86, she was working at Holiday World, an amusement park about an hour away from Boonville, in Santa Claus, Indiana, the actual place where, yearly, millions of letters written to Santa went to die. She was a singer and dancer in one of their variety shows. Most of her coworkers were older and, of course, they all drank and smoked. So I wouldn't feel totally out of it, age-wise, she agreed to let me bring Rob along. Little did she know . . .

The day of the big shindig, Rob and I drove to Holiday World with her. Our job was to rally the troops—to remind her friends about the big party at our house. While Natalie performed six shows in the sweltering heat, we rode rides and smoked cigarettes all day, waiting for the park to close. As soon as she finished her last performance,

we raced home to start prepping. The three of us hurriedly tried to straighten up the house. Before we could finish, people began showing up in droves, not just the people we'd invited but seemingly every amusement park employee. Dozens of cars jostled for the limited parking in front of our house. The overflow parked in front of our neighbors' houses and for several blocks in every direction. There were too many cars to ignore, and with loud music blaring all night, we weren't exactly discreet. Just how we thought we were going to get away with it without getting in trouble only proves what greenhorns we were.

Fortunately, all the guests brought booze: God knows how many cases of beer, in addition to a couple of kegs. The house resembled a popular dive bar on a Saturday night. This was like a dream come true. I began guzzling beer like I was in a power-slamming contest and puffing away like a chain-smoking drug czar, determined to show the older crowd I was one of them.

"Jeremy!" Natalie yelled from across the room. She staggered up to me. "You were smoking . . . I saw you." She was shit-housed, and so was I. Her angry expression quickly melted into a goofy I'm-*really*-drunk smile. We fell into each other—laughing. It was less of an embrace than the need to hold each other up to keep both of us from falling.

Eventually, the booze gave me enough liquid courage to chat up some of the older chicks who worked with my sister. Feeling over-confident, I tried to Casanova my way into some tonsil hockey with one of them, but she wasn't having it. No college chick was about to hook up with a skinny-ass thirteen-and-a-half-year-old, especially one who looked eleven. Fortunately, I finally located another one who was a good sport about my attempts at the pitch; she even

macked with me a little. However, when I belched, then breached—nearly sharting myself—she alerted my sister, who told me to stop hitting on her friends.

I decided to head up to my room, where I assumed Rob was hanging out. People were sitting in groups at the bottom of the stairs and further up on the staircase landing. I staggered over and around people and almost reached the first landing when I lost my balance, tumbling and crashing into people along the way down . . . all the way to the very bottom. Fortunately, some dude caught me just before my head smacked into the hardwood floor. Though the applause was for his heroics, I co-opted it as my own. I was trashed again and reveling in it.

The party slogged on until the wee hours of the morning, ending only because my sister and her friends had to leave for work. Everyone was destroyed, totally hungover . . . none more so than Rob and me.

Natalie rode to work with one of her friends. Our plan was to spend another day at the amusement park after we'd cleaned up the house, which now resembled an aluminum recycling plant decimated by an atomic bomb. Though we both felt—and probably looked—like hungover zombies, we started bagging up hundreds of empty cans.

After several hours of scrubbing, dumping ashtrays that belched dozens of cigarette butts, and moving furniture back into place, we hauled a dozen trash bags outside and tried stuffing them into three large metal garbage cans. Too many to fit, we piled the extras on top of the cans.

After a quick shower, we headed back to Holiday World to enjoy some fun in the sun. On the way, Rob whipped out some pot. I'd never tried it, but when it came to the opportunity to get high, my

mantra was already "There's no time like the present." We chased away our hangovers by putting a hurt on his nickel bag.

Due to the lax park security, we were able to sneak in a bottle of Jim Beam, which we consumed in thirty-two-ounce Cokes. Feeling like I was getting away with something made it all the more enjoyable. We drank, smoked, toked, and rode rides all day in the scorching sun. We were sunburned, buzzed, and baked. But I sobered up pretty fast when Natalie found me to share some disturbing news.

"Dad called. Mom found a beer can on top of the stereo. Right there in plain sight. Great job cleaning up!"

"Guess I missed one."

"One? You wish! He saw the trash bags you piled on *top* of the waste cans. He opened them up and went through it all."

"Oh shit!"

We were fucked! We'd gone to great lengths to pull off this party, and I had screwed up the whole operation.

"Way to go, Jerums. We're both in big trouble now. If this prevents me from getting to finish high school in Cincinnati, you're dead meat."

We had to go home and face the music. Boy, were our parents epically pissed. Had they known what a party animal I'd been, they would have been even more so. They grounded me and took away Nat's car. Though it was a bad scene, part of me didn't care. Pot was a great accompaniment to booze. And partying with the grown-ups was a blast. I hoped it wouldn't be the last time—and I made sure it wasn't.

———— • ◆ • ————

*With my ability to abuse alcohol and with my newfound interest in get-*ting stoned, could sexual awakening be far behind? Admit it, these

are important moments in one's life: both getting blasted and blasting off. I felt like I was quickly moving out of the minor leagues when it came to booze. So I had getting blasted down pat. As for blasting off, that was soon accomplished when I discovered the joys of jerking off.

The first time I got off, my lubricant of choice was Vaseline. That turned out to be a rotten choice, because it was thicker than a Snicker. I might as well have used honey . . . or motor oil. Sliding my hand up and down, I started to feel the earth move, though it was most likely my twin-bed mattress bouncing like a trampoline. Every muscle in my eighty-pound body was tensed. The more I stroked, the more intense it got. I pumped away like a miniature oil derrick—anticipating a gusher. I'd heard it was akin to shaking a Coca-Cola bottle and then popping the cap.

I had a big fluffy towel handy to handle the enormous eruption. It was sure to be one hell of a toe-curling explosion. Oh . . . here it comes . . . here it cums. 5-4-3-2-1 . . . BLAST OFF! For several seconds, my body experienced a series of spasms from the seismic aftershock.

Anxious to see the monumental jizzfest, I was disappointed to discover only a pea-size drop of clear liquid still clinging to the end of my dinky dipstick. I figured my nad factory wasn't firing on all cylinders just yet, which is why my sperm tank was empty. Though that thought was a little troubling, I was still harder than a choirboy in a porn shop. So with nothing better to do, I decided to give it another go. Same result.

I soon realized that beating off was like trying to wipe your ass with a wagon wheel . . . there was no end to it. I must have gotten off a half dozen times. I'd have attempted number seven, but I was

beginning to get a little bored, not to mention more than a little concerned I might start ejaculating blood if I didn't give it a rest.

Armed with this newfound hobby, I was happier than a wood-pecker in a lumberyard, and certain my right forearm would soon resemble Popeye's. In the next few weeks, I was lucky not to have torn my fucking rotator cuff, trying to achieve all those liquid-less nuts!

My next goal soon materialized: to have sex and not be the only one in the room while it was happening. It's not that I disliked being a soloist, but I was anxious to see what kind of body music I could produce as a duet. I was hoping to convince a girl I met in the high school band to join me (in more ways than one). We'd been flirting with each other for a while and were starting to get into each other pretty seriously.

Brilliant minds that we were, we soon devised a plan: she'd spend the night at a mutual friend's house, and a buddy and I would sneak in her bedroom window. Pretty original, huh? Of course, as self-appointed DJ, I brought what I hoped was good "makeout music." My jacket was stuffed full of cassettes—including Yngwie J. Malmsteen's *Trilogy*. Nothing like a little march-of-the-dragon metal to get chicks all hot and bothered, right? This addle-brained thinking was an indication of how much pot I was smoking at the time. But, wouldn't you know, it worked.

We began with kissing, but soon tonsil hockey gave way to stage two. This consisted of me rubbing the outside of her blouse, which was made of some kind of synthetic material. The more I rubbed, the warmer it got. Not wanting to rub her nipples raw or set them ablaze, I started working my way underneath her blouse and toward the much-anticipated bra itself. As if decoding an erotic form of Braille, my fingertips blindly glided over the bra strap till they

reached the fastener. Knowing I was mere seconds away from un-leashing those luscious flesh melons, I was now painfully tenting.

I twisted and turned and fumbled, but the lock to all that volup-tuousness would not give way. WTF! Can just one thing go right?

If there was a secret to unfastening a bra, I wasn't to learn it that night. She was either tired of my fumbling, trying to be nice, or just as horny as I was . . . but in one shift movement she reached back and unfastened the bra, revealing her nubile breasts. My mouth was agape and my eyes did that Wile E. Coyote "I can't believe how good Roadrunner is going to taste" thing.

I was now confronted with what to do with these generous scoops of mouthwatering teen flesh. So many choices! I decided to sample them all. I rubbed them, sucked on them, and squeezed the fuck out of them. I treated her nipple like the knob on the video game *Tempest*—mindlessly turning it back and forth, back and forth. I couldn't help wondering, Does her look denote pleasure or pain? Since she didn't order me to stop, I surmised she was either a masochist, basking in pleasure, or nerve dead.

After nursing her noobies like a starving infant, I was deter-mined to explore . . . *the Forbidden Zone.* I'd been anticipating this moment since we'd first met. In fact, I'd thought of little else for weeks.

Though stealing second base had been frustrating, I couldn't wait to slide into third. To make things easier, she sported sweat-pants. Quivering with apprehension, I paused at the top of the waist-band. Not certain if I was green-lit, I proceeded cautiously. I slowly inched my way down—rubbing the outside of her sweatpants—gradually working my way toward paradise. When my fingers de-tected the much-maligned camel toe, the mysterious mound of

Venus, or, as the description in my Dad's huge *Oxford English Dictionary* described it, the *mons pubis,* I concentrated on massaging it until it started to warm to the touch. That description was an understatement. It was like I'd flipped the on switch for her space heater. Fearing the friction could cause the sacred area to ignite, I was surprised to discover it getting moist instead. I prayed it was passion not piddle.

In my mind, love juice was the green-light special, so I shoved my hand inside her sweatpants and immediately encountered . . . *Yosemite National Forest.* Though it was 1986, it might have been 10,000 BC. That was the way it was back then: people had hairy junk. There was no waxing, no shaving for bikini lines. Hair pie was a sign of the times.

Admittedly, I'd begun the evening as a rank amateur; however, I was determined to end the night as a professional. This was a rite of passage, and I had to succeed. I'd battled a contrary brassiere, circumvented a chastity belt of a waistband, and unearthed a bearded clam. Nothing could stop me now from reaching vaginal Valhalla. My fingers wandered through the hair maze, hoping to embrace her love oyster before I found her poop shoot. Undaunted, I slid two fingers into the clammy opening.

At that point, I had no idea what a clitoris was, and, had I found it, I would most likely have treated it like the proverbial bald man in a boat—irritating the hell out of it. I slid my finger in and out until she began moaning. Once again, I couldn't tell if it was from pleasure or inflammation. After a few minutes, I decided to give it a brief rest and engage in more boob squishing.

As my fingers withdrew, I got a whiff of a mesmerizing aphrodisiac. It was an alluring vibe . . . and my fingers reeked with it. They

say of all the senses, smell is the strongest. Personally, I'm like a dog with a sniffing fixation, and the scent of her poon-tang perfume had my tail wagging.

I'll spare you the rest. Just know that when I got home, I showered with a plastic baggie over my hand. I managed to preserve that glorious aroma for a couple of days. Some call it "stank finger." I thought it was manna from heaven.

Only a few weeks later, I was given another opportunity to score with a girl I'll call Charly, short for Charlene. However, my introduction to actual sexual intercourse was akin to a carnivore sitting down to eat what turns out to be a vegan burger: a little off-putting. Charly, was bisexual and really rad. She informed me that her parents were out of town and invited me over. Not sure what all her invitation entailed, I decided to take my drum kit over to her house and make recordings of the most offensive shit we could manufacture. The plan was to compose horrible lyrics, and then, like maniacs, scream them into the mic while I thrashed away.

In addition to recording, we'd started drinking early and went at it hard. Of course, it didn't take long to get completely hammered, which led to innocent fooling around. She'd also invited over this cool gay dude, and he was getting blitzed, too.

Eventually, Charly and I graduated upstairs to her bedroom, where we continued making out. She lit candles and put on some Japanese music. It may have been the combination of booze, bamboo flute, and bowed lute, but before I knew what was happening, she started going down on me. This was a first, and I watched in amazement. However, I was so fucked up and super numb that at times it seemed like I was only observing the blow job but not actually feeling it.

She continued to fellate me until I flipped her over and started going down on her. I was so involved that at first I didn't notice the pain. WTF! I soon realized she was furiously scratching my back like a cat covering crap on a linoleum floor. I definitely didn't dig it, but though it hurt like hell, I decided I must be doing something right. I continued to "dine at the Y" for a while, hoping to recover from an acute case of dizziness.

After I gave her a good twenty-minute tongue-lashing, she pulled me up on top of her and, miracle of miracles . . . it happened! My love muscle found a parking space in her vaginal garage. Stoked, all I could think was: Alert the media . . . I'm no longer a virgin!

Charly grabbed my ass, pulling me in. While I pumped away, I sucked on her neck, giving her a hickey. She returned the favor by planting one on me that was positively vampiric. Though I wasn't into having blood extracted from my jugular, I was thrilled to finally be getting laid. Honestly, I was so numbed out, I'm not even sure I had a complete erection, but that didn't stop me. I kept going and going until all of a sudden I saw a flash of light . . . but it wasn't from an orgasm.

"What're you doing?" Charly yelled, loud enough to bust my eardrum.

"Who, me?" I sheepishly answered, afraid my lack of technique had betrayed me.

"No . . . *him*!"

I looked up and saw her friend posed behind a camera. Apparently, he'd decided to record my first coital experience for posterity.

I yelled, "Get the fuck out of here, dude!"

Before exiting, he snapped a few more quick pics, did a sweeping pirouette, and disappeared down the stairs.

Slightly stunned by that bizarro interruption, we paused a minute, then tried to regroup. But, sadly, the gay paparazzi had killed our vibe and my erection. She tried desperately to resuscitate my boner, but it was no use. I was completely desensitized. It was like trying to drag a dead horse back into the barn. My cock had a mind of its own and apparently had decided this party was over.

Charly went to shower. I followed after her and, though I pled my case for another go at it, she passed. That's when it occurred to me that I never came. That's like climbing Mount Everest but forgetting to plant your flag. I hoped it still counted as a notch in my belt, even though it was more like a nick. Oh, well . . . next time I'd finish the job.

We went back to her bedroom and passed out. I woke up a few hours later worried about getting my drum kit out of there before her parents returned. I was also concerned about covering the enormous eggplant of a hickey she'd given me. It was summer, so it wasn't like I could hide it under a shirt collar. I'd heard you could get rid of one by smearing it with toothpaste. I tried it and failed. At home, I sold it as a joke. My parents weren't buying it, but they were cool and let it slide. I retired to my room to relive my first fuckfest. Praise Jesus . . . I was now officially a member of the Big Boys' Club.

I found out later Charly was a full-on lesbian. It occurred to me that I may have flipped her switch with my incredibly underwhelming performance.

Occasionally, I check eBay to see if photos documenting my "first time" are listed for sale. If you show up at a Death Punch meet and greet with one in hand, I promise to sign it for you.

SEX, MORE SEX, AND A LITTLE ROCK 'N' ROLL

2007

e finished the Family Values tour and earned a few weeks off. I desperately needed it. I wanted to get with a trainer and start addressing some leg problems I'd recently developed. I never knew when my right leg would decide to go on hiatus, and for someone known for his machine-gun double-bass shredding, this was akin to an opera singer developing a vocal-cord nodule the size of a fucking cumquat.

The bizarre problem began with my right foot turning outward—barely engaging the kick-drum pedal. With every passing day, it had gotten worse. What began as a physical problem spiraled into a psychosomatic mind fuck. I worried constantly about when it would kick in, because it seriously affected my playing and snuffed out any remnant of joy that hadn't already been destroyed by the natural grind of touring.

After a few episodes of gimp-leg syndrome, my confidence was totally shaken. I convinced myself it couldn't be fixed. On top of that, the anxiety I felt—worrying about my leg—occasionally caused vertigo. Right in the middle of a set, I'd get so dizzy it felt like I was about to tumble off my drum seat. I'd immediately become nauseous, scared I'd blow my cookies right onstage. What I didn't know at the time was that excessive boozing was a contributing factor—"excessive" being a monumental understatement. What I *did* know

was that we were embarking on a big arena tour with Korn and Hellyeah in a couple of weeks and something had to be done . . . and fast. If you think I was just being a pussy, try furious double-bass drumming with a gimpy leg for an unrelenting forty minutes—in front of *thousands* of people—and you'll understand my concern.

With Angel's help, I found a trainer who assessed the leg problem and introduced me to a series of strange exercises—spending a half hour or more just rolling my body on hard foam rollers—that worked out the tightness and knots. He recommended I work on various exercises with Angel, who taught yoga. Trying to take orders from someone I no longer considered my partner was a constant struggle. Even though she was trying to be helpful, she frustrated the hell out of me. Jerk that I was, instead of being grateful, I usually ended up verbally abusing her.

I kept working at the various exercises because I had to get myself back to normal. However, the drinking never tapered off; I got hammered every day. It was an easy way to clock out and not have to deal. I'd stockpiled lots of reasons to keep numbing myself: my rocky on-again, off-again relationship with Angel, the frustration of my leg problems, the personality clashes of the band, and my low self-esteem all fed my need for validation. And validation seemed to come only when I was blitzed.

Occasionally I'd call my folks and let them know how I was doing. I explained about my anxiety-aided vertigo, and Dad told me to "just breathe." Sounds good, but try breathing deeply when you're pounding drums like a madman. For me, an important part of being a successful rock drummer is the visual element. When I play, I might as well be in a nine-round boxing match. I give it everything I've got, and I'm soaked to the ass crack one song into the set. I

thanked Dad for the useless advice and hung up, dreading what lay ahead.

Once the arena tour began, it didn't take long for my leg problems to kick in. I spent more than an hour every day doing toe exercises, all kinds of weird shit to rehab myself back into playing shape. But I refused to slow down on the alcohol. Quite the contrary.

Other than Zo, our band drank our faces off. As a result, it didn't take long to start butting heads with the Hellyeah camp. Talk about two bands that drank themselves stupid every night. The problem usually revolved around chicks. Girls who were talking with some of the guys in Hellyeah would end up talking to me. Band members thought I was intentionally trying to snag them, but I wasn't. I'd either be watching Korn play or just hanging out drinking after the show ended. I had no idea who any of these chicks were or who they were with until *after* we'd hook up. Those guys were forever getting all bent out of shape about it.

One night, I ended up on Joey Jordison's bus with Tom from Hellyeah. We were drinking and doing shots. Joey was visibly uncomfortable with the two of us in his space. Tom was drunk and—having obviously built up some resentment toward me—tackled me into the table in the front lounge. When I got back to my feet, Joey was standing there with a get-the-fuck-off-my-bus look. I was more than happy to oblige. New to the touring game, the last thing I wanted to do was make enemies. All I wanted was to have fun, get drunk, and have sex. Pretty original, eh?

Thanks to MySpace, I was able to line up various get-togethers before we arrived at a venue. However, I was often suckered into believing the Internet beauty was the real deal a little too late. One such "beauty" showed up at an early tour gig. Unlike her svelte

photo, she turned out to be considerably chunkier. However, her face was somewhat attractive and, even more important, she was all about *me*. Suddenly it wasn't about quality, it was about landing the plane, as pathetic as that now sounds.

In spite of my eagerness, I wasn't about to let the rest of the guys see me with Miss Pleasantly Plump. So we jumped into her car and headed for a restaurant, where I started slamming wine. With each glass, her appearance improved markedly. Finally I was ready for The Conquer. Having overimbibed, I was completely numbed out, so I popped a Viagra. At thirty-four, booze had already become the enemy when it came to getting it up.

We went back to her place. Spoiler alert: she lived alone with a cat. What a shocker. And, nervous? She talked nonstop. I knew this had to happen fast, or it wouldn't happen at all. When the Viagra kicked in, I pulled her to bed, yanked off her clothes, and started going down on her until she was begging to get pounded by Rocker Guy.

In my mind, she was definitely the one scoring in this exchange, but, man, I soon discovered I had that bass-ackwards. She clamped down on me like a leech on a ball sack. I don't know whom she'd been practicing on, but her lips didn't get that way from sucking doorknobs. Numb or not, it didn't take long before: Super Splooge.

Selfish bastard that I was, my first thought was: *All right! I don't have to fuck her.* Looking back, if she was half as good at doing the deed as she was at giving head, I probably missed out on the time of my life. Still, this way I figured I wouldn't have to put up with her bugging me on MySpace. I expedited the conversation in order to hurry and get out of there.

On the way back to the hotel, she asked what time she should show up for our show. I used my default excuse about not being able to

hang, because, say it with me, "I have to do press." I could tell she was disappointed, but in my fucked-up, insecure state, I was all about me. I needed the juice from The Conquer, and I was willing to pretty much fuck anyone or anything to get that validation. When she pulled into the hotel parking lot, I said, "Adios," and that was that.

Later that night, I joined Ivan and Darrell at a strip club right outside of town. The place was decked out like something from Rob Zombie's *House of 1000 Corpses*. While we were having a drink, I met this hot little brunette stripper right before her turn to dance. Halfway through her routine, she yanked me up onstage, climbed on top, and started mock sixty-nining me. She was chewing on my rod right through my jeans. After the dance, we exchanged numbers and I invited her to the show the next day . . . another would-be notch in the ol' Conquer belt.

That was the kind of spontaneous happening that made touring a blast. And if it ever got dull, I could always count on Bobby to help liven things up. He was the only tech we could afford on this tour, so he teched for all of us. You have to give it up to the kid for busting his ass every day, even though I insisted he get blitzed with me every night.

We'd become inseparable running partners. We closed a fuck-load of trim on that tour, and there were many nights of us "sharing." Once, he and I took this chick to a hotel and she was giving him head while I was trying to bang her. I was so drunk it was all I could do to stay erect. Without warning, he starts singing Disturbed songs at the top of his lungs.

"*Don't* deny me. Don't *deny* me. Don't deny *m-e-e-e*." Except it was more like "DO NOT DE-NY ME!" All proper and staccato and loud enough to attract a crowd.

I tried to ignore him, but he kept it up. I started laughing and couldn't stop. I could tell the chick was getting irritated, so I finally yelled, "Shut the fuck up, Robert! I'm trying to concentrate here."

"Sorry, man, but I can't have her DE-NY-ING ME!"

Talk about a buzz kill.

Another time, I'd run into these chicks somewhere in Louisiana. Bobby and I were doing our routine on them. Basically, we told them we were gonna take them backstage and bang them. They willingly came with us, but once there, they protested, "We're not that kind of girls."

Bobby lost patience and bailed. The minute he left, the chicks that "weren't like that" started making out with each other with me as ringmaster. I dumped one of them on Matt and continued to work on the other. Because we only had a few minutes before the bus was scheduled to leave, she wouldn't do the deed. But she agreed to drive to the next show. I doubted that, but sure enough, both of them traveled to Texas. Turned out they were strippers and actually had some cash. They bought Matt and me dinner and drinks. After getting smashed, we branched off.

On the way back to the hotel, we purchased more booze. The chick I was with came loaded with some serious issues. She'd been molested by her mom or some weird shit. We started going at it, and she was one of those, "Slap me in the face. Slap me in the pussy. Choke me."

I was extremely uncomfortable with this scenario. I'm just not into pain, especially during sex—either dishing it out or receiving it. I hate when chicks scratch me or bite or any of that. (As previously mentioned in the Charly episode, I'm not even into hickeys.) Still, she kept insisting, so I started slapping her softly.

107

"Harder. No, *harder!* And choke me . . . *do it!*"

Because I'm not that guy, I felt horrible. But she kept begging me, so—hoping to put an end to her pleading—I finally relented and gave her a good whack. Instead of ending this nightmare scene from *Marat/Sade,* she was turned on even more—insisting I choke her out to the point of orgasm. What the hell! I could have refused, but like a compliant wimp, I grabbed her neck and started choking her until she finally got off.

"*Oh . . . ,*" she panted, " . . . that was incredible!"

Though complicit, I couldn't help thinking, What the hell's wrong with people? Personally, I don't relate to the pain part. And I'd have never done that sober. But then, I wouldn't have done most of the shit I've done if I hadn't been drunker than a funker.

That scene was emblematic of what became the tour from hell: crazy partying and wild-ass chicks at every venue. We were drinking copious amounts of alcohol, which led to raucous nights—and, eventually, more infighting.

It seemed like Ivan was always starting some shit. His need for drama became an incredible annoyance. Once, Zoltan was working at his computer in the front lounge when he heard the bus door open. Ivan had grabbed handfuls of snow, forming them into a gigantic snowball, which he was planning to throw at Zo. He bolted up the stairs; however, before he could heave the ice-packed snowball at Zo, he slipped on the metal steps and fell back out of the bus—crashing to the ground. He let out a loud groan. Apparently he'd fucked up his knee, because he started crying. A few minutes later, he came hobbling up the bus steps.

"You've got to help me. Someone just jumped me and kicked my ass."

Zo barely looked up from his monitor. "Dude, what are you talking about? You slipped and fell out of the bus."

"No bullshit, I got jumped. Seriously, man . . . "

We soon learned that anytime Ivan said "No bullshit," it was *complete bullshit!*

That kind of crap went on all the time. We drove tour managers fucking crazy, to the point where they would up and quit. We were not an easy bunch to work for. Part of it was just bad behavior enhanced by way too much booze. Another part was the borderline-personality behavior we all brought to the party: Zo's compulsive micromanaging and never-ending obsession with pointing out everyone else's imperfections; Ivan's volcanic anger and near-constant combativeness; Matt's need to be a jerk to almost everyone he encountered; Darrell just being the crotchety old fart he was; and me, the sarcastic drunken retard who couldn't let anything pass without comment. Together we were like a bus full of sweating nitro—just waiting to explode.

The fall tour quickly rolled into the next, with Disturbed. Management told us to avoid trying to hang out with them, so we kept to ourselves. However, one night after drinking lethal amounts, we heard a loud knock on the door. Wary of this late-night interruption, we opened it to find Disturbed, the entire band, in full party mode.

"What's the matter? You guys think you're too good to hang with us? Get the fuck out here and party." Apparently, they'd been wondering why we'd kept our distance.

I was happy to finally get to hang with them, but I was also way too fucked up to know I shouldn't. I took one step and fell out of the

bus—ripping open my tattoo on the side of the door. Ivan grabbed me and got me back to the jump seat. Stunned, I sat there a minute before staggering back to my bunk, where I tried to pass out.

The second my head hit the pillow, my eyes sprang open. I didn't want to miss any of the action with Disturbed, so I got up—swaying back and forth like a hammock in a hurricane—and headed back outside. Mikey and Dan were doing multiple shots of Jäger, so I joined them. Bad idea. It didn't take long before I was fumbling over my words and making an ass of myself. I can't remember who, but someone from my camp guided me back to the bus. This time I conked out immediately.

The rest of the tour was a blast. We got to know Disturbed, who turned out to be a great bunch of down-to-earth guys. They also liked to party, which was a plus for me because they were swimming in free booze. Nightly I made a fool of myself, drinking till I was sloppy drunk. For me touring meant two things: getting hammered and conquering as much tail as I could.

The Conquer took on all kinds of aberrations. As soon as I finished a show and Bobby packed up the trailer, he and I would shape-shift into bird dogs on the hunt. Once we spotted the prey, it became a game to see *where* we could fuck . . . the more unlikely the spot, the better.

It really got out of hand on the first Rockstar Energy Drink Mayhem Festival. There were many nights of yanking chicks into the Porta-Potty. We're talking after a whole day of people splarting Duncan Hines Butt Clay and filling it to the rim with Brim. You know what I'm sayin'? It looked like someone had ingested a large bag of chocolate chips, washing them down with an Ex-Lax cock-

tail. What other explanation could there be for the Jackson Pollock shit splatters on the walls? It was disgusting, and no deodorizer could mask the putrid aroma. *But* that didn't stop us from bumping uglies in the shit-box sauna. It became a game of seeing if you could get it off while still holding your breath.

"If you can smell it, it's in you!" became the battle cry.

Once, I was getting it on with this hot chick in a Honey Pot. I'd had too much nasty Jäger, and I had started to feel its effects. As I was kissing her, the pungent vapors made me nauseous. When I started gagging, I stumbled outside to puke, hoping I hadn't blown my shot at fucking her.

After upchucking my guts, I returned to the shitter, where—like a lovelorn woman awaiting the return of her long-lost seaman—she anticipated my return. How romantic. Even though she knew I'd just barfed up my intestines, she was right back into playing tonsil hockey. If that wasn't distasteful enough, she sat on the nasty toilet seat and started going down on me.

Due to the bad booze, the stifling heat, and the shitful ambience, it required some serious grabbing and massaging to stimulate some blood flow. I finally managed to get my limp noodle inside of her. Technically, it hardly qualified as intercourse. At that point, it could best be described as "rammin' the ramen." My perception of a good time had become seriously skewed.

During that first Mayhem Festival, things got more and more bizarre. I had no clearly defined boundaries. That was never more on display than the night I was in a venue bar, talking with Adam from Machine Head. Midsentence, my attention turned to this chick that came strolling past us, giving me that let's-get-it-on look.

When she meandered into the women's restroom, I cut short my conversation with Adam and followed right in after her. Another chick, who'd apparently had her eye on me, saw me disappear into the john. The first chick and I were in the stall—starting to go at it—when I heard a sultry voice say, "You wanna be with *that* ugly bitch?"

Before I could even react, a head appeared over the top of the stall. Here was this super-tall goth girl with rad lip piercings. For some reason, I got instantly turned on—so much so that I walked out of the stall, leaving the first girl behind. The abandoned chick was still talking shit when the goth girl and I left to return to the bar. When I asked what it was like trying to kiss with lip piercings, she started macking on me. We were going at it right there in the bar when I realized we were attracting a crowd of onlookers.

I said, "Come with me." I dragged her back to my bus, straight to my bunk.

She was wearing a skirt, so it was easy access. Without even asking her name, I went down on her. This was after a whole day in the sweltering sun, but I didn't care. I have a pussy-eating fetish, and—hammered as always—I ate her out until she got off; then she started pleasuring me. In addition to her lip ring, she also had a tongue ring. Bonus!

Following my usual modus operandi, I had unprotected sex and got off relatively fast. I gave her an old sock to clean up with—one I'm sure I'd jerked off into numerous times. (We call those "bunk socks" or "dream catchers." When it comes to cool, rockers have no peers except maybe swine.)

She tidied up and we went outside to smoke and continue drinking. I enjoyed her so much I dragged her back to the bus for round two . . . though I was completely obliterated. What a guy.

———◆-◆-◆———

Later in the tour, I ran into a chick who used to be married to one of the greatest rock guitar gods of all time. I'd gotten a message on MySpace from her, just before the tour reached her town. It was a brief message . . . and somewhat unusual, even for me. (Skip this if you have a weak stomach. You, too, Mom—this is seriously disturbing!)

The message read: "I wanna have piss play with you." At that point, had she said, "I wanna shit down your neck and cover you in pig's blood," I'd still have signed on. It speaks to the depths to which I had fallen. However, in my overly stimulated brain and deadened soul, it seemed pretty rad. Like a pathetic puppy panting with its tongue out, I answered back, "Cool . . . can't wait." I gave her my number.

We started talking back and forth and made plans to get together when the tour arrived in Phoenix. Darrell and I decided to go to the house where she and another chick, who was into Darrell, lived together. They arranged for some shady dude to pick us up and take us back to their house. No sooner had we entered than a weird vibe washed over both of us. Darrell was immediately uncomfortable and decided to leave; ignoring my intuitive voice that warned, "RUN, you dumb shit, RUN," I stayed.

I hadn't been there two minutes before the chick began showing some of the dominatrix videos she'd made. In one, she was wailing on some guy who was bawling like a baby. I sincerely hoped she didn't think I was going to be a submissive slave like that pathetic pussy. To bolster my courage and take the edge off, I started seriously pounding booze.

She asked if I wanted to go to her room.

113

I said, "Cool, but first I need to use the john."

Little did I know these very words possessed magical power, like "Open sesame!" or "My parents are gone for the weekend."

Though urinating was normally a solo gig, it suddenly became a duet. She latched on and guided me into her bathroom. I had been boozing all evening and my bladder felt like a bloated blimp. I pulled out my johnson and began taking a long, record-setting Austin Powers–style whiz that sounded like a racehorse pissing on a flat rock. We're talking urination that was lining up to be one of those two-to-three-minute specials.

As if she were grabbing the brass ring at the fair, she knelt down by the toilet, glommed onto my dick—and directed the spewing piss snake *into her gaping mouth.*

Holy fuck! She was gulping my golden shower like it was vintage champagne, letting some of it dribble out of her mouth all down her front. She must have swallowed a two-liter of UnMello Yello before my spigot finally ran dry. Why did I find this so gross, yet such a radical turn-on?

The minute she'd lapped up the last drop, she started giving me head. I pulled her back into her bedroom, where she continued to gobble my knob. In spite of the labial glissandos and arpeggios, it was taking a while because I was buzzed and more than a little weirded out. "Are you *ever* gonna come?" she finally asked with a look of disdain.

Insecure—I'm not one to eagerly embrace criticism—I looked at her as if she were the cause of my flaccid cock. "Yeah, if you don't stop," I answered accusatorily.

My selfishness knew no bounds, and her boundaries were nonexistent . . . a lethal combination. Though I could tell she was a little

offended, she went at it even more determined. I finally got off and she swallowed it with an audible slurp. Nothing like a urine cocktail with a semen chaser.

Next up: more booze. She quickly got wasted. Then, without warning, she began crying and acting psycho. I mean, she was wailing like an abandoned banshee. By the time I'd calmed her down, I once again required use of the pissoir. I was perfectly content to go it alone—in fact, I hoped to—but, right on cue, she followed me into the bathroom and began quaffing my wastewater once more.

I couldn't believe it. Like a camel preparing for a long, waterless trip across the arid desert, she consumed it all . . . every last disgusting drop. Fortunately, I'd skipped the asparagus earlier in the day, though this bizarro chick would probably have found the sulfurous odor to be another kinky turn-on.

We ended up back in her bed, and she started sucking me off like she was hoping to extract the elixir of life. There was no way I was going to get off with only mouth music, so I suggested, "What say we fuck?"

It seemed to be a normal request, but nothing about this was normal. When she didn't answer, I knew something was up. I finally asked her to stop fellating me, and her response was to begin sobbing again—uncontrollably—except this time it really flipped me out. It took a while to talk her down, but by then I'd had enough of this freak show. I insisted I needed to get back to the bus so I wouldn't miss bus call (even though we were already in the city where we were playing).

Leaving her behind on the bed, I walked out to the living room, where I encountered a disturbing S&M scene in progress, this one involving her roommate and another chick. The chauffeur dude had

assumed the role of director and photographer. I couldn't discern whether the chick was crying because the roommate had her in a dog collar, or because that was the role she'd assumed. Did I still possess enough humanity to come to her rescue, or at least ask if she needed help? Not I . . . the conquering coward. Instead, as I tiptoed past them, I whispered, "Sorry to interrupt, but would anyone have the number for a cab?"

Nice timing, right? The chauffeur gave me the name of the cab company and I bolted out the front door. I called the cab and waited curbside—pacing, but no longer pissing.

Back at the bus, I tried to process that bizarre scene. My reflection posed more questions than answers. The most prominent being: What the fuck *was* that? Any doubt that drinking leads to poor decision making was pretty much validated then and there.

I tried to examine the weird shit I was getting myself into from partying, but that kind of introspection really isn't available when you're ankle-deep in the quagmire of alcohol-infused drama. If I appear to be judging the Golden Shower Goddess, know that I later judged myself even more harshly. No doubt about it . . . I was lost.

Turning away from the light: I was walking in the shadow of my own creation. It was only a matter of time before everything would get even darker.

ROCK 'N' ROLL REBEL

1987-89

Freshman year of high school marked the beginning of all kinds of great new shit, very little of which I can be proud of, but all of which contributed mightily to helping form the future me—the musician and the addict . . . the two being inseparable.

High school meant marching band, something I'd been looking forward to for years. But the band I most anticipated was the one I formed with this dude named Neil, a guitar player.

I'd known Neil since grade school. We'd both wandered aimlessly in the outfield during Pee Wee baseball games, poster boys for attention deficit disorder. I remember once when Neil was staring off into space, a fly ball magically landed in his upturned glove. Shocked, he looked at it like it was some alien object. (How dare someone hit a ball in our direction—disturbing our daydreaming and endangering our craniums?) This could have been Neil's first and only chance at a double play, but mesmerized by how the ball ended up in his glove, he failed to throw it to the second baseman.

Not long after school began freshman year, he began routinely coming over to my house with his rig. We'd noodle around for hours. I was just starting to get into double bass. Dad had recently surprised me with *two matching sets* of Tama Swingstar drums. They were shiny silver, and I couldn't believe how awesome they were. I combined them to form one big double-bass kit. He also

built a drum riser in the basement so, in case it flooded, my drums would be safe. I was stylin'!

It was about this time that another classmate, Jarred, introduced me to a band that would change the way I thought about music: Metallica. I immediately fell in love with them, especially the way Lars Ulrich made drums such a key element. I was determined to be a killer shredder like my new hero, Lars.

Neil and I jammed Metallica's "Seek and Destroy" for hours on end. Inspired by that song, we began making up originals. However, it didn't take long before I grew tired of just guitar and drums. Before we could be considered a real band, we needed to expand, add other players. Neil was also friends with Jarred. He asked him to join us as our bass player. Now all we needed was a singer. We couldn't find one for a while, so we had to be content as a strictly instrumental group. We chose to call our band Anesthesia, copped from Metallica's "Anesthesia (Pulling Teeth)" bass solo off the *Kill 'Em All* album.

After weeks of daily practice, we started to gel. Equally as important, we started to get fucked up together. For me, this was like striking a vein of gold: a band composed of friends who liked to get loaded.

Even when we weren't playing, we hung out as much as possible. Every day before school, we met and smoked weed and as many cigarettes as time permitted. We'd wander into first period tardy and completely baked out of our gourds. Like a pro, I always carried Visine in my pocket to mask my glazed eyes, and cologne and gum so I wouldn't reek—fooling no one.

High all the time, I was useless in the classroom. I survived by cheating. (I should point out that the majority of my classmates—

especially those in honors classes—also cheated occasionally, but it was my standard operating procedure.) Mostly I just tried to blend in; however, in speech class it was hard to go unnoticed.

The first time I had to give a speech—standing in front of a class full of kids with my knees knocking like maracas—I nearly flipped out. When it was my turn, I had a full-on anxiety meltdown, certain everyone knew I was high. Everyone did, in fact, know—including the teacher. Lucky for me she was a cool artsy-type lesbian who preferred to be everyone's "friend." Had she been a traditional teacher, I'd have failed miserably.

The innocent-looking Jeremy of my youth had now completely morphed into "that troubled Heyde kid," and I looked the part. In recent months I'd developed a dark, disheveled, downer vibe, letting my hair grow long and wild. Honestly, it looked like it had been styled with an eggbeater, but back then I thought it made me look like the punk I wanted to be. My smile, once admired for its sweetness, had permanently disappeared in public, replaced by a sullen, rebellious sneer.

In addition to being a shitful student, my reputation as a little troublemaker spread quickly. I was disliked by most of the faculty. Can't say I blame them. I was a total douche who hated authority. That meant teachers, principals, and anyone who tried to tell me anything. Forced to go to school, I made sure everyone suffered.

My math teacher was really zaftig (that's a nice way of saying she was a fat cow). I couldn't stand her, so I put a needle in her chair. When she plopped her fat ass down on it, she sprang to her feet like she'd been speared. Frankly, I was surprised the needle could penetrate her beefy bovine buttocks. Even though she was a grumpy asshole of a person, she didn't deserve that.

My judgment wasn't just clouded, it was nonexistent. I was popping as many pills as I could without tossing my cookies: black beauties, tranquilizers, and truck-stop speed. If I could get it, I did it. My grades sucked but my cheating skills were still intact, and they kept me from failing. My care factor was at an all-time low except for music and, of course, pot, pills, and booze.

Some friends told me about LSD and how rad it was. I was ready to try some pro-level drugs. I'd been in the minors long enough. It was time to progress to the pharmaceutical major leagues. I'd heard lysergic acid was trippy and might cause weird hallucinations; some said it could even "fry your brain." I was scared yet intrigued. Good ol' Rob acquired some and convinced me to try it. It looked like tiny little squares of cut-up comic-book paper. He instructed me to put it on my tongue and let it dissolve. I had no idea what to expect. After waiting almost an hour for the effect to kick in, nothing was happening. I was disappointed because I'd heard that acid was so incredible.

"What's with all the hype, Rob? I feel nothing,"

"Just give it a little more time. It'll kick in."

At first, the transformation was subtle. I noticed a plastic cup from Hardee's restaurant. Picking it up, I was amused to find a picture of Ernest from the movie *Ernest Goes to Camp.* The absurdity of seeing that goober on a drink cup struck me as the most hilarious thing ever. I started laughing and couldn't stop. After a couple of minutes, I noticed I was still laughing, which made me guffaw so hard I practically shredded a lung.

"What's up, Vern?" kept repeating in my addled brain. No sooner had the laughter subsided then I'd hear myself say, "What's up, Vern?" and start in again. This went on for hours. It was ridiculous,

but it was also one of the best times ever, even though it came at the expense of poisoning my brain.

About this same time, an older neighbor friend of mine who sold weed convinced me I could make bank dealing at school. He said I needed a bankroll to get started. I had no idea where that would come from. Then I remembered that Mom kept a stash in her dresser drawer. She tried to save 10 percent of her income to tithe at church. Could I really sink this low? Damn right I could.

When no one was around, I went upstairs to her bedroom to steal the cash. I was amazed to find she'd squirreled away a wad of bills totaling eight hundred bucks! Wow, I thought, that would be a lot of weed, but, man, could I launch my business in a big way with all that bread.

Then, from out of nowhere, something awful happened. I momentarily discovered a conscience and a tiny bit of perspective. My sweet mom, who worked her ass off to save money to give to the church and generate nice karma, was about to be robbed by her drug-addict, alcoholic, degenerate son. I couldn't do it. I closed the drawer.

I started away, but with each step I could feel my newfound sense of right and wrong beginning to wane. Shrugging off my unwanted conscience, I hurried back, yanked open the drawer, and grabbed her bankroll. Fuck the better angels of my nature! I peeled off a dozen twenties—hoping she wouldn't miss them—and put the rest back.

I rushed over to my neighbor's house and exchanged the cash for a cigarette pack full of joints. The next day I brought my wares to school. Word quickly spread: Heyde's in business. The joints began selling like gangbusters. At every bell break, kids gathered around my locker. In one day I'd gone from pariah to the most popular guy

around, and all it took was committing a felony at school and an unforgivable crime at home.

Not only was I the most popular, I was also the most paranoid. Several times while I was in the middle of dealing, a teacher would walk by on her way to the principal's office—causing me to panic. With my luck, I knew I was bound to get busted. So as soon as the traffic cleared, I ripped out the back panel of my locker and stuffed the pack of joints in there. I convinced myself that was a smart move, like a drug dog couldn't smell it if they brought it into the school.

My judgment was obviously impaired. That's enough reason not to get high on your own supply. When dealing, it's imperative to think clearly; however, I was a druggie who smoked as much as I sold.

The next day, when a rumor circulated that they were bringing in a search dog, I totally freaked out. Luckily, I got the weed out of school in time, but on the way home, my luck changed when I ran into one of my supplier's friends. Almost thirty and a total loser, he was someone to avoid. However, before I could make my escape, he confronted me. Knowing I had the stash on me, he insisted I give him some. When I told him I couldn't, he grabbed my arms and started shaking me down. I tried to run away, but he chased after me. He easily caught up with me, ripped my shirt, reached into my jacket, and grabbed the pack of joints—taking a handful.

That shakedown left me totally wrecked. I decided then and there to sell the few I had left as quickly as possible, hopefully make my mom's money back, and return it to her dresser drawer before she discovered it missing. If this plan succeeded, I vowed to never do that shit ever again.

Though I did manage to sell the joints and replace her money, a few days later a "friend" broke into our house and stole all of it . . . all $800! When Mom discovered it missing, she collapsed in tears. She'd worked for months to save it on a teacher's salary, and it was gone in an instant.

"Do you have any idea who stole it, Jeremy?"

"No, Mom. I wish I did," I said sympathetically. I was officially a thief *and* a liar. I felt really awful, but I couldn't say I knew who stole it or she might discover I'd originally taken it to buy weed. What a shitty path I was on, one that made me hurt the people I loved. But not one I would abandon anytime soon.

By sophomore year, I was getting drunk every day after school. Jarred and I would go to an older neighbor's house and ask him to buy us beer. We thought he was cool as hell, buying alcohol for us minors. With my parents still at work, we'd sit on my screened-in porch and try to do homework while we smoked cigarettes and got wasted. We weren't getting much homework done, but at least we weren't out breaking the law, something we'd been doing with more frequency—especially on weekends when we had more time to get in trouble. One such weekend, while my folks were shopping in Evansville, we hit on an amazing beer-and-pot-induced plan: "Let's go steal shit!"

Wasting no time, Jarred and I walked to a local convenience store where I'd pilfered things in the past. The trick was to wait until the cashier was busy checking out another customer.

We wandered around waiting for one such opportunity. It wasn't long until the perfect scenario developed. The customer was a tall guy who conveniently blocked the cashier's view. Seeing my chance, I began stuffing shit into my jean jacket. I stole a magazine, Visine,

124

gum, cassette tapes—whatever I could get my hands on—whether I wanted it or not. I looked like Large Marge from *Pee-wee's Big Adventure*. Jarred loaded himself down as well.

Somehow we managed to get out of there without being stopped.

When we got back home, I was surprised to see my parents' car in the driveway. We quickly stashed the loot in the backyard, behind the incinerator, and went inside. My folks were standing in the family room—waiting for us. Instantly I knew we were in trouble. Apparently, the minute my parents had returned from shopping, Jarred's mom had called, saying the clerk at the convenience store had seen Jarred stealing. Since I'd been with him, she said I'd probably stolen, too. Oh, yeah, and one more thing . . . she'd called the cops.

Mom and Dad were furious. Dad told us both to get in the car. I was hoping Mom would stay home, but she insisted on coming, too. When we pulled into the store's parking lot, the cops were already there. Without explanation, they put Jarred and me in separate cars. I should have been terrified, but because I was still drunk I was, in some fucked-up way, enjoying the whole experience—I thought it made me cool. All it really did was confirm I was just another clueless juvenile delinquent.

As I sat in the cop car, still buzzed from the beer, I suddenly remembered I had a bag of weed and a bowl *on me*. Total freak-out! What if I got searched?

As the cop drove me to the police station for booking, I carefully slid the weed and bowl out of my jacket pocket—cramming them down the crack of the backseat. The cop kept eyeing me in his rearview mirror, but I stared back, stone-faced. However, once at the station, while another cop read us our rights, I started smiling and couldn't stop.

125

"You think this is funny, boy? I can wipe that smile off your face real quick!"

"No, sir . . . I'm sorry . . . I wasn't . . . I'm not laughing . . . sorry," I answered, like the smart-ass I was. All I could think about was how I'd managed to stash marijuana in a police car. I only wished I could have been there when it was finally discovered.

When the cop finished processing our paperwork, he said we'd be informed of our court date. On the way out of the station, the cop who'd driven me stopped us. He knew Jarred and pulled him aside.

"You're lucky I didn't nail you guys for drinking. I could smell it on both of you."

All I could think was, We're even luckier you never checked our coat pockets.

Jarred left with his parents, and I got in my folks' car. It was a horrible, guilt-ridden ride home. They barely spoke, but the vibe was deadly. Mom was heartbroken to think her son had stolen from a store and been arrested. Even though I was barely capable of feeling anything at the time, it hurt to see her crying. Thank God she didn't know all the other crap I was into. It would have killed her.

Once home, she disappeared into the house, but Dad held me back.

"Can't you see what you're doing to your mother?"

He could have said what a total disgrace I'd become, and I wouldn't have thought a thing about it. But knowing how much I was hurting Mom really got me. I was thoroughly disgusted with myself. I went up to my room and passed out.

The next day, it was obvious she was avoiding me. She'd hurry past, not saying a word, but she looked really sad; that killed me even more. For the first time in years, I had a moment of clarity. I

realized I cared about someone other than myself. I didn't want my parents to think their son was a piece of shit . . . even though I was one.

Jarred and I were given probation for our little shoplifting spree. I knew I was facing six months of not being able to fuck up, and it seemed like an eternity. In addition to this probation period, we were also required to do sixteen hours of community service. I'd seen inmates of the county jail in their orange jumpsuits picking up trash along the highway, so I figured we'd have to do that or some other mindless activity. True to form, they made us unload Christmas trees onto a vacant lot, where they were being sold by the Kiwanis Club.

We did this for two Saturdays, eight hours each day. It was actually fun because we'd smoke weed and cigarettes whenever we took a break. Fortunately, there wasn't any drug testing, so we just had to keep from getting caught, which we managed to do.

Having completed the sixteen hours, we received a signed statement as proof. We acted contrite and convinced our parents we'd learned our lesson. From now on, I was determined to keep my nose clean. Yeah, right.

To celebrate my emancipation, I hurried to another friend's house, showered, and prepared for one of our wild weekends. His folks had gone somewhere, so we invited some other friends over and we all smoked pot and drank whiskey and Little Kings beer. It was cheap and packed a mighty punch. We got so drunk and baked that some of us decided to become blood brothers. (Uh-huh: he said *blood*.) Using a big hunting knife, six of us held on to the sharp blade, slicing our hands open. We then took turns shaking hands all around, happily mixing and mingling our bright red body fluid.

Luckily, the AIDS epidemic hadn't yet spread to the hinterlands, but there was definitely an epidemic of IDIOCY.

Stoked, the newly formed Fraternity of Blood Brothers decided to celebrate by going to the high school and kicking in windows. I was always down for some good old-fashioned destruction of property. I approached what I thought was the English teacher's room and began kicking in her window. I could hear my "brothers" around the corner, destroying one window after another. What a great way to celebrate the commingling of our blood and my newfound freedom.

Our depravity didn't stop there. Following our felonious assault on the school, we drove to a graveyard and threw glass beer bottles, shattering them on the gravestones. It was a moonless night, and sparks flew every time bottles collided with granite. Even worse, we turned over a bunch of old headstones. We were fucked-up idiots thinking we were having fun, but we were really just disrespectful little thugs who hadn't learned a damned thing. We went from shoplifting to criminal trespassing and destroying public property. Alcohol and drugs made it all seem "normal."

The fun just kept coming. We hung out, drank more, and around midnight someone got the brilliant idea to drive to a car lot and smash out car windows with a crowbar. Hell yeah! Long live DOP: destruction of property. Just another fun Saturday night in the old burg.

We piled into a friend's car and headed for a car lot on the outskirts of town. The music was blaring and the joints were burning.

Back in the day, there was no security and this place didn't even have a fence to keep intruders out. In fact, other than a little outside light by the office, the cars sat in total darkness—just asking for it. The six of us were happy to answer the call.

The minute we arrived, I grabbed the crowbar and started smashing windshields like I was possessed. I destroyed three or four brand-new cars before it occurred to me that there might be a security camera recording my deviant behavior. I looked toward the little office building and determined that this low-budget operation couldn't afford anything so high-tech. As we were leaving, I decided to get in one last shattering and nailed another car.

Subconsciously I must have decided to punish myself, because I cut the shit out of my hand on the last windshield; not the hand I'd sliced in our fraternal bonding but the other one. My blood-splattered clothes made it look as if I'd been on a killing spree.

We jumped back into the car and headed back to my neighborhood—stopping to burn the rest of our communal joint.

As we sat there toking, I got the fantastic idea to drive my friend's car. Stoned, he agreed. Though my head was whirling about, I climbed behind the wheel, floored the accelerator, and tore through the neighborhood. I was underage, drunk, and high, but that was a minor point. This was the perfect ending to a really fun night. As that thought danced around in my brain, I was returned to the present by a chorus of people shouting in my ear.

"Look out! Jeremy . . . hit the brakes!"

Before I could skid to a stop, I grazed a parked car. Had I not reacted quickly, I could have wiped out several parked along the curb. Having experienced enough driving for one night, I climbed into the backseat and passed out.

I knew what I was doing was wrong, but I had absolutely no self-control. It was all or nothing. Whether it was alcohol or drugs, I had to consume *everything* until it was gone. I was an addict, with a need to fuel the fire. The more I drank, the more I smoked, the more I

wanted. When we couldn't get booze, weed, or pills, we started huffing gasoline. Yeah, you heard right: *gasoline.*

At first, huffing took place at the house of a friend whose father worked nights. We'd huff gas out of an old Pinto parked out back. All of us took turns, our mouths pressed to the opening of the gas tank like little piglets sucking their mama's teats. It was unbelievable the hallucinogenic buzz I'd get: visions of fantastical shit. Once I looked over at Jarred and he'd turned into a storm trooper from *Star Wars.*

In case I've made it sound the least bit inviting, just know huffing gas was totally disgusting. Not only did we reek of it, it polluted our taste buds. It made cigarettes taste like putrid, unleaded shit: totally rank. Not only that, it could result in irreversible brain damage.

Huffing became our default drug. We'd rake together fifty cents, fill up a gas can at the station, and take it to my basement. Within minutes we'd be blasted out of our minds. In my hallucinatory state, I'd see people turning blue. I saw Jesus. Buddy Rich. Scarecrows. Together, we'd have quite the conversation. Nothing ever caused me to hallucinate like huffing gas. I'd dropped acid and ingested mushrooms, even though I didn't like them. They made me queasy and the buzz was too intense. I'd have to drink soda just to get the mushrooms down. Acid was my favorite, but gas the most hallucinogenic. Usually I'd huff till I passed out; other times, to the point of having convulsions. It never occurred to me I might die, or what kind of damage it could do to my brain. It was just comforting to know if I couldn't find anything else, I could always huff gas.

One day after school, sitting in my neighbor's car with an old rusty gas can we'd found in his shed, we were listening to *Master of*

Puppets and huffing away like morons. We smoked one cigarette after another—mindless of how easily we could have blown up the entire car and each other. After a couple of deep inhalations, I started convulsing. My eyes rolled back in my head and I slipped into unconsciousness. My buddy shook me, but I wouldn't come to: I convulsed even more. When I didn't respond, he punched me several times in the arms, chest, and finally in the head. When I finally snapped out of it, drool was dripping out of my mouth, all down the front of me. I'd really scared him, and when he told me what had happened, I got frightened, too. It didn't stop me, though. It didn't even slow me down.

As if I weren't getting into enough trouble, with Rob's help I managed to get into even more. Not only did we share our love for drumming, but he was also into some heavy shit that made us bond even faster. He'd perfected a real con-man personality. He could slip into his nice-guy persona so convincingly that my parents trusted him. However, that trust ended on a school night when I was late getting in.

Totally stoned, we tiptoed into my house. Who should be sitting in the dark, waiting? Dad! When he flipped on the light, it scared the shit out of us. I'd been coming in high a lot, and he was hip to it. When he confronted me, I thought he possessed some fucking psychic intuition. But in actuality I was so baked, a blind person would have seen it.

We'd already solidified plans for me to stay at Rob's house and party the upcoming weekend. However, Dad took one look at us and said, "You're grounded!" He glared at Rob like he could see right through him and told him to forget about me staying with *him* anymore. Then he headed upstairs. That's when I snapped.

131

"I'll fucking stab you!" I said through gritted teeth.

I turned to Rob and started saying what a dick my dad was, but before I knew it, he stormed back downstairs. Grabbing hold of me, in one swift motion he picked me up and slammed me into the wall. I was stunned, and so was Rob.

"Go home," he told Rob, and then escorted me to my room. He said he was taking away *all my music*. Just try it, I thought.

When he got home from work the next day, he came into my room carrying a hammer. Before I could utter a word, he grabbed a tray of my best cassettes—Slayer, Metallica, and Venom—and smashed them to pieces. He ripped down my posters, picked up the rest of my cassettes in the big cassette holder, and started out, ready to toss them into the trash. I had to think fast.

I wanted to say how much I hated him, but instead I pleaded, "Please don't throw away all of those tapes. At least let me give them away to someone."

I couldn't believe he bought it, but he finally agreed. I guess he figured he'd made his point. I invited my good friend Harvey over and gave him the rest of my tapes. I asked him to just hold them for me until the time was right to give them back. He agreed. Brilliant! I'd managed to keep from losing all my music, even though I deserved to have it all taken away and more.

Who the fuck tells a father who's always supported him in every way, who's bought him everything he wanted and let him practice drums in the basement—with a band so loud it rattles the second-story windows—that he's gonna stab him? Only an ungrateful bastard like me . . . that's who.

It took some time to restore order. Eventually, I went around Dad and convinced Mom to let me spend New Year's Eve with Rob.

It's not like I needed an excuse to have a big blowout celebration. But, hey, this New Year's was extra special. We were gonna hang out with his older brother, Joey, a guy who'd recently been released from prison. How cool was that? Partay-ing wit da big dogs!

On the way there, I learned this would be the most time Rob had ever spent with his own brother, then nearly thirty. Joey had been court-ordered into a reform school before Rob was born. By the time he got out, Child Services had removed baby Rob from their crackhead mother, putting him up for adoption. So this was his first chance to reconnect with a brother he really didn't know at all.

We drove to Joey's pad, which turned out to be a hideous shithole in a run-down apartment building. Had I not known he was a convict, his hard-ass vibe would have been a dead giveaway. To this day I have no idea why he'd been in prison. All I knew was that he'd spent most of his twenties in and out of jail. Still, the more hardened the criminal, the more exciting I would have found it.

We arrived shortly after noon. Getting to know you was not to be part of this gig. We barely said hello before we started drinking beer and whiskey . . . lots of it. By midafternoon, I was already soused. We broke out some joints with hash oil and added that to the mix. At this rate, there was no way I would make it to midnight. In fact, by six P.M. I was on the verge of passing out.

Like Roy before him, Joey started making fun of me. Rob, trying hard to impress his brother, joined in. The more shit they said about me, the more paranoid I became. We were all baked and we'd already consumed a week's worth of booze, but Joey had something else in mind: "Let's score some crank!" (That's slang for meth. If you knew that, I'm preaching to the choir.)

133

I'd snorted it before, along with coke. I knew it would keep me awake so I could continue drinking, a side benefit. Coke never did anything for me, but crank was a motherfucker.

We drove to a shitty part of town and scored the crank. We hurried back to his dump, anxious to add it to the mix. Although I was toast, I rallied a little when he pulled out the drugs . . . along with A SYRINGE. "We're gonna shoot up, boys!" he announced. My first thought was, This is real taboo territory. I'd always believed anyone who shot up was a worthless junkie. However, I was so wrecked I replaced that thought with, Fuck it, I'm in!

Obviously, this was not Joey's first crank rodeo. He loaded up the syringe like a pro, shooting up with a hefty amount. Then, like Dr. Feelgood, he fixed Rob, who would've willingly shot up battery acid just to be hanging with his big bro. Though it took a concerted effort just to hold up my head, I eagerly awaited my turn. Within a few seconds of being injected, I transformed from a slobbering, head-bobbing drunk into someone ready to run a marathon. My heart rate instantly increased by fifty beats a minute.

Now a passenger on the Amphetamine Express, I could drink whatever I wanted, as much as I wanted, and still be level enough to handle it. Then, from out of nowhere came a sobering realization . . . the three of us were sharing a needle. It occurred to me that this could have dangerous consequences. But before I could act on it, the thought vanished. All I cared about was shootin' up with the big boys.

We continued to drink. Smoked more weed. Drank more . . . smoked more. Soon the speed started dominating the buzz. Hours flew by. We decided we needed more speed. Had to have it *now*! We raced out to Rob's car like firefighters answering an alarm. We were

responding to an emergency, all right, but it was the urgent need to score more crank and stay fucked up.

Like idiots, we sped back to the crack house. It was New Year's Eve. Cops were everywhere, patrolling the streets, on the lookout for drunk drivers. Because we felt invincible, we acted like we were invisible. Somehow we made it without being stopped. It was an old abandoned building in Evansville's inner city, a mecca for drug-gies, people constantly venturing in and out at all hours. Surely the neighbors had reported what was obviously illegal activity. However, on a night when law enforcement was passing out DUIs like invitations to the Policemen's Ball, there were no cop cars in sight.

Joey grabbed the money out of Rob's hand like a baton in a relay race. He bounded up the front steps of the dilapidated porch and, before he could knock, the door opened and he disappeared inside. Returning in a matter of minutes, he whooped it up like he'd won the lottery.

We got back to his ramshackle apartment shortly before mid-night, quickly shooting up this last batch. I was so high all I could do was just sit in a chair, grip the sides, and hope I didn't crash to the floor. No longer able to join in the conversation, like a zombie I drank and smoked while they yammered on.

HAPPY NEW YEAR! (Oops, missed it!)

The next thing I knew, daylight was streaming in through the plastic curtains. Daylight . . . goddamn daylight. I looked around at the trash heap—and the two of them lying on the floor, passed out in the middle of it—and I suddenly felt like I was among aliens. Un-comfortable and miserable, I wanted to leave, to run out the door and away from whatever horrible shit had happened there.

Joey was a fucking creep. And maybe Rob was, too. I wasn't sure how I felt about anything. I was disconnected from my own body. I'd just shot up a shitload of crank with a stranger who'd only been out of prison a few weeks—sharing a needle with a derelict who could have HIV, hepatitis, or God knows what else. Jesus! What the fuck was I thinking? I looked down at my arm, where the needle had broken the skin, and it was bruised. It was the arm of a junkie . . . a loser. I felt disgusted with myself. Only losers shot up. At least that's how I'd always viewed it. That was me: *I was a loser.* Who was I to judge Rob or his brother?

With each passing minute, I got more and more despondent. I just wanted this shitty feeling to disappear. I wanted to fall asleep and not think about what I'd done or who I'd become. In one evening, I'd gone from just another punk addict to *that* guy?

Fifteen years old and shooting speed. In just a couple of years, I'd morphed from a decent kid into a drug-addicted monster, one my family could barely stand to be around, one *I* could barely stand to be around. For the first time, I was scared of what was next. My life was rapidly spiraling out of control, and I was a bystander watching it happen.

I'd never felt good enough. When my parents or anyone told me I was talented or what a great kid I was, I'd think, Yeah, that's because you don't know me or the shit I've done. Growing up, I couldn't have asked for more love, yet I didn't love myself, so I still felt empty. I tried to mask my insecurities with humor, then later with drugs and alcohol. When someone attempted to engage me in an honest conversation, I'd squirm. I developed a way around it by speaking for both myself and the person complimenting me. For example, if someone said something like "Jeremy, you're a great

drummer," without skipping a beat I'd add, "But don't let it go to your head, asshole. Travis Barker's still my favorite!" Compliments don't sit easily on the unworthy. Love goes unacknowledged by the unlovable.

The crystal-clear realization that I was an alcoholic and a drug addict didn't mean I'd stop using. Hardly. Even if I could quit for a few days, a few weeks, or even months, I was still an addict who craved the highs. Now, however, those highs were coming with less frequency, and it took more and more for me to get a buzz.

What I didn't know at the time was the struggle my parents were going through concerning what to do about me and my addiction. While I thought they were unaware of what a fuck-up I'd become (except for the obvious examples), it had been an ongoing discussion since I was fourteen.

Watching me slowly deteriorate was destroying Mom. She believed there was something they could do that would make me stop. Dad, a child of alcoholics, knew that nothing they did or said would make a difference. When she suggested a drug-rehab facility, he said, "Until he *wants* to quit, rehab won't take." He told her they had two choices: lock me in a room and throw away the key, or hope that when I finally hit the wall, I would hit it hard enough to wake me up but not kill me. That choice was excruciating for both of them.

The year before I turned sixteen, they consulted a deep-trance medium named Michael Blake Reed who lived near Toronto. Skeptical at first, they'd driven from Indiana to Toronto to see him in person. Like "the Sleeping Prophet," Edgar Cayce, this guy would go into a deep trance, completely unconscious, and channel a group of disembodied entities called the Evergreens who would speak through him, telling you things no one but you yourself could possibly know

and answering questions about your past lives, your present circumstances, and what your future might hold.

Supposedly, the Evergreens were a "soul grouping" of between 6,500 and 7,000 souls who had lived every kind of life—from murderers to saints—and they acted like a spiritual computer to determine the various choices a person might make; they could glimpse your "possible futures" based on the choices you were likely to make.

Unbeknownst to me, a year or so earlier they'd told my parents that *by my sixteenth birthday*, something would happen that would alter the direction of my life. Of course, my parents never told me, so I knew nothing about it at the time.

The weekend before my sixteenth birthday, my parents were out of town, performing in Indianapolis at the Indiana Community Theatre League Festival. This was an opportunity to invite some friends over and get fucked up. I was hoping to obtain enough LSD to ensure that the party would be epic, but as usual I was penniless.

Natalie, who was getting her BFA from the University of Evansville, was still living at home. After ransacking the house looking for dough but finding nothing, I stole $180 from her purse, money Dad had given her to buy textbooks. Fortunately, I'd already purchased the LSD by the time she discovered her money was missing. Although I disavowed any knowledge of the theft, she didn't believe me. While my friends and I were hallucinating and having a wild-ass time, I suffered moments of regret about robbing my own sister.

The thing I feared most, however, was what would happen when my folks returned and found out about the theft and our LSD blowout. I was ecstatic when, like the great sister and enabler she was, she decided *not* to tell my folks. Boy, was I grateful; I was also more guilt

ridden. There was that damn conscience again. I liked it better when I could commit heinous acts without self-reproach.

Fortunately, I was able to temporarily repress those feelings when, just three days later, on the eve of my sixteenth birthday, Jarred and I decided to get blitzed. Knowing we had no money to purchase booze or drugs and unable to find someone who would lend us any, we turned to our old standby: huffing gas.

On the night of January 7, 1989, while my parents were asleep upstairs, we snuck into my basement and started huffing. Though it had happened before, I wasn't prepared for what happened next. After just a couple of deep inhalations, I began convulsing—violently. This time I couldn't stop. It was horrifying. I could see Jesus *and* the Devil . . . and they were struggling to see who was going to get me. I was scared shitless. Unable to stop the wild spasms, I finally lost consciousness. Had Jarred not been with me, I'm certain I would have died. He stayed with me all through the night to make sure I didn't swallow my tongue or choke to death on my vomit.

Early the next morning, I came crawling into my parents' bedroom. Still on my knees, I reached up and shook Dad awake.

"What, J-Bo . . . ? What time is it?"

"I need help."

"No kidding."

"I mean it, Dad . . . I almost died last night."

"Oh my God! What happened?" asked Mom, sitting up.

"You've got to put me in one of those places where they lock you up. If not, I'm gonna die."

There was no need for further discussion. This was what they'd

been waiting to hear. The scene quickly dissolved into a full-fledged drama. Though Dad remained calm, Mom was a combination of happiness and hysteria.

Dad went downstairs and hurriedly flipped through the Yellow Pages until he found a place called Parkside at Mulberry Center, a drug and alcohol rehabilitation clinic in Evansville. He called them, explained the situation, and they said, "Bring him in."

"Jeremy, get dressed," he yelled up the stairs. "They want you to come in right now."

"*Right now?*" repeated Mom, flitting about.

"Just as soon as we can get him there."

The ensuing hullabaloo woke Natalie. Fearing I'd finally ODed or worse, she came rushing out of her bedroom. When Mom explained what was happening, I heard her say, "Thank God!" She volunteered to help me pack my suitcase. When it was time to leave, she hugged me good-bye.

"I love you, Jeremy," she said. "Please let them help you . . . *please.*"

"I will," I told her, and she acted like she believed me. I wanted to tell her, "I love you, too!" But even though the words wouldn't come, she knew I did.

"Come on . . . they're expecting you right away," said Dad. He carried my suitcase to the car. Hand in hand, Mom and I followed. She gripped my hand like I was going away forever. I guess it was because only a few hours earlier, I almost had.

Little was said during the entire thirty-minute trip into Evansville. Dad eyed me occasionally in the rearview mirror. Mom nervously fidgeted around while trying to appear calm. Every few minutes she'd look back at me and smile. I could see she was fight-

ing back tears. But unlike the other times, these weren't tears of despair and disappointment. These were tears of hopefulness. Not tears of joy—not yet, anyway. There were still too many uncertainties.

We all knew of people who'd been court-ordered into treatment, people who had relapsed the minute they were released. And even though I'd begged to go, there was no way of knowing whether it would actually help me, whether or not it would "take." I *wanted* it to . . . I *needed* it to. There was no doubt in my mind: I'd been spared. I'd stared death in the face, and it scared the hell out of me. I was determined to get clean once and for all.

The Evergreens had predicted it: something life-changing would happen by my sixteenth birthday. After nearly dying the night before, I felt like it had. Miraculously, I was still alive.

As we pulled into the Parkside parking lot, Dad turned and said, "Happy birthday, Jeremy."

"Oh, that's right," said Mom. "I almost forgot . . . Happy birthday, my sweet boy." Sweet boy? That was something I hadn't heard for years.

Happy birthday indeed! Without fully comprehending it, I'd been given the best present anyone could ever have: another chance to live, another chance at life.

I was determined that my sixteenth birthday wouldn't be my last.

CHAPTER 9

NEVER ENOUGH

2008-09

he tour finished and we were stylin'—selling a lot of records and enjoying a Top Ten radio hit with "Never Enough." The label agreed to release another single and chose "Stranger Than Fiction." I thought it was just average, but it was the best we'd managed to produce during some sessions we'd recorded at Korn's studio, so we went with it.

About this time our manager quit, which was understandable because she wasn't getting the credit she deserved for finding us and bringing us to the label. Uncharacteristically, our management and label were the same company. This would prove to be problematic in many different ways; however, when you're looking to get in the game, you sign on the dotted line and hope for the best. In this case, the hope and the reality didn't quite mesh.

To replace her, they chose a "really nice kid" to manage us. Fresh out of college and greener than goose shit, he'd never managed a band before. He proved to be more than competent at helping with daily tasks. But he was powerless and terrified of losing his job. Sometimes you need someone to rip people a new asshole, or at least stand firm. But when it came to a confrontation between the label and us, he'd cave, always siding with them for fear he'd get axed. (It happened anyway.) This is to be expected when all the power is in the hands of the same corporate entity. Had our management been

separate from our label, we'd have had someone in our corner fighting for us. But that wasn't to be.

When it came to capitalizing on our success, having an inexperienced manager really hindered our progress. That was the situation we were dealing with while gearing up for our second headlining tour, a ten-week marathon that would prove to be one long motherfuckin' trek. Fortunately, my legs were working again, so I was in a relatively decent head space.

On the relationship front, Angel wanted us to get back together, even though she knew I wasn't going to be exclusive. Clearly a bad idea, but in hopes of "having it all," rather than nixing that plan, I decided to keep her around for my own selfish reasons. I relished having someone to take care of me at home, and she was a great caretaker. So I massaged it to have it both ways. Selfish, yes, but a perfect depiction of me at the time.

The Black Sheep in Colorado was our first tour stop, and we sold it out two nights in a row. The crowds were enthusiastic and crazy as always. Colorado seemed to love us, in part because Ivan was from Denver. To fill out our set, we attempted to play our cover of Faith No More's "From Out of Nowhere," a song that would end up on the *Avengers* soundtrack. I thought it was crap; however, it seemed to go over pretty well.

After the show, several of us ended up next door at a dive bar, drunk off our asses. I'd been there earlier that evening because the toilet at the Black Sheep was a public toilet, crowded with patrons for the show. Ivan and I both used the ladies' room, and we destroyed it.

On the way out of the Jane, a chick recognized me. I told her straight up, "If you value your life, don't go in there . . . ever!" She

laughed and asked me to take a pic with her. I said she could now tell everyone she got to stew in the intestinal fumes of the Death Punch drummer and singer. (If you're starting to get the idea that many of my memories from touring are scatological, just know that being a dumb-ass drunk reduces one to adolescence and the requisite behavior.)

We returned to the bar and got thoroughly obliterated. As we were leaving, we encountered a woman affiliated with radio station KILO. Her on-air name was Mama Kilo. Not sure why, but she was "parked" outside the bar. I use that particular verb because she was wheelchair bound. As we exited the bar, Mama Kilo tumbled out of her wheelchair and crashed to the ground. Had it been part of a comedy routine, we would have applauded: it was a thoroughly convincing pratfall. However, she appeared to be hurt. Though drunk, we weren't totally without compassion. Bobby and I helped her back into her wheelchair, for which she was grateful. Fortunately, she wasn't seriously injured. The incident actually helped sober me up.

I include this next little vignette to show the depths to which I had fallen. If you thought I'd already reached them, stay tuned.

Somewhere in Pennsylvania, we played a venue that had originally been a church. Stained-glass windows had been removed, the rough openings boarded over, but pews remained in the balcony, a solemn reminder of its former sacred stature. If it still harbored any desire for the salvation of its congregants, we exorcized it that night. Having rocked the show, we celebrated our irreverent performance with our own form of communion—90 proof.

As per usual, potential sexploitation was part of the postshow agenda. Darrell had invited a chick to visit him, but for some reason he'd been ignoring her all night. Even though he'd initiated the get-

together, socializing didn't come easy for him. A natural loner, he went from the venue directly to the bus, where he remained, messing around on MySpace.

The chick was pissed that she was being ignored, and rightly so. She'd come with her own agenda, and it didn't include being neglected. She was there to get laid, and the longer he made her wait, the more annoyed she became and the more she drank. Being buzzed myself, I started talking to her. In no way was I trying to hit on her—I just felt sorry for her and was trying to be respectful.

"I'm sure Darrell will be out here in a few minutes to hang with you. He's just busy taking care of some things. Let me go check and see what's keeping him."

I excused myself and went to the bus. There sat Darrell, alone, communing with the Internet. "Dude, you need to come take care of business with this chick. She's getting antsy."

I can't recall his exact response, but he acted like he could care less. I was thinking, Okay, man, I tried. My next thought went from being "respectful" to wanting to capitalize on the situation. As Zoltan would say, "You just left the goat to guard the cabbage." (Oh, those wild and crazy Hungarians and their witticisms! Bet that's a real knee-slapper in Székesfehérvár.)

I returned to the bar, where the drinking continued. By now she was ripped, and when I heard, "I wanna fuck and I love anal," I must have looked like I'd won the lottery. Spotting the eager look on my face, she added, "You and me, baby."

"I can't do that to Darrell," I said halfheartedly.

"Darrell? You mean the Darrell who isn't fucking here? That prick! He doesn't figure into the equation," she said. "Darrell had his chance . . . and now it's all yours."

Sadly, that sounded totally legit to my alcoholic ears. "Okay, meet me by the bathroom in five minutes." Once again a restroom stall would become the scene of the crime.

I waited a couple of minutes and then discreetly walked to the bathroom, where I navigated her into the stall. I'll spare you the particulars, but I will say that she howled like a she-wolf. Everyone in the place had to have heard every moan and screech.

As fate would have it, no sooner had we finished than a head appeared over the top of the stall. Good guess . . . it was Darrell's. He looked at me like he'd been violated. I was speechless. Finally, I uttered, "Yup!" I mean, what could I have said to make it better? I was fucking busted. He stormed off, and I ran after him.

I could hear the chick yelling, "What about *me*? What about ME . . . ?"

When I caught up with Darrell, outside, he was as angry as I'd ever seen him. "I came in to help load the gear and you're in there fucking my girl." Suddenly, she was "his girl" again.

I didn't buy that he was there to help load gear. It looked more like his typical avoidance and addiction to MySpace had given way to his need for alcohol. Besides, he never was really a proactive kind of dude. But, inebriated, I could have been wrong.

"Man, I'm sorry. I have a problem. When I drink I can't control myself. I'm a drunk *and* a sex fiend."

That explanation proved to be totally ineffectual. It took a week of me apologizing—many nights of drinking and waiting for Darrell to be drunk enough so I could talk to him—to smooth things over. Although I finally succeeded, the rational part of me knew that I'd been a shitty and unreliable "friend."

Night after day after night, I was poisoning myself with as much booze as I could consume before passing out. If I managed to be

conscious when the sun came up, I'd crawl into my bunk like a re-
luctant vampire, pull the drapery to block out the light, and hope I'd
get a few hours' sleep before I had to play again that night. With ev-
eryone up and around long before me, and with crew running in
and out, that was rarely possible.

As with the previous tour, I soon developed a weird form of ver-
tigo. Feeling like I was about to topple off my drum throne any min-
ute, I couldn't wait for the shows to end. The experience was so
disorienting that I not only feared having to play, but I hated the
very act of playing. The only thing that appealed to me about a gig
was the partying to follow. And our parties were legendary—if not
in enjoyment, at least in the amount of alcohol we consumed.

It seemed like we each killed a bottle of Crown a night and shared
three cases of beer, not to mention my use of weed. That was a deadly
combination for a group that was growing in our dislike for one
another.

One night, Darrell and I were smoking cigarettes in the jump
seat in the front of the bus. The only thing separating the jump seat
from the front lounge was a thin curtain. Typically, we were both
hammered. Somehow fighting became the topic, and Darrell an-
nounced, "You know, man . . . I'd love to fight Ivan."

As if on cue, the curtain ripped open and there stood Ivan—
looking like he'd just grabbed the gold ring. With a malevolent
smile, he said, "Really, Darrell . . . *really*?" Before Darrell could even
respond, Ivan grabbed him and smashed his head into the
windshield—cracking it (the windshield, that is). This was a solid
head smashing. I don't know if you've seen *Jason X*, where Jason
dips the girl's head in liquid nitrogen, freezing it cryogenically, be-
fore shattering it on the counter—but this was reminiscent. Though

149

Darrell's cranium wasn't fractured, the whole scene was pretty intense. To make it worse, it happened while we were blasting down the highway at seventy-five miles an hour.

I did my best to break it up, all the while trying to keep them from causing the bus driver to wreck. Zoltan and Bobby came to help, but the damage had been done. I apologized profusely to the bus driver, a guy named Pops who was a fucking giant of a man. "Hey, Pops, I'm really sorry about the windshield."

"I could give a shit!" he said. "It don't make me no never mind. But y'all just spent a thousand bucks. That's what it costs to replace the windshield."

Great, I thought. By the time management gets its share and we divide our take at the gate five ways, I just played for nothing.

Once again, alcohol had fueled an unpleasant incident. It had become the theme of the tour, which we promptly renamed the Burn This Bitch to the Ground tour.

The one thing that made the tour bearable was having Bobby to pal around with. He was such a buzz saw of energy, and between the two of us, we were always creating havoc. There was no way to know what he'd do next. He loved being able to hang in our camp; however, his hang time was often cut short because he just couldn't curb his smart-ass mouth and attitude. I can't say I blame him. We had to be one of the worst bands of all time to work for, and he had to endure a lot. Everyone was a complaining asshole with no regard for others. That disregard soon extended to Rockshow, and it was obvious I wasn't going to be able to protect him or his job.

Death Punch was now at a level where I needed someone who was a competent technician. Though it was never anything major, Bobby occasionally fucked up as my tech. Add to that the band's constant irritation with some of his pranks and my burnout factor, and I knew a change was imminent.

This was going to be tough, because he and I were simpatico. I'd needed his humor to survive the hours of mind-numbing boredom that is touring. Still, I wanted to try a new direction and also force Bobby to follow his dream of being an actor. Rotting away as a tech was no place for someone with his talent, so we fired him. The way it went down was typical Bobby.

He'd recently purchased some fake mustaches and was all decked out in a stupid outfit when we pulled him off the bus to tell him. Seeing him in that ridiculous getup, it made having to fire him seem even more pathetic. He was crushed and so was I. He looked at me as if to say, "And you're okay with this . . . ?" The decision had been made, and I couldn't reverse the call even if I'd wanted to. We let him go in his hometown of Chicago. It was a sad farewell.

At the next venue, our new tech, Joel, joined us. He appeared to be a really nice guy, the perfect Band-Aid to cover the pain of losing a friend. A Christian and a virgin, the poster boy for teen abstinence groups, he had no idea what kind of minefield he had walked into. Fortunately, he proved to be a great sport about everything—which just proves that being naïve and clueless might be the best way to survive being surrounded by a bunch of assholes.

Joel didn't have time to get acclimated. He had to hit the floor running. I'd gotten a new rack at the beginning of the tour, and Bobby had set it up from day one. Together Joel and I started the

long process of assembling my drum kit and the complicated rack. I was clueless and he seemed equally perplexed, but we finally figured it out. I could tell Joel was more technically skilled than Bobby, but it wasn't going to be the same without Rockshow.

The more this band progressed professionally, the more we suffered on a personal level. The band's trajectory was on the upswing, but everything else was on a downward spiral. As a group, we barely had the energy to slog through. Any added negativity and it became impossible. The band was getting more and more out of control.

Matt had begun bringing his then girlfriend and her kid out on the road. Though she was a sweet little girl, this was definitely no place for her. Can't tell you how many times we woke up, hungover, with *SpongeBob SquarePants* blaring in the front lounge. We'd quickly gone from a rock 'n' roll bus to a preschool on wheels.

One morning, Darrell was blindly stumbling down the hallway when he tripped over the little girl's toys. He looked at Matt and said, "Really . . . ?"

"Get used to it!" yelled Matt, whose sense of entitlement was starting to wear on everyone. In any situation, Matt always acted like he was especially privileged. This extended to whatever venue we played. There were times when all of us had chicks watching from the wings. But that wasn't good enough for Matt. He'd allow his chick to stand in plain view of the audience, the child by her side. Once, when Zoltan was in the middle of playing a song, the little girl grabbed some drumsticks and wandered out onstage. When Zo felt something tapping on his legs, he looked down to see her doing a paradiddle on his shin.

Black-eyed, three-years-old, and always getting hurt!

Natalie, Grandpa Dutch, Grandma Helen, and four-year-old me (not knowing in two short years I'd be drunk for the first time at Grandpa and Grandma's house).

Mom, Dad, Nat, and me, five-years-old. Good ol' choreographed family photo . . . interesting framing.

Stealing the show in *The Legend of Sleepy Hollow*, 1982.

As captain of the school safety patrol in sixth grade, I used to help kids cross the street. Sweet Jesus, help us!

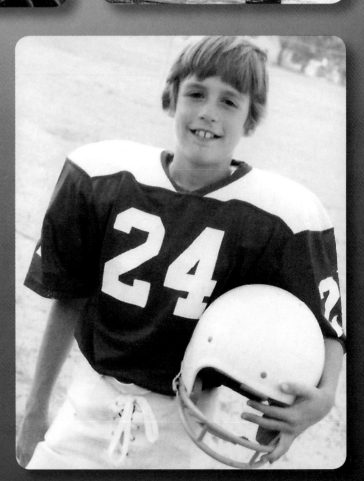

Pint-sized defensive back in Junior League Football, sixty-eight pounds of pure fury, 1983.

Me at twelve-years-old, jammin' in my bedroom to a one-member audience: Prince!

Practicing in the basement and going deaf from the concrete walls, 1987.

Playing the lead role of Jesus in *Godspell*.

The band glossy for Cornucopia of Death, which we sent out in promo packs to get gigs.

Jason Hook and me going to opening night of the KISS reunion tour in 1996.

The original Five Finger Death Punch lineup behind the scenes of "The Bleeding" video shoot, 2007.

Shooting my closeup in "The Bleeding" video.

Me and Bobby "Rockshow" Watson partying on the tour bus, 2007.

Drinking with the legend Vinnie Paul, 2007.

Probably the first good picture of me behind a drum kit: headlining the Death Before Dishonor Tour, 2008.

Tying one o
with Ivan.
(Never give
brown liquo

Signing at NAMM with some of my drum idols, bloated and looking like Elvis right before he died in 1977.

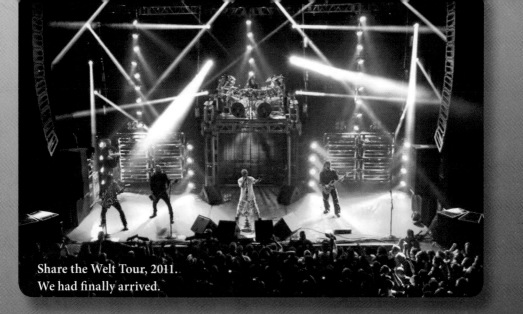

Share the Welt Tour, 2011.
We had finally arrived.

The "white beast":
Trespass America
Tour, 2012.

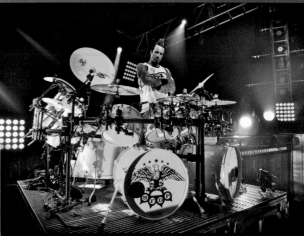

My original book cover, under the title *Cheers to My Sobriety*. (On cocaine you feel like Ron Jeremy from the neck up and Christopher Reeve from the neck down)

On the red carpet
with Alice Cooper
at the 2013 *Revolver*
Golden God Awards.

Coheadlining the sold-out
Mayhem Festival
(and waving to Mom)
in Chicago, 2013.

My newest endeavor, entering the acting
world as Uncle Colt and Cletus.

It's doubtful you'd ever see Iron Maiden with a bevy of girl-friends and kids crowding the stage. We were hoping to build some cred as a serious band, but Matt's insistence that his "family" be in the forefront and underfoot made that increasingly difficult.

In addition, his need to impress everyone encouraged his girl-friend to become self-important, too. With each passing day, she got mouthier to our crew. Once, when a tech was carrying an armload into a venue, she let the door slam shut in his face. When he finally managed to get inside, he said, "It would have been nice if you'd held the door for me."

I couldn't believe it when I heard her retort, "You're just a *roadie* . . . I'm the wife!" Her attitude was definitely a result of listening to Matt lord it over everyone.

In spite of all that, I still liked partying with him. His angry tirades were often entertaining, and his sarcasm could make Daniel Tosh seem tame. However, the more inflated his ego and the more he drank, the more tiring it became.

Consuming insane amounts of alcohol was threatening to tear it all apart. Personally, my body was in shock. My playing was sufficient, but I hated everything about it. I needed this tour to end . . . soon. We all needed a break from the road and one another. Something had to change.

Unlike Matt, when Darrell drank he didn't become annoying to be around. Instead he became a stumblebum. I've seen him stagger and crash into walls. Once, he'd turned around and yelled at the driver, "Can you take those turns any harder?" We had to remind him that the driver wasn't present and we were still parked.

The problem with Darrell's hangovers was that they kept him from functioning. A perpetual grump when he'd wake up at three

153

or four in the afternoon, he never felt like doing meet and greets or radio promotions. Those tasks always fell to the rest of us. Once, when we returned—beaten up from a radio promotion where we played paintball—he emerged from his bunk with a guitar embossed on his face. He'd passed out on top of his guitar.

"Where've you guys been?" he asked . . . clueless. It didn't take long before this got old.

His attitude became increasingly belligerent when he was asked to join the rest of us in doing promotions. His attitude was, I play guitar and put on a show for the people—don't expect me to play paintball, too. The real reason he didn't participate was that he was painfully hungover and didn't want to be pelted with paintballs. Ivan, Matt, and I drank as much or more than Darrell, but we still managed to get up and do promos and phone interviews or whatever was needed to help promote Death Punch. But somehow Darrell thought he could opt out.

As a person, I loved Darrell and got along with him great. But as far as a business was concerned, we'd reached an impasse. As a band, we seldom agreed on anything; however, we were unanimous in our belief that we couldn't go forward with him on guitar.

I began communicating with Jason Hook to see if he might be interested in joining the band. I knew he wasn't happy being in Alice Cooper any longer, because he was tired of being a hired gun. I asked if he'd be interested in joining Death Punch and he was like, "Fuck yes!" I talked to the rest of the guys, and they thought it was the right move. Everyone liked Jason and knew he was a phenomenal player. We decided to finish the tour and make a seamless transition.

Darrell suspected his days were numbered. One night when we were hammered, he asked, "Am I getting fired after this tour?"

The question took me by surprise. I was a total pussy when it came to hurting people's feelings, so I mumbled, "What . . . ? Fired . . . ? No, I don't think so . . . " What a wuss!

We pressed on for the last few weeks, but it was pathetic. We were deteriorating rapidly. Even the tour manager was starting to slip. The last few weeks of the tour, he'd gotten hammered on Crown and was sloppy running the show. Offstage, his drunken antics continued. Once, he pulled his shirt off and smeared mayonnaise all over his stomach. He came into the lounge where we were sitting and plopped down on our laps, pinning our arms. He had this weird-ass, demonic look. When we tried to get away, he smeared the shitty condiment all over our faces. It might have been funny if it hadn't been so disturbing. The more he drank, the more aggressive he became. We'd hired him to manage the lunatics in the band, not to become one.

———————◆◆———————

We coasted into the last date in San Diego on proverbial fumes. As soon as the show was over, like usual, I started pounding drinks. Though it was raining, I decided to step outside for a cigarette. Completely blotto, I slid on the slippery bus step, landing on the side of the curb and cracking my ankle. It hurt so fucking bad that I fell to the wet ground and started crying like I was a kid who just stepped on a rake or got his foot caught in the spokes of his bicycle. As I lay there writhing in pain, the sky opened up in a major downpour.

Matt was watching from the window seat, observing my moment of agony. Hobbled, I dragged myself back onto the bus. Always quick with a caustic remark, he had something smart-ass to say; however, I was too drunk and in too much pain to respond. When I finally made it to my bunk, I passed out.

The next morning, the bus pulled up to our storage unit in Burbank so we could unload the trailer. Forgetting I'd hurt myself the night before, I jumped down out of my bunk. When I felt a shooting pain in my ankle, I crumpled to the floor. I couldn't put any pressure on it, which made unloading a real joy. The last thing I wanted to do on break was rehab an ankle as I had my legs.

I called Angel and told her about the accident. When she came to pick me up, she insisted I go to a walk-in clinic to have my ankle X-rayed. I agreed, but not before ordering her to stop and buy a fifth of Crown. I drank the whole thing when I got home. Knowing what an asshole I could be when blitzed, she gave me some space. Most of that first day off, I sat on the deck with our dog, Bean, drinking, listening to music, and calling band members to discuss how we were going to break the news to Darrell.

The band decided to wait a couple of days before we dealt with his situation. I told Zo to give me a warning first, because I knew the minute Darrell hung up he'd call me. Zoltan's heads-up would be the go-ahead for me to start pounding booze and getting sloshed so that when Darrell called, I'd be able to handle it. However, I was such a jonesing drunk I couldn't wait for the heads-up. I poured the first of many Crown and Diets. I called Jason to tell him what was going down, but got his voicemail. Waiting for Zo's call, I kept tossing them back. Hours went by and I was drunker than Cooter Brown (another one of my grandma Helen's country expressions).

When Jason finally returned my call, he asked if I'd heard anything.

"Dude, I'm fucked up . . . I haven't heard anything."

Finally, Zo called to say he'd delivered the bad news. By then I was completely useless. I hung up, knowing Darrell would be call-

ing any second. Before I could even exhale a sigh of dread, my phone rang.

Darrell acted as if he was in total disbelief. Even though he suspected it was happening, the reality shook him to the core. I tried to comfort him because he was a good guy and I felt bad about it. But there was no consoling him. I knew things would never be the same between us.

The more I reflect back on it, he was no more fucked than any of us. But in order to move forward with the vision of the band, it wouldn't have worked with Darrell, because he was just too negative—always seeing the glass half empty, always seemingly depressed about something.

I spent a half hour on the phone trying to soothe him. I ran out of Crown, so I transitioned to wine. I could barely even string sentences together. When I finally ended the conversation, I called Jason back, letting him know the deed was done. The Jason Hook era had begun.

◆

To get Jason up to speed, I went to our rehearsal space and recorded the drums of our entire live set. Playing from memory, I tracked the whole show with all the little additions we'd made from performing them live. He dumped the tracks into his Pro Tools rig and ran the set as if it were the actual show. By mastering our set list from day one, he hoped to not miss a beat. He wanted to impress the guys, but they were already impressed. They liked him as a person and knew he was a badass guitarist. To fine-tune everything, the two of us got together five or six times. When we finally rehearsed as a band, he nailed everything. We were convinced we'd made the right choice.

Next up: a European tour, the perfect opportunity to assimilate Jason. This was our first time going to Europe, and we were all stoked. The Defenders of the Faith tour was to kick off in the United Kingdom, specifically England.

To amuse ourselves, we developed stilted British accents and wisecracked, "We're having a jolly ol' time here in England . . . gallivanting about, sucking cocks and whatnot!" To help us get started on the wrong foot, a British magazine actually used that quote in an interview article. (As a result, I've never really trusted anyone in the press. All most reporters care about is a headline. They'll do anything to interest readers. I get it. So if I feed a line of bullshit to the press, now you can understand why.)

The trip to England was a complete drag. I wasn't a fan of the food or the dreary weather. Most of the shows were just adequate . . . all except one. We were opening for Lamb of God as usual, but just as we were starting to close our set with "The Bleeding," Jason's tech (who was teching for all the string players) handed him a seven-string guitar. I counted in on the hi-hat and Jason began the pick-and-roll beginning, but no sound emerged. It flubbed him up so badly that he stopped. Apparently, one of the strings had slipped out of place and gotten caught on a crack in the neck of his guitar. Ivan made some kind of wisecrack, and we started over with the same result. Ivan got pissed and encouraged the audience to start chanting, "Fuck you, Jason!" They were more than happy to oblige. We started "The Bleeding" a third time, and by now everything was fucked and out of tune. The crowd began heckling, and as we continued, the jeering grew louder. By the time we finished, the whole place was booing. Had this been a music hall back in the day, they would've been throwing heads of cabbage and rotten fruit. We ex-

ited the stage as quickly as we could. It was a fucking disaster. We were all shaken by it.

Ivan roared into the dressing room like a bull that had been threatened with castration. He started throwing shit all over the place. We'd witnessed this behavior before, but this time it was monumental. That scene, especially the booing crowd, set the tone for what would be a pretty tough trek across Europe. (I'll spare you the flag-waving, but after traveling around the globe, I understand why people say America is the greatest country in the world. And it's not all about burgers, fries, and adequate plumbing.)

To be fair, it wasn't all a downer. We rode the "Ferry Cross the Mersey," stayed in cabins, and had a royal blast. Some of the crowds were great . . . small but enthusiastic. It quickly became obvious the shows weren't being promoted. Our management had shipped us to Europe (at our expense), hoping to create an international audience. Had they done their job beforehand, the numbers would have been significantly greater. Though disappointed, we still threw down. And, as always, we hung out with the great fans that were there.

The tour was a good way to break in a new bandmate. With Darrell, we'd become a tight unit. But Jason afforded us a totally different energy. Once we figured out the nuance and technical skill he added—making the requisite adjustments—we started to crush.

Jason had been to Amsterdam numerous times with other bands. He made it sound really kick-ass. "Wait till you see the Red Light District . . . it's insane. It's like window-shopping for chicks who are all 10s! I mean, Cindy Crawford hot!"

As soon as we closed the first show, we slammed some booze and headed out to sample the infamous Red Light District. The brick

streets were jam-packed with bicycles. It was bizarre seeing few cars but mobs of people cycling.

Everyone but Zo was already pretty tanked . . . especially Jason. He'd brought along his tiny flip-cam video camera, about the size of a small cell phone. He'd used it to record backstage antics, parts of the show, and our exploits on the bus and in airports. Hoping to capture all the glory of our walking tour through "the district," like an inebriated Einstein he'd taped the camera to the front of his jean jacket.

None of us knew he was recording all the girls, who were assembled in the storefront windows like seminude fashion mannequins. We were laughing and commenting on which ones were the hottest. Because we were hammered, none of us noticed the signs—posted everywhere—saying that taking pictures of the girls in the windows was strictly *verboden*!

All of a sudden, one of the chicks spotted Jason's camera. She jumped down from the window platform, flung open the door, and came barging out like an enraged pit bull. Grabbing Jason by the hair and jacket, she started yelling for the other girls, who quickly followed her out. They were all screaming and tearing at him like banshees—drawing all kinds of attention from dozens of onlookers.

Then, from out of nowhere, these two mobster types appeared. They grabbed Jason and pulled him into the alley. Ivan and Zo were trying to keep up with them—fearing they were going to beat him up. Matt and I just stood, frozen like complete wusses, watching it go down.

These guys weren't playing around. When one thug ripped off Jason's camera and started waving it in his face, Ivan began pleading to let Jason go. They weren't having it, so he offered them money.

160

His first offers were ignored, but when he reached 150 euros, they agreed and released him. They also gave back the camera, but not before deleting everything—including all the tour footage.

I was relieved Jason wasn't hurt, but I was so shit-housed and horny that I wandered off and continued window-shopping. I found a chick, a gorgeous brunette, who was about a 12 out of 10. She could tell I was enamored (and hammered) and invited me inside.

This was not to be a casual get-to-know-you. She smiled and said a phrase she'd obviously memorized, "Take off your clothes." I immediately complied. She was wearing neon yellow lingerie, which glowed in this room decked out in black lights. There I stood, glowing purple, with my drunk-ass cock dangling, limp as a noodle. She led me to a twin-size bed and had me lie down while she wrapped a condom on my flaccid joint. When she finished, she took my latex-coated penis into her mouth, and in no time it rose to full attention. Though she was a pro, it helped that I'd popped a Viagra before we left the venue.

Without pause, she climbed on top of me and instantly became a champion bucking bronco rider. Fortunately, I was still numbed-out enough that this wasn't going to be an eight-second ride. I mean, this girl was fuckin' hot! All I could think was that for sixty euros, I was getting an amazing fuck job that hadn't required even one second of "auditioning." Suddenly, the whole idea of paying for sex up front seemed awesome, unlike "paying for sex" by buying booze, dinner, and expensive entertainment (not to mention the emotional expense) back in the States.

She was so skilled that I came rather quickly. I hurriedly got dressed and, as I walked out the door with a huge smile on my face, I ran right into Zo. Before I could tell him what a fantastic time I'd

had, a grubby guy pushed past me. I turned to see him walk through the door with the same chick I'd just fucked. That's when it dawned on me how disgusting it was—knowing those chicks fucked dozens of guys every day. I was too drunk to consider how shitty for her it must be to have to earn money that way.

When I rejoined Matt and Ivan, they were pissed because I'd wandered off and gotten laid. Knowing Jason was going to be all right, my attention had turned to something more important: me. I needed The Conquer for my damaged self-esteem. Add to that being hammered and hoping to avoid confrontation, and I could always be counted on to do the selfish thing.

Next we headed to Germany. Unlike England, I loved everything about it. The incredible scenery, the badass architecture, and the fabulous weather were a pleasant change. Plus the chicks were really hot. And, oh, yeah, did I mention the chicks were hot? There was this scorching blonde who recognized me. She was into drummers, and her two favorites were Tommy Lee and yours truly. It had to have been a drummer thing, because I sure as fuck didn't have his bank account or his cockage.

The first night we got together, I brought her up to the dressing room with one of her friends. She wanted to meet the band. Ivan, Jason, and I had all been drinking. Ivan could really get out of control when drunk. We got in an argument about God knows what, and he started pushing Jason and me—breaking bottles and throwing shit. Jason shoved Ivan back. It quickly escalated. The chicks huddled together, terrified. I walked them out and apologized. Nice introduction to the band, right?

We made plans the next night for her to come to another show in another town. As promised, she was there. Right after the show, I escorted her into the dressing room, where we began making out. She wore this great-smelling perfume called Miss Sixty. I told her how great she smelled, and she gave me the bottle to use as air freshener in the bus and dressing room. We christened her Miss Sixty.

Angel had been stalking my MySpace page, so she knew the chick was traveling with me. She grilled me six ways from Sunday about it. Big mistake! I was pissed, and to show how much, Miss Sixty and I banged each other's brains out for the rest of the German tour. Passive-aggressive, anyone?

Death Punch returned home shortly after Germany. Predictably, Angel and I resumed our unhealthy relationship. She was so codependent she actually let me buy her Miss Sixty perfume because I told her how much I liked it. That scenario perfectly sums up our twisted relationship. But being a total fuck-up myself, I couldn't see it . . . much less care.

CHAPTER 10

REHABBA-DABBA-DOO

1989–91

oing to rehab meant getting the broken parts of myself fixed, like taking an ailing car to a mechanic: the engine sputtering, overheating, making strange noises, the brakes squealing, a headlight out, a taillight busted, a fender mashed, and a trail of noxious smoke billowing from the exhaust. *But*, after the mechanic works his magic, it looks and performs like a race car. Same thing with rehab: you come in fucked, someone you barely recognize and someone you can no longer stand to be around, and thirty days later, after therapists wave their magic wands, you leave shiny and new . . . whole again. Right? Wrong!

Without giving away the whole story, just know that out of the twenty-eight teens who entered rehab with me . . . only two would make it eleven months without relapsing. And by the end of the first year, only one of those two would still be alive.

On day three of my residency, my roommate, let's call him Melvin, was admitted. Tall, lanky, and looking as if he'd slept in his clothes for months, Melvin was a nice guy but really fucked from drugs. From all the shit he'd smoked and ingested, he'd been damaged so severely that he appeared to be retarded (the politically correct "mentally challenged" was not yet in use).

From a small town—across the state line in Kentucky—Melvin could have been his own grandpa, might have had a sister-momma, an aunt-grandma, or a cousin-daddy, if you catch my drift . . .

inbreeding being the name of the game. Like a dimwit, he made a series of weird noises, constantly mumbling to himself. It didn't matter if another human was present: he'd talk to a dresser, a urinal, an unmade bed, carrying on quite the conversation. He was border-line nuts, and his percussion section of noises quickly drove me to the brink of insanity.

I'd be doing my assignments for group—due the next day—and my concentration would be destroyed by his snorting, clicking, humming, moaning, and grunting like a pig.

"Mel! Stop making noises, man, I'm trying to study."

"Huh . . . ? Oh . . . Sorry." He never failed to apologize, but less than a minute later, he was doing it again.

Instead of focusing on my work, my mind was judging how un-lucky I was to be stuck with this oddball: Great, I'm trapped in hell with this fuckin' 'tard while I'm legitimately trying to get shit done and be productive. I figured this was the universe making sure part of my rehab was a "patience lesson." Like I needed the extra chal-lenge. What doesn't kill you makes you stronger, right? Maybe . . . but it still sucks.

I quickly settled into the daily routine of rehab. I was really en-joying it—learning a lot and still having fun with the other patients. I liked to have a good time and joke around, and most everyone was receptive to my humor.

It wasn't all fun, though. That first visit with my folks was tough, because the therapist had me read the laundry list of drugs I'd taken. Though they tried not to react, I could tell they were sickened when they finally knew all the shit I'd been doing to my body and brain. The therapist told them I was lucky I hadn't suffered permanent brain damage or died from huffing gasoline, because it was so deadly.

The second week of treatment: family group therapy commenced. That's when things got even heavier. Everyone's parents came to the facility to visit loved ones and work on issues. This was when we fessed up to all the bad shit we'd done, whether to our families or in general. Serious topics were explored in depth, and there were few dry eyes; even the most macho fathers caved when confronted with the pain-filled stories their children recalled.

This was the first time I'd taken inventory of exactly what I'd been doing, who I'd become, and whom I'd harmed. I felt shitty about most of it. Having a little clarity allowed me to look back on how fucked I'd been. Telling my parents all the times I'd stolen from them and all the times I'd lied was difficult, but it ultimately started a healing process. They were always super cool about everything. They were just relieved their son wasn't going to die, that he could finally start having a real life.

Understand, I'm not saying everything was perfect in rehab. We were still a bunch of fuck-ups, thrown together for various reasons. Many of the kids in my group were court-ordered to be there. Some were forced into it by their parents. As far as I knew, I was the only one who actually begged to go into treatment.

Even though visitors were checked, some snuck in drugs to their friends. One of the girls and I almost had sex in her room. It would have happened, but we heard noises in the hallway, and I was afraid I'd be caught and kicked out. Even had there been more oversight, it wouldn't have mattered. As a group, we'd spent years perfecting our anti-authority behavior.

By the third week, I was convinced I no longer needed the environment, the counseling, or the routine. Certain I'd gotten my shit together, I was ready to be free of the institutional surroundings. I

missed my family and I wanted to go home. What I didn't know was that the therapist had warned my parents that by the end of week number three, patients often asked to leave. They were told to be ready to stand firm if and when I asked to be released from treatment.

Right on schedule—knowing my parents were coming—I'd prepared all the reasons why I shouldn't have to stay the full thirty days. "Some of these kids are really fucked, Dad." "I've worked really hard and I know what I have to do to stay clean." "I miss you guys!"

My mom wanted me home so badly, I could see she was buying it. Not Dad.

"Here's the thing, Jeremy. It's a thirty-day program, and you still have another week. You need to stay until you complete the process."

I was having none of it. I fired the big guns. "If you don't let me come home, I'm gonna walk out of here." I had no doubt that threat would work. Wrong again.

"This isn't easy to say . . . but if you walk out of here before completing the program, just keep on walking. We love you and want you back home, but we're not going through this hell ever again. It's your choice, son."

I knew he was dead serious. Wow, I wasn't expecting that. Fuck! This tough-love shit was brutal. I relented.

At the beginning of the last week, my parents came for visitation and I pulled Dad aside. I had something I wanted to ask, and I really needed an answer.

"Who's this God they're always talking about? They mention a higher power all the time, but the only God I've known is drugs." I don't know what I expected him to say, but this is what he told me:

"If you asked a hundred people who God is, you're likely to get a hundred different answers. Personally, I believe we're connected to something greater than ourselves. It's that still, small voice inside, the one that knows what you should be doing and is telling you—through feelings—what's right and wrong. It's just a 'knowing,' and it can't compete with your ego voice, that loud one that's always telling you that '*If* you do this . . . that will happen . . . and how *great* it will be.' The true voice is simple: 'Do it. Or don't.' Your spiritual voice is your gut, it doesn't lie. The ego voice is full of bullshit details. And though it sounds convincing, it's the one that always leads you into trouble."

"But what should I do? Am I supposed to pray or what?"

"You have to do what you feel works for you. If you want, try this . . . Tonight, right before you go to sleep, have a conversation with your higher self. *Ask* to be shown what you need to do. *Ask* for the tools to accomplish what you need to do. *Ask*, and you'll receive. But you have to be patient enough for things to manifest. No sitting around wondering why you haven't gotten what you asked for . . . *yet*. Doubting undoes your best intentions. It requires some faith."

I really didn't understand everything he told me, but that night I had "the conversation." The next time they came to visit, I couldn't wait to tell them how I felt. "I did what you said. I don't know why, but I felt better. So I've been doing that every night, right before I fall asleep."

———◆—◆———

I finally made it to the part of treatment where they let me go home with my parents to have lunch. Though they were both vegetarian, they fixed me what I requested: lamb chops. I couldn't believe how much

I'd missed home cooking. Then, even though I wasn't supposed to, I went to my room for a minute to listen to music. We were under strict rules during treatment: *no* TV and *no* music. I got to listen to one song before it was time to head back.

On the way to Parkside, the topic turned to me having to lose all the friends I'd partied with and limit the amount of music I listened to, or at least the amount of metal. One of the things the counselors preached to us in treatment was changing old habits. This didn't sit well with me at all. As far as I was concerned, I wasn't going to party ever again, so why couldn't I see my friends and listen to the music I wanted, when I wanted? *And* there was no way I would agree to give up being in my band. However, I played along—knowing damn well I wasn't going to stick to those bogus rules.

Another thing I was unaware of at the time was that my main counselor told my parents that out of all the kids in my group, the staff voted me "mostly likely to relapse," because I refused to give up friends, drop out of my band, and go to a shitload of meetings. There's nothing like a no-confidence vote from the very people whom I counted on to help me heal. But had I known their prediction, it would've only made me more determined to prove them wrong.

Lots of people were graduating through the program and leaving. I made friends with many of them and we exchanged numbers, planning to hang out when we were released. The families in my group decided to meet once a month. I was happy because I'd get to see Brittany, a really cute and nice girl. Our parents seemed to get along, so I was looking forward to it.

I now had a connection with my higher power. It was something I couldn't really explain. But I just knew I was being guided, that I was going to be successful with sobriety. I've got this, I thought. For

the most part, I really did have it dialed. The plan was to stick to the guidelines of going to meetings—though not as many as they suggested—and work the steps of the program.

The day finally came for me to be released. Super excited, I packed my stuff and said good-bye to everyone. My parents picked me up and announced we were going to Florida the very next day for a family vacation. I was so happy and proud of myself for graduating the program, but now the real work was to begin. It's easy to stay sober in a protected environment; it's another thing to be out in the real world and maintain sobriety. Still, I had a few more days before I had to worry about any of that. I was going to fucking Florida!

We drove to one of Dad's friends' condos in Seagrove Beach. It was only an eight-hour trip from southern Indiana to the Gulf. Seagrove is next to Seaside, that really ritzy but plastic community used for the setting of *The Truman Show*. It was a great getaway, beautiful weather and a perfect follow-up to a successful stay in rehab.

I was on the beach every day, listening to music on my Walkman. Dad smoked cigarettes at that time, so we smoked together, watched movies, hung out at the condo or near the water. It was super-cool fun. Mom kind of kept to herself, lying on the beach and meditating the whole time.

While I was there, I called my friend Jarred to let him know I was out of rehab and that I'd be home in a couple of days. He told me he'd gotten a "minor consumption" charge and was determined to quit drinking. I said that was a bummer . . . but, on a selfish note, I knew I'd be able to hang out with him because he no longer drank. Now I wouldn't have to get rid of my best friend. I'd have support in my sobriety and get to have my buddy, too.

In her attempt to support me, Mom pledged to never touch alcohol again. I thought that was unnecessary, but I appreciated her commitment (one she's kept to this day). While we were in Seagrove, Dad tracked down some nearby A.A. meetings. He went with me. Man, having to sit around and listen to World War II vets tell the same old stories they'd been telling for forty years was a monumental drag. Hopefully, when I got back home, we'd find some meetings with kids who'd never heard of General MacArthur, the beaches of Normandy, or D-day.

Going home also meant returning to school. I wondered what school would be like sober. Boonville being a small town in every way, everyone knew I'd been in rehab . . . so that was weird. But, to my surprise, almost everyone was nice and supportive about my attempted life change. Teachers all shook my hand and welcomed me back. Even people who thought I was a druggie loser were pretty cool. I'd underestimated what the positive reaction would be toward someone trying to get his life in order.

I was feeling good until someone said they'd heard a rumor that I went into rehab for fear of being upstaged in the talent show by a friend and fellow drummer. Huh? It's incredible the shit kids come up with. At first it made me angry, but then I thought, Let the assholes think what they want. The truth is I was going to die . . . and somehow that seemed reason enough to go into rehab! I felt free in ways I hadn't in years, and I wasn't going to let anyone alter that feeling.

My parents ended up being cool with me staying in Anesthesia with Jarred and Neil. It also helped that Jarred decided to clean himself up. He and I hung out all the time. We were sober and inseparable.

*Believe me when I say I had no intention of ever auditioning for a fuck-*ing musical! But when the high school drama department an-nounced auditions for the yearly spring musical, *Godspell*, my interest was piqued. I'd been a fan of the soundtrack since I was a kid . . . not necessarily because of the music, but because of the red-black-and-white album cover featuring the abstract face of a hippie. I'd also sung along with the musical's most popular song, "Day by Day." So the rock drummer decided to audition. So much for having an unshakable conviction.

Mom, who taught voice and music history for years at Oakland City College, helped me prepare. Unfortunately, even though we prac-ticed hard, I gave an average audition. Afterward, I explained how it went, how I'd probably end up in the ensemble, which I had abso-lutely no interest being in; I'd had my sights set on the fucking lead.

Dad told me to go back to the school and talk to the director, to be completely honest with her, to acknowledge my audition wasn't very good but to assure her that I would work hard and was the right guy for the role. I repeated his exact words to the director, a really nice lady who heard me out. The cast list was to be posted the next day.

I anxiously awaited the news. I could barely pay attention in any of my classes (not that unusual, really). When the final bell rang, I hurried down to the auditorium where the cast list was posted. There was a gaggle of students gathered in front of the bulletin board. I worked my way to the front. Next to the name "Stephen" (the part of Jesus) was: JEREMY HEYDE. I'd gotten the lead role! Man, was I stoked. I was going to play Jesus. Christ Almighty . . . who in his wildest dreams would have ever thought the former druggie

174

loser was perfect to play the Son of God? The universe had a fucking great sense of humor. Life was truly the shit!

I heard kids muttering under their breath about how "Heyde's never even been in the drama department," how "unfair" it was "to give him the lead."

I thought, Ya know . . . it's called acting. And I acted with sincerity to the director and got the part . . . so suck it! (I had yet to perfect Christ's turn-the-other-cheek philosophy. Still haven't . . . unless you count the gluteus maximus.)

I ran home and told my parents, who were equally excited. I got busy learning the role. Mom worked with me every day on the songs. I wasn't a singer, and there was a shitload of songs I had to pull off. Being up front and leading the show was a different vibe, quite an adjustment from being behind a drum kit. Still, I was determined to pull it off.

I've never lacked confidence, but there was *a lot* of dialogue. And, though I'd quit using, I had trouble staying focused. ADD or ADHD were not terms anyone knew about, but attention deficit/ hyperactivity disorder would be one that described me to a tee. However, I was compulsive enough that when I decided to do something, I could *will* myself to do it.

Rehearsals were fun, especially flirting with girls who would never have given me the time of day when I was the drug-addict metalhead. But there was so much to accomplish in such a short amount of time, it didn't allow for much socializing. As the rehearsal process continued, it seemed like none of us was nailing all the details. We weren't prepared the way we needed to be in order to pull it off. Like they say, ready or not . . . the curtain *always* goes up.

The closer we got to opening night, the more I started to panic. I still had several pages of dialogue to memorize, and we hadn't rehearsed some of the later scenes very much. My stress level rocketed out of the stratosphere. My confidence turned to, Oh fuck! If I don't pull this off, I'm gonna look like a dicksack for not stepping up and being the man! I'd been given a shot against everyone's wishes, and now I had to own.

I developed insomnia, and I was suffering from acute anxiety. Only a few days before the first show, I was still memorizing lines. I finally realized I was going to have to step up and lead, or else be a laughing stock. This was my one opportunity to completely turn around my reputation in town, at school, and with everyone in general. I jokingly fantasized about what it would be like for the curtain to open on opening night and to blow my fucking brains out in front of an auditorium full of people. At least it would be a chance to do something they'd never forget.

Finally: opening night! I was scared shitless. I went to the auditorium early, got dressed, and then walked down to the gym, needing to hang out by myself in the dark. I hadn't really felt fear like that in my body ever before. It was almost paralyzing. I tried to visualize doing well. I asked for help from my higher power.

I've always considered my higher power to be my subconscious, part of the energy that makes up what is God. I never considered God to be some old bearded asshole in a robe who sits around judging people—helping some, punishing others. To me we are all part of that divine energy. I embrace the God energy. To this day it's been my driving force and my saving grace. It should be pretty obvious by my irreverent language and attitude that I don't buy into organized horseshit religion and that fake, holier-than-thou attitude. I

tap into what's in me. I value that personal relationship above all else. So I asked for help and guidance and headed back to the auditorium.

Backstage, the cast gathered before showtime to huddle, like we were a sports team. We put our arms around each other and then disbanded with "Break a leg!" before taking our places onstage.

At this point I was so freaked it almost felt like I was having an out-of-body experience. Suddenly the lights lowered and the curtain opened. It's amazing what a motivation sheer terror can be. I began my dialogue and somehow made it through the opening segment. The show was going well until, during a long stretch of dialogue, I totally went up on a line and froze.

Everyone waited for me to finish my long monologue, the cue to get up and move on to the next scene. I stood there with a blank look on my face, having no idea what line came next. Though I skipped a section, I finally remembered the tail end of the speech, freeing myself from the deer-in-the-headlights mind freeze. I could almost feel everyone's relief. We continued on, but I was wrecked and couldn't stop thinking about it the rest of the act.

During intermission, the director came into my dressing room. I asked how bad my fuck-up was, and she was totally cool. She said the scene still made sense, to just move on and not worry about it. That made me feel slightly better, but I was still bummed.

Finally we reached the big finale where I get crucified and die. The auditorium was as quiet as a queen's fart. Then I could hear people sniffling. A good portion of the audience started bawling. What a trip to see hundreds of people in tears. And when the final curtain dropped, there was dead silence . . . then tremendous applause.

The cast took final bows, and, when it was my turn to take an individual bow, everyone in the auditorium stood up. It was overwhelming. When the curtain closed, I ran into my friend Harvey, who grabbed me and said, "You did it, man!" That's what I needed to hear . . . from someone I could always trust to tell me the truth. I felt a two-ton weight slide from my shoulders; like a switch had been flipped on, here came a torrent of tears. I'd been so stressed preparing for this show, I was finally able to let down. Plus, it meant the world to me to nail it.

After the show, I shook hands with "the multitudes," most of whom I barely knew. It seemed like half the town was there. I'd made a big impact with my performance, and it completely changed people's perception of me. My reputation did a 180-degree turn over the course of a two-hour show. I went home that night and collapsed into bed, thoroughly exhausted. From that first night's success, I had the confidence to kick ass the rest of the run.

For the first time, I understood why my parents loved performing in musicals. Of course there was a sense of accomplishment, but the adulation and applause was infectious. Man, how I dug the spotlight!

———— ◆ ————

Once Godspell *finished, the rest of the school year was a breeze. I had* teachers and most of the student body, except for a few redneck assholes, back on my side. One cretin in particular was always picking on Jarred and me. He and a couple of his buddies decided to fuck with us because of our long hair, which they threatened to tie to the bumper of their trucks—dragging us to death.

One day, while we were driving around in Jarred's Jeep, one of that ilk started chasing us. This particular asshole jumped out of his

truck, ran up to Jarred's window, and punched him. Big mistake! Jarred flung his door open, jumped out, and put the dude in a headlock—tightening his grip until the redneck jerk begged him to let go. Because Jarred was still on probation, he couldn't hit the guy, but he made him pay.

We thought that would be the end of it; however, the next day at school, that same asshole pushed me into a locker. He told me he was gonna fuck me up. Another friend of mine was standing nearby. Anthony was a tough motherfucker whose nose had been broken so many times it barely had any cartilage. He came to my rescue.

"Hey, man, what's with you pickin' on Heyde?"

"Mind your own fucking business."

Anthony was never one to mince words. Instead of answering, he hit that kid hard enough to kill his whole family—spinning him around 360 degrees. He hit him with the other hand and spun him back 360 degrees the other way. He then grabbed him, flipped him, and smashed his head into a brick wall. A few teachers ran up to stop the fight (if you could call it that). They carried the kid, unconscious, to the nurse's office. We found out later he was taken to the hospital with a concussion. The whole group of relentless fuckers started backing down after that.

I'd never really had to fight much, except once in fifth grade when I punched a neighborhood bully in the face, knocking him off his bike because he kept talking shit. Other than that, I usually got along with everyone, happy to be the dude who made everyone laugh. Lucky for me, I had badass friends who had my back . . . since I was always smaller than the rest of the boys in my class. Besides, I had no interest in all that macho bullshit. I was more interested in becoming a rock star and enjoying all the perks that came with it.

Once again, our band geared up to play the high school talent show, but this time my heart wasn't in it. Not long after we rocked the talent show, the band dissolved. Jarred and I still hung out a lot, but Neil drifted off in his own direction. As with any "operation," the anesthesia eventually wears off.

I knew it was time to find a *real* band, one that had goals and ambition. That's when a band found me.

The summer before our senior year, Jarred and I decided to go to summer school and get some second-semester classes out of the way. By doing this, we could technically graduate early. I figured it was worth sacrificing summer vacation to be done with school forever. We signed up and breezed by.

Besides summer school, I'd dedicated myself to practicing more. It all seemed to come together, and I really noticed a major improvement in my drumming chops and, particularly, shredding double bass. I'd been close to being able to shred the way I'd wanted; now it finally clicked.

For the past few years, my parents had been into New Age metaphysical practices like meditation and channeling. Remember the Evergreens' prediction of my life changing on my sixteenth birthday? Well, Mom and Dad had another life reading and asked about me. In a deep trance, the channel, Michael Blake Read, said, "Jeremy's path is one of a career musician. We [meaning the soul grouping known as the Evergreens] see him touring with a band on the West Coast. It may take years for him to reach his goals, but he's not alone on his journey. He has many spirit guides helping him." And then these words really blew me away: "Tell Jeremy . . . Buddy Rich says 'Hi-dee hi.' Buddy's interested in several drummers, but he's specifically interested to see if Jeremy can learn to be a performer

without using drugs and alcohol." For those too young or uninformed, Buddy Rich was one of the finest jazz drummers who ever lived. He was the shit back in the '40s, '50s, and early '60s, but he was an alcoholic and a drug addict, and it finally caught up with him.

Several weeks after receiving that bizarre news, I was practicing in the basement. Out of nowhere I started playing some chops I'd never played before. They just started coming out of me, spontaneously—through me, rather than from me. Excited, I ran upstairs and asked Dad, "Did you hear those licks? Isn't that wild?"

Then, a few months later, Dad and I were headed to a basketball game in Evansville. On the way, we stopped at Coconuts record store to check out some music. While rummaging through a cutout bin, he found an old cassette of a famous drum battle, recorded in 1952, between Buddy Rich and Gene Krupa.

"You've always wondered what Buddy Rich sounded like," he said. "Now you'll know."

When we got back in the car, I put it on, and right in the middle of one of Buddy's amazing solos were those same licks that had "magically" appeared to me, weeks before, out of nowhere. Dad and I just looked at each other . . . and smiled.

My association with Coconuts would reemerge later that summer when I got a call from the store manager. His name was Joe Smith (not nearly as original or unique as Joe turned out to be). Besides being the record store manager, he was also a shredding guitarist. I'd purchased lots of music from him over the years. He asked if I'd be interested in auditioning for his band, C.O.D.—Cornucopia of Death. They were the local metal kings, with some punk influence as well. Ever since Anesthesia split up, I'd wanted to be in a heavy band; this was my opportunity to get to the next level, playing

with a local band that toured the surrounding tri-state area. I said I was definitely interested.

Joe and I got together at my house and talked about what C.O.D. had going on. Then we went down into my basement so I could audition. I basically did the most shredding double-bass drum solo I could, and he was like, "Yeah, man!" He offered me the gig, and I didn't hesitate to accept it. Finally, I was going to be in a band that was serious about doing it for real. He called me later that night with more good news.

"We're going into the studio in two weeks, so we have a lot of work to do. And, oh, yeah, your cost to help for the recording is six hundred dollars."

I was seventeen with no job, so it might as well have been $6,000. When I told Dad, he said, "Call him back and tell him you'll join his band if he'll give you a job at the record store."

I explained my proposal and Joe laughed and said, "You fucker! Okay . . . I'll do it." Then he added, "You don't get a paycheck until you work off your share of the recording expenses."

I agreed, even though I'd only be making $3.80 an hour. (At that rate, I figured I'd be on Social Security by the time I recouped.) Coconuts also required dress shirts, slacks, and ties, so Dad bought me dress clothes. Since my hair was really long, dressing up definitely made me look like less of a scumbag. Chicks seemed to like it, too.

We started working on material for the recording session. Joe showed me eleven songs, and they weren't like three-minute pop songs. These had extravagant arrangements, requiring a lot of work. Thankfully, he was patient and positive and helped me get the stuff down. The best part was that he encouraged me to play my ass off, saying not to worry about overplaying. He wanted me to shred. This

was my big chance to show off what I'd learned, to showcase my chops.

Life became a steady routine of rehearsing and working at the record store. I loved checking in new releases at the store and making displays and talking to customers about what was new. I enjoyed selling music. This was the most fun I'd ever had. Music had become my life . . . and life was good.

The two weeks passed quickly. It was time to start recording the album. The studio was over an hour away, across the state line in Illinois. Before we left, we stopped off at Coconuts and we picked up the major-label debut of a new band called Pantera. Joe had been a fan of their indie releases and was super stoked about the new record. It wasn't scheduled to be released for a couple of days, but because we received new releases early, we jumped the street date and bought it, jamming it all the way to the studio.

Cowboys from Hell was a different animal with an incredible sound, better songs, and more balls! I was blown away by the guitar sound and the riffs—plus it had the best metal drum sounds ever. I knew Pantera was gonna change the metal scene. They instantly became my favorite new band, taking the crown from Metallica. I hyped the album and sold a shitload to customers.

Once at the studio, we loaded in our gear. I had a massive double-bass drum kit that took forever to mic up. By the time we got ready to start tracking, I was already exhausted from having to pound every drum a hundred times so the engineer could get levels. Had he been half as competent as he thought he was, it wouldn't have taken nearly as long.

I got through a couple of songs relatively okay. Then we got to a song called "Roadkill." It had a little drum break at the end of every

chorus. I kept fucking it up because it had a tricky double-bass part with a cymbal choke I couldn't execute. I must have done twenty-five takes or more; the singer and bass player started to lose patience.

Joe was cool about it and yelled at them to be supportive. He encouraged me to stay positive until I nailed it. I was getting super frustrated because I just couldn't get it down: I'd developed a mental block. I tried several more takes—after having flubbed at least forty—when the other guys left the studio to get some food. Thankfully, Joe persevered. He had my back and was always keeping me positive, praising me as much as he could.

I'd never recorded in a studio before, so I was virtually clueless. I'd just learned eleven hard-ass songs in two weeks before being thrown to the wolves. I wanted to be great and hated that I wasn't performing the way I thought I should be.

After what seemed like the same amount of time Han Solo was frozen in that cryogenic metal shit in *The Empire Strikes Back,* I managed to nail one. Burnt, we decided to call it a day and headed back to Indiana. It took a couple more sessions, but we finally completed our debut album, *Nip It in the Bud.*

Listening back to it even now, it's a fun record with lots of crazy drumming . . . some of the most adventurous drum parts I've ever recorded. It was raw, sloppy, and had an energy I miss in the way things are recorded today. Now everything is "fixed" and made perfect. It takes the personality out of the music. CDs were just becoming popular, but not enough to mess with, so we printed up a thousand cassette copies to sell at shows. I was excited to show my friends and family the finished product.

The next step for C.O.D. was to start preparing for a yearly concert in Evansville called Mother Mesker's Homemade Jam—a huge

show where I'd make my debut with the band. It featured all of the top local acts at a big outdoor amphitheater.

We started practicing, rigorously. Not only was it gonna be the biggest crowd I'd ever played for, but there would be local media coverage of the event. I was on fire with energy and more ready than ever to show everyone what I could do. Anxious, with that excited burning sensation in my stomach, I didn't sleep much the night before the show. I finally managed to nod off for a few hours before waking up ready to go.

When we arrived at the venue, I couldn't get over its size: five thousand chair-back seats and room for three thousand lawn chairs. Though a little unnerved, I couldn't wait to perform. When our number was called, I began loading my massive drum kit onto the stage. There was a palpable vibe in the air. Once the show began, I'd never felt energy come through me like that—ever.

We hammered our way through a few songs, finally reaching my drum solo. This was the moment I'd been waiting for since I got that first cheap-ass Sears drum set when I was younger. As it began, I honestly checked out. I could feel myself floating out of my body. As cheesy as this might sound, it felt like I was being led by a spirit guide. I shredded my ass off, and when I finished, I jumped to my feet and: total *silence*. However, a few seconds later, the most thunderous roar I'd ever heard rained down from the crowd of four thousand. The drugs, the booze, and the bullshit that went with them didn't even come close to matching that feeling. I couldn't stop smiling, because I knew this was the breakthrough I'd fantasized about for years.

No sooner had we finished our set than it all began to blur. I wasn't sure what had just happened. Though seventeen, I was a

young, insecure kid who'd spent most of his teenage years emotionally stunted from using drugs and alcohol. So I was really vulnerable. I ran off the side of the stage and up to Joe.

"Did we suck . . . ?"

"Listen to the crowd, man! What do you think?"

I looked out, and everyone was still standing and going crazy. It was the best feeling ever. Backstage, the buzz was all about me and the band. I could overhear people talking about our performance. I thought my night couldn't get any better . . . that is, until the headliners took the stage.

It was another local band called Chet & the Molesters. They had a killer drummer, the best I'd ever heard. His name was Chet Harger, and to this day he remains one of my biggest influences. The guy was like a reincarnated Gene Krupa. His choice of tasty chops, combined with his confident stage presence, schooled most of the planet. He was in total control. I couldn't stop watching him, soaking in as much as I could.

After the show, the two of us made an instant connection. He invited me over to his house to jam. I think he appreciated my choice of drum parts and chops, even though my execution wasn't fully developed. This was by far the best day I'd ever had. That night, I lay in bed reliving the whole experience—thinking that if I could get this kind of incredible reaction in little ol' Evansville, Indiana, imagine the kind of reception I'd get when I showed them what I could do once I got to LA.

Oh, the hubris of the tragically naïve.

CHAPTER 11

THE ANSWER...
WAR IS HELL

2009

month after returning from Australia, Jason and I packed our bags and went to stay at Zo's house in Vegas. It was time to start writing the next album. The guest rooms were unfurnished and we slept on air mattresses. Forget comfort, this was going to be a spartan experience at best. We turned his living room into a studio with a Roland V-kit, a really nice electronic drum kit we bought for this project. We jammed ideas during the day and drank our asses off at night. Our hangout time was spent up on his roof deck . . . just the three of us.

Matt had just moved his girlfriend and her kid into his house. Since he was a difficult guy to have around—especially when we were trying to write—we told him to just go have fun, and when it was time to record, we'd call him. Not a bad deal: equal pay for doing very little work.

Ivan was back home in Denver. We sent him tracks as soon as we created them, and he began writing lyrics. It took a while for us to get in the flow of making the record because it seemed like every day we'd develop another computer problem. Either Pro Tools wouldn't work or the computer itself would die. We went through three different computers before we found one that actually functioned. The Death Punch Curse was in full effect.

We decided to bring in someone to help us record the drums and vocals and make them sound killer, someone who had a great ear and

musical sensibility along with great recording techniques. Making a record can be fucking tedious, and we were looking for anything to help make it a more pleasurable experience. Luckily, we found Kevin Churko, who lived in Vegas and had produced the last two Ozzy Osbourne records. An up-and-coming producer, Kevin had worked for Mutt Lange, one of the biggest producers of all time: Def Leppard, AC/DC, Bryan Adams, and Shania Twain, to name a few. From the master, he'd learned how to record bands and capture the best performances. He was also a drummer, so he and I hit it off right away.

I'd edited my own drum tracks, in addition to the other guys' tracks, on the first record. Kevin was a killer editor, so I was more than happy to relinquish that task. I hit the studio juiced and ready to go. I recorded six songs the first day. Thanks to his recording method, it was the most fun I'd ever had in a studio. I felt a great sense of relief, and, for the first time, I started to get excited about making a new record.

Back at Zo's, we continued working on ideas. Trying to get three people on the same page and creating in close quarters for long periods of time began to beat me down. I couldn't wait to finish every night so I could get as drunk as possible. The promise of a good buzz sustained me through much of the process. I wasn't the only one stressed out. We all drank . . . even Zoltan, who hardly ever drank. We'd pound German Riesling, jam music, and bullshit for hours.

Once, Zo was in his cups and disappeared upstairs. A few minutes later, I heard a yell, then a crashing thud, followed by an *"OW!"* He'd fallen down the fucking stairs. We all laughed about it, then passed out in the hallway. Hours later, his girlfriend woke us.

Jason was under so much pressure, he bought bottles of Jäger and emptied them throughout the day. Zo would come in to listen to ideas and Jason would be fucking hammered. Jason always preferred to work by himself, or to have me there to bounce something off of. However, this arrangement—working in close quarters, bombarded with alcohol-soaked ideas—really got to him.

Surprisingly, I never drank during the day. I had to have a clear head to write and track drums. Editing was also a major part of my contribution as the first arranger of a song. Many times, Zo would give me his riffs; I'd sift through what I liked, then start editing them together as songs. After everyone did his thing, it would morph into the songs you've come to know. Other times, he would do a whole song, musically, by himself, and it would live almost untouched. Often he looked to me to see what I liked. He'd fart out a bunch of riffs, and I'd say "That one's cool" or "That one's not rockin' me."

Only a few minutes into editing, I'd start growing impatient. Because the process is so repetitive and often mind-numbing, it reached the point where I couldn't do it without drinking. Once, while editing "Succubus," a party erupted. I was really fucked up but still trying to edit, and it was a disaster. Drunk, I forgot to save the original edit before I started hacking away. Zo got furious and yelled at me. That was the first time he'd ever gotten angry at me personally. It really freaked me out . . . not that I didn't deserve it. After that incident, I never felt comfortable editing around him.

On our first album, *The Way of the Fist*, Zo had all the songs nearly completed when I came in to help fine-tune them. But this record was a different. He leaned on me quite a bit. When I got fried, I'd turn to Jason for help. He added a whole new dimension. Jason has an awesome musical sense, and he took the guitar work to a new

190

level. His talent—and the way he made people feel comfortable while working—was a welcome bonus. Creatively, this was going to be a good marriage.

It was during this time that I decided I to buy a house in Vegas. Because of the crash in the housing market, they were really inexpensive. Both Matt and Zoltan already owned houses and had been living there a while. Angel wanted to move out there with me. I was reluctant, but my codependency was at an all-time high, so I agreed for her to move from Los Angeles. We started house shopping and found one in two days. I put in the offer on a brand-new model home, and it was accepted.

She was super excited to move with me, but I was already dreading the thought of it. I wanted to have my first house all to myself. I'd never had a nice place of my very own. Like a selfish teenager, I wanted to do *whatever* I wanted with *whomever* I wanted *whenever* I wanted—and not have to answer to anyone. I decided not to move her out and to end the relationship once and for all. I called her and told her that I was over being with her. She was devastated. Of course, by the time I informed her of my decision, she'd put in her notice at her job and with her landlord and was already packed.

She sounded so pathetic, I instantly felt bad about crushing her. Being a people pleaser sucked! She pleaded with me to come to LA and talk face-to-face. I needed to follow what my heart was telling me, but I agreed. Although our relationship had been a disaster for years, I couldn't get my shit together enough to end it. My greatest fear was where I put all my energy . . . and I was the one creating it. The cliché "I just knew that was going to happen" shouldn't be a surprise. It didn't take her an hour to convince me that moving to Vegas was "the best thing for both of us."

All this extra stress occurred while we were in the process of making the record. I decided I needed one more blowout before Angel moved to Vegas. Jason agreed to be my partner in crime. Leaving Zo's, we headed to the Strip to check out a cover band. We knew the keyboard player, Brent Fitz, who was Slash's drummer. We were hanging out in his dressing room along with Bruce Kulick, who was the guitar player and used to be in KISS. For some reason Kulick decided he didn't want us in there and yelled at us to get out. Being the passive-aggressive pussy that I was, I said to Jason, "Fuck mister fourth-string KISS guitarist, let's get the fuck out of here."

We bolted from that show and went to see the Sin City Sinners, another popular cover band. We wasted no time in getting ripped. Emboldened by lots of booze, Jason decided he wanted to join the band onstage, jamming to Queen's "Tie Your Mother Down." They were happy to let him join in until he stated blowing it. That's not an easy song, especially when you're fucked up. Embarrassed, Jason decided to end the song in a 1980s flourish by slinging the guitar around his back while it was still attached to the strap. To put a memorable ending on a less than stellar performance, the strap broke and the guitar went flying into the Marshall amp. The guitarist who'd lent Jason his axe was really pissed. Unfazed, Jason jumped off the stage, and he and I hit the bar.

True to form, we ran into some groupie chicks. I started flirting with this hot blonde—who really got my interest when she said she had Ecstasy. Since I was already buzzed, the thought of adding a synthetic drug with an amphetamine-like, hallucinogenic kick was irresistible. I wasn't even taken aback when she said she'd sell me some. Jason and I both made a purchase. We popped them and headed for her place. I got in her car, and Jason followed in his truck.

192

On the way, I was telling her all the shit I was going to do to her, and she was totally receptive. As soon as we got to her house, Jason decided to bail and drove back to Zo's.

As I stripped down for our big XXX-fest, Angel started blowing up my phone.

"Who keeps calling?" the chick asked.

"It's no one," I said—powering my phone off.

Distracted and hammered, I went right to work on her, but it soon became apparent I was too fucked up to get it up. The next thing I knew . . . it was morning. For a moment I couldn't remember where I was or how I'd gotten there. Disoriented, I panicked, knowing I needed to get back to Zo's to write and work on the record. Plus I knew he'd be pissed since I hadn't even bothered to tell him what was up.

I stumbled out of bed and tried to put on my clothes, which wasn't easy since I could barely keep my balance. I finally gave up and dropped to the floor.

"What are you doing?" the girl asked, sounding really perturbed. It was obvious she wasn't pleased about the previous night's subpar performance, so I figured a ride to Zo's wasn't in the offing.

"Trying to find my fucking socks!"

She said her cat probably had snagged them and hid them somewhere.

I put on the one sock I could find, said, "Thanks for nothing," and walked to a nearby gas station to wait for a cab. When I powered my phone back on, Angel had left tons of messages, and before I could hear any of them, it rang again.

"Where've you been? I've been calling you all night."

"Yeah, I can see that," I said. I then lied and told her Jason and I got hammered and passed out at one of his friends' homes. I'm sure

193

she could tell I was bullshitting, but she wasn't going to let that stand in the way of her moving in with me. Nothing about this move made sense, but it was an indication of just how unhealthy our relationship was . . . and what a monumental fuck-up I'd become. I got on a plane for LA the next day.

I'd hired Bobby to fly out and help me move her belongings to Vegas. Together we loaded the U-Haul and headed for Sin City. On the way, I ran over a tire in the middle of the interstate and destroyed the U-Haul. Luckily, I had insurance that covered all damages. That accident was symbolic of where we were in our lives: unable to dodge destructive obstacles and damaging everything in sight.

The time had come for Ivan to start recording vocals, so I agreed he could hang at my house. The plan was to take him to Kevin's studio and stay there with him, helping massage his ideas and trying to keep him focused. Of course, since we were both drunks, it wasn't long before we were polluting ourselves and the sessions. After a long day in the studio, we'd buy bottles of vodka and guzzle them into the wee morning hours, jamming music and having a blast.

Just so we're clear, Ivan is a walking catastrophe (and I mean that in a loving way). He was constantly fucking something up in my house. He spilled a whole glass of vodka and tonic into my laptop. We're talking a sticky fucking syrupy mess *in* the computer, through the keyboard and all over the keys.

Another time, I woke up to find an interesting "gift" on my dining room table. I lived in a brand-new community in Vegas; there was an empty model home next door. It was a show home, furnished and pimp. You've heard of Newton's cradle or, as I prefer to call it, Newton's balls? It's this cool little device with metal balls suspended from wires that swing back and forth, demonstrating three physical

laws of motion. When I stumbled downstairs for a much-needed cup of coffee, the gizmo—named for the English physicist's family jewels—was sitting in the middle of my dining room table.

"Where'd this come from?" I asked, leery of the answer.

Ivan, who had just awakened, rubbed his eyes and mumbled, "Got you a gift."

"Really . . . ? When'd'ja find time to do that? We didn't go to bed till three A.M."

"Well, I sorta found it . . . in the house next door. Like it?"

He thought I deserved a gift for letting him stay with me, so he broke into the house next door and "appropriated" it. It was *so* Ivan. He could've gone to jail for stealing something that was maybe worth fifty dollars max, but he wanted to get me a gift . . . and so he did.

Before returning to Denver, he recorded half the songs on the album. He needed a break; we all did. I hit the Strip to party. This night would end up being a pivotal one in my life. I'd followed the oh-so-familiar path of every alcoholic and drug addict. So the next step was a natural progression.

We were at the Hard Rock when someone offered the root of all evil: *cocaine!* I'd dabbled with it years ago, but due to the cost, my usage was short-lived. Now, however, I could afford to get into it big time. There was always someone wanting to get close to the camp, and supplying drugs usually worked. I was more than happy to accept the offer.

We went into the toilet stall. Using my trunk key, I snorted a key bump in each nostril, and then we returned to the club for more drinking. I wasn't where I wanted to be mentally, so I went back to the john and did a few more bumps. We decided to take the party to

my house. "Never Enough" wasn't just a hit song, it was my mantra. We did cocaine on the way, and once we got there, we jammed music and did more. I didn't really feel the full effect of the blow, so I wasn't super high. That night, I actually fell right to sleep. When I woke up the next day, I called Jason and told him I did blow and that it didn't really do anything for me.

"You got off easy," he said. "Don't do it again, it'll ruin your drinking." It wasn't long before I understood what he meant.

We were getting close to finishing the record. I was talking to my old friend Joe Smith back in Indiana, telling him about our current project. He said Shinedown had a big hit with their cover of Lynyrd Skynyrd's "Simple Man."

"Dude, you guys should record your cover of 'Bad Company,'" which we'd been playing on tour. "It will go over huge in the Midwest."

"Fuck! You're right."

I mentioned the idea to Ivan, and he was into it. Zoltan was hesitant, but once he heard Ivan's vocal, he agreed. Including it on the album never occurred to us, but we agreed it would make an interesting bonus track. (Not only did it become a single, it recently became our first platinum—digital download—single, and remains one of our most popular sing-alongs at every show.)

By now I thought the album was fucking solid, especially because I knew we had the singles we needed. Without radio success today, it's impossible to have much of a career. My thinking had always been: you're only as strong as your radio hits. The first record proved that no matter how cool we thought the songs were, without radio hits, our sales would have stalled at about two hundred thousand. That's why the label had insisted we go back in to write songs

that would work on radio, because other than "The Bleeding," we had nothing that would have gotten any airplay.

Make no mistake: this is a brutal game. Bands that say they don't write songs for the radio are bands that don't plan to sell records. Those who play heavy just to be heavy, or add weird time signatures just to be technical, or play super fast just to be fast, have decided not to compete. And staying current and having a career with longevity means staying competitive. I love to be criticized by those who think otherwise, because they aren't competition.

Snarks, Internet trolls, and losers are the first to criticize success of any kind. "It's not heavy enough." "They sold out to radio!" "It's not technical enough . . . blah, blah." It's easy to be technical and confuse people; anyone can do that. But try writing a song that connects with a million people, and then fucking get back to me. At the end of the day, *it's about the song.* Can people relate to the story, can they hum the fucking thing or even dance to it? Those are questions answered only by sales. If you want a career, that's the game. Don't wanna play? It's your choice. Either way, there's one indisputable truth: the song always wins every time, no matter what trends are popular. Good songs will find an audience. Why does Bon Jovi still have hits when hair-metal rock died in '91? Because he has fucking songs! End of sermon.

Once I knew we had the songs, a sense of relief descended over me. I couldn't wait to release *War Is the Answer*!

———•◆•———

Immediately after finishing the album, Death Punch was off to Japan and Australia. Before we left, Jason reminded me, "Convert some money into yen at the airport. US dollars are worthless in Japan." I

assumed he'd shared that information with everyone, but apparently not. We'd barely settled in at the hotel when Ivan knocked on Jason's door.

"Hey, man, can I borrow some yen? I'll pay you right back. I forgot to get any." Jason obliged. Ironically, when it was time to eat, Jason couldn't afford to pay for his own dinner because he'd lent too many yen to Ivan. Of course, he never got repaid. Now, whenever someone asks to borrow money, the stock answer is, "Sorry, man, no have yen."

Tokyo had an interesting vibe. It wasn't at all what I expected. It was like New York with a superinjection of neon. We'd heard all these stories about how attentive Japanese chicks were, and we were anxious to confirm them. So the very first night, I pulled this chick back to my room. We got drunk and ended up in the sack. She kept saying, "Please, no hurt pussy. No hurt pussy." I wanted to laugh, but she was so serious. Finally, I tried to ease her mind: "You don't have anything to worry, I'm not packin'." It was meant as a joke, but from the look on her face, I'm not sure it translated.

Before we left for our return flight to the States, we did some shopping. I tried to buy Angel a geisha robe, but there was a torrential downpour. Soaked to the skin, we rushed back to the hotel empty-handed. No sooner had we gotten on the elevator than there was a giant earthquake. It rattled the fucking hotel for a full minute. We found out later it registered 8.5, and fortunately was centered off the coast. None of us was hurt, nor was the hotel, which, like most of the buildings in Japan, was built to withstand a major earthquake. It was a hell of an end to a memorable trip.

Next up: Australia. We flew on some obscure airline that served us weird pastry filled with spaghetti and sauce. It was like a Chef Boyardee calzone but tasted worse. The seats were torturous and the

whole experience cost us way more than we made, especially since we played in a bar that only held about three hundred people.

After the show in Brisbane, the party was on. We scored some coke from someone in the bar, and I did a huge line off the toilet seat in the john. Drunk, high, and horny, I ended up following some married chick into the bathroom and making out with her . . . while her husband was right outside. This is how people get killed; from the looks of him, he would have been happy to oblige. Luckily, he was too drunk to notice. And I was too high to care. Cocaine did nothing to improve my judgment.

We also played shows in Melbourne and Sydney, but I have little memory of either—though I remember enjoying cocaine at every venue.

———◆———

When I got back home from the Asian tour, I was hanging with my friend Josh, whom I'd invited to stay at my house. As always, we got drunk and were jamming tunes. We'd managed to consume a case and a half of beer topped off with Patrón. While goofing around, I stepped on his foot, tripped, and broke my little toe. I couldn't put on a shoe for a week, let alone walk, and the next tour was only two weeks away. There was no way I could practice with the band.

We had a big photo shoot with *Revolver* magazine, and I was still hobbled. I didn't want to tell Zo because I didn't want to introduce panic right before the tour. Plus, I knew he'd lambaste me for being drunk and injuring myself. Wanting to avoid the Wrath of Dad, I hid it from him.

Right before the tour, we held our record-release party at a club called Wasted Space at the Hard Rock in Vegas. The day before the

party, I was finally able to put on a shoe. It hurt like hell, but the timing worked out.

I flew in my friend Jarred from Indiana. And my dad flew in from Seattle. When we picked him up at the airport, I was still hungover and shaky from the night before. With the release party looming, I was on edge. As usual, Angel was driving me crazy. Because I felt like shit, I had her drive. But I couldn't stop verbally abusing her for not going fast enough, for not passing the car ahead . . . for anything and everything. Obviously, Dad was picking up on my negative vibe.

I found out later that Angel had asked him to speak to me. She was worried that I was "out of control." He told her that she needed to stop enabling me and take care of herself. He actually told her it would be better if she packed her things and left before her self-respect was completely gone.

"But Jeremy's such a good person. He has a great heart. I know I can help him."

"I think I'm aware of Jeremy's good heart. But as far as being able to help him . . . no one can do that but Jeremy." The truth was he partially blamed her for enabling me to start drinking again.

After the show I left Dad in the hotel room and went back down to the club. I did a shitload of cocaine, key bump after key bump in the toilet stall, even snorting lines off the toilet-paper dispenser. The cocaine thing had quickly become my new obsession, allowing me to drink all night and still socialize. Of course I overdid it, and it wasn't until the sun was coming up that I decided to call it a night.

There was no way I could go back to the room my where Dad was sleeping. I hung out with a few die-hard fans for a few more hours. Then I rounded up everyone and headed back to my house. I was still trying to come down off the blow, so I made Jarred drive.

Dealing with depression, guilt, and paranoia wasn't my idea of the best way to end a party, but this was nothing compared to what was to come. The coke era was just getting cranked up.

———◆◆◆———

The Shock and Raw tour was the name chosen to support War Is the Answer. To ensure having more chicks at our shows, we did a promotion where the first hundred ladies got in free. Our management/label put us up to it, saying Limp Bizkit had successfully done something similar back in the day. We went along with it and got fucking sued by some asshole for sexual discrimination. This dude was pissed because *he* didn't get in free. No one could believe that this bogus claim would hold up in court, but it did. It costs us plenty to settle the suit.

You wouldn't believe the shit people try in hopes of extracting cash from the machine. We've been fortunate to make money playing music, but we're far from rich. We make a great living by most people's standards, but we're also in the highest tax bracket. By the time people who do next to nothing take their cut and the government takes half, there's not that much left. And believe me, frivolous lawsuits are the last thing we need.

———◆◆◆———

Shock and Raw was going well, but some of us weren't in very good shape. I was certainly struggling physically. It didn't help that I was drinking and doing cocaine whenever I could get my hands on some. Unable to sleep, I was staying up all night, quickly becoming a hungover zombie. I had to take naps before we played just to have enough energy to get through the set.

I ran into a girl at a show in Baltimore whom I'd chatted with on MySpace a year or so earlier. I was drunk and we were making out. Little did I know her sister was taking pictures of us. When we were leaving Baltimore, she texted me and said she was planning to come see me in another town on tour. I explained that I had a girlfriend at home, but that the relationship wasn't going well. I was totally upfront with her about my situation. She seemed cool with it.

<p style="text-align:center">— • ◆ • —</p>

The next morning I got a call from Angel, who was crying and yelling into my ear. "Some girl called our home phone and said she has pictures of you two kissing. They're posted on her MySpace page."

I felt blindsided, but I was too hungover to try to patch that one up. Apparently, when I signed up for home phone service, I'd neglected to make the number unlisted. I don't know how this psycho chick got my real last name, but she did and she called Angel, who begged me to get the pictures taken down. I hit up the chick and pleaded with her to take them down. Instead she posted on her page, "I just played someone."

I said, "Look, I was honest with you about my situation. You said you were cool with it."

She laughed. "You're so naïve."

I don't get why she went out of her way to fuck me over, but the damage was done.

I called the phone company, insisting that I'd requested my number to be unlisted. They told me it was unlisted only for print, but not if someone called information. Man, I was pissed and let them have it. "I don't want *God* to be able to fucking reach me, so whatever it takes to make my number unlisted, make it happen now!"

Knowing how many risky situations I'd put myself in, I was lucky that was the first time things went south. But it was definitely the start of me not trusting chicks I met at shows.

◆━◆━◆

We brought in a lighting guy to help bump up our show. This dude was a cool cat named Brandon Webster. He was part of the Webster's dictionary family. He'd worked for Megadeth and for Static-X, winning awards for his lighting designs and light shows. He made no bones about the fact that he liked to party. Partiers like other partiers, and he and I bonded right away.

Our first gig together, we went barhopping after the show. We walked into a bar and the bartender says, "Sorry, guys, we're closing."

Neither Brandon nor I is the type to really take no for an answer. Brandon said, "Listen, we need six shots of Jäger. I don't know what you're prepared to sell them for, but I'll give you three hundred dollars." Of course, the bartender was happy to oblige. I thought that was pretty impressive. I was always looking for fun people to party with, and now I had a new one.

We also added a great new sound guy, Bruce Reiter, to the fold. He'd engineered sound for a lot of heavyweights. We now had a major-league team in place. Our sound crushed every night and our lights were fucking rad. The popularity of the band was increasing, as was my use of drugs and alcohol.

◆━◆━◆

One night I was sharing a bag of blow with a guy who'd scored some after a show. We were drinking our nightly greyhounds, vodka and

203

grapefruit juice. I took the coke into the bathroom to do a keyer, but I was having trouble opening the bag. I pulled on the fucking thing—trying to be careful—when, all of a sudden, it ripped open and exploded into a colossal white cloud of "*Nooooooo!*" Most of the blow fell on the bathroom rug. I frantically got a credit card and scraped up what I could, arranging it in a line on the sink. I went outside with a hangdog look on my face.

"You blew up the fucking baggie, didn't you?"

"Yeah, but I saved most of it. I even carved you a line. It's waiting for you."

He looked at me suspiciously before disappearing into the john. A few seconds later, I could hear him choking and coughing. When he returned, his nose was burning. "You motherfucker! You scraped up a lot more than blow!" God knows what kind of nasty DNA and excreta I added to the coke, but he ended up with a bad sinus infection.

Shock and Raw was a shitful experience. I was chemically depressed and my body was fucked. As a result, my playing suffered, which, in turn, made me even more depressed. Booze and blow were all I cared about . . . well, besides sex. But even that was slowing down.

That tour, I went through several drum techs. They were either good at teching but drama starters, cool people but average techs, or great at both but only available for a couple of weeks. It didn't matter, really. I missed Bobby, my sidekick. Time off was a much-needed break.

Being off the road was supposed to be an opportunity to recover from all the damage done on tour. Not for me. I drank every day and my cocaine usage increased: lots of all-nighters that turned into

two days of wreckage. Plus, the comedowns were horrible. The guilt I felt was the worst ever. I'd lie there—trying to sleep—with one thought repeating in my mind: You're a loser, Jeremy. What are you doing with your life? I started popping sleeping pills to come down, and if and when they worked, I'd wake up completely fucked. The grogginess would linger for days. Instead of recovering, I was getting worse.

I ventured out to see Bobby, who was in Vegas teching for a band opening for Megadeth. His girlfriend, a porn actress, was there, and we all went out for drinks. I managed to get Bobby the drunkest I've ever seen him, and he told his girlfriend to come fuck both of us back at their hotel. I'll spare you the details, except to say that afterward, I went home and crawled into bed with Angel. No, shower—only the smell of guilt emanating from every pore. I'd turned into the worst shitbag I knew.

I did bring Bobby back to tech for me again. We went to Canada for seven shows with Korn. Canada was fun and the chicks were willing. My latest debauchery took the form of doing lines off various female body parts. Name a location, and I've snorted there . . . the funkier the location, the better. Maybe I was just waiting to see if someone would finally say, "No way." But it never happened.

I did lots of psychedelic mushrooms. Jason had never done "magic mushrooms," and he gobbled them like candy. Once he got past feeling queasy, he was off and flying. There were plenty of trippy experiences traveling in the bus, frying balls on 'shrooms.

One night while I was peaking, Bobby sidled up to me and said, "Imagine having to listen to the entire Deicide catalog on ten . . . right now." I fucking laughed so hard I think I pissed a little. That was one of the rare times when the effects of mushrooms made

touring seem like fun. Other times, when I was depressed, they just intensified the feeling.

Though only seven shows, that little trek above the 49th parallel left me pretty feeling desperate and destroyed. I knew I was in trouble, but I didn't have a clue what to do about it. Getting clean never occurred to me, because I was certain I couldn't face the rigors of the road, the dysfunction of the band, and my rocky relationship sober.

Had I been able to write a country song to describe my life at the time, I would have titled it "Raisin' Hell and Livin' in It." Yee-fuckin'-haw!

CHAPTER 12

GO WEST, YOUNG MAN

1991-92

.O.D. started gigging on a regular basis, and I learned really fast what it was like to deal with performance adversity, especially physically. Our material had tons of blistering double bass. We practiced for hours at a time, and it never occurred to me that I needed to stretch first. All I cared about was shredding my ass off.

It wasn't long until I noticed that my legs weren't responding properly. I'd lose muscle control and consistency. This freaked me the fuck out. Anytime I played, I was in constant fear my legs would give out. At night I'd lie in bed and stress over it. It quickly became an OCD thing for me. Not only was I depressed, I got on everyone's nerves talking about my "leg problems."

I was far from being a seasoned pro. We'd only done a handful of dates. One show I'd be insanely on fire and nail every shredding double-bass part; the next show, my legs just wouldn't operate the way I wanted them to. Though it was torturous, I still had a blast playing the shows—living off the biggest adrenaline rush.

Due to the rigor of playing constantly, I was forced to take better care of myself. I stopped smoking cigarettes and quit chewing tobacco. Originally, I'd started chewing Kodiak to help me get off cigarettes. Chewing was a short-lived, nasty habit, one almost harder to break than quitting smoking. It's not a huge seller to girls either.

Nothing like kissing someone with little black pieces of shit stuck in his teeth and breath like the south end of a horse going north.

I was getting up at five A.M. to go to the high school track and run, or to the gym and work out. When it came to drumming, I was as serious as two dogs fucking. I wanted to go to the next level with the band and as a drummer. School was nothing more than an unnecessary burden. I couldn't wait for it to end so I could buckle down and do nothing but practice, perform, and work at the record store. When the end finally came, I was stoked.

C.O.D. practiced all the time. We added another guitarist to the band, an awesome guy named Scott McEllhiney. He was a shredder and a super nice guy. With the addition of Scott, killer guitar parts became our stock-in-trade. Now we were just focused on being the most insane and technical shredding band we could be.

It was a weird combo, though, because our lead singer was punk style, a more narrative-type vocalist, with limited metal-style vocal ability. However, he ruled onstage and was funny as hell. He always talked mad shit to the crowd and was a sarcastic asshole! I loved him and the fact that he got a reaction out of people. I think he got a kick out of me, too. He was always hyping me up and putting a humorous spin when he would announce me after a drum solo.

"Ladies and gentlemen, give it up for Bobby Brady on drums!" The crowd ate it up.

We gigged our asses off throughout the Midwest before branching out with dates in West Virginia. We finally got a big opportunity when we were approached to open for Pantera in Indianapolis. At only seventeen, I believed I'd reached the big time.

―――――――

The day of the gig, while doing a sound check at the venue, I spotted someone watching from the wings. Could it be? It was! Dimebag Darrell was watching us perform a song that featured brutally fast double bass. After we finished, he caught my attention and yelled, "Faster, man. Play it faster!" Here was an idol of mine, and he was into our trip. When I got a chance to talk to him, he was super cool. We gave him a C.O.D. T-shirt. He thanked us and said he would wear it. A few months later, I was looking at a *Metal Maniacs* magazine, and there was a picture of Dimebag wearing our T-shirt. Things were definitely on the upswing.

Encouraged, we sent our promo packs to record labels in hopes of getting signed. It was a retarded promo pack that included the CD, an 8x10, and a cover letter. We also included a bag of Fruit Loops and a check from the band account made out for five dollars! We sent dozens. One went to Monte Connor at Roadrunner Records. He actually responded, saying of all the promo packs he'd ever received, ours stood out as the most "creative." He said he'd hung up the check in his office. However, when it came to getting signed, he had no idea what to do with us.

Encouraged, I talked to a few different labels, including Big Chief Records, a subsidiary of Metal Blade Records. The A&R guy's response was, "This is joke rock! I get this stuff all day long."

We thought everyone was crazy for not understanding our brilliance. I'm pretty sure every band thinks they're the shit and deserve to be huge. That's part of the fun of being in a band: fantasizing about *the dream.*

We kept plugging away for months, gigging and sending out

promos. Nothing was happening. Some of the guys weren't digging the vigorous show schedule—dragging themselves to work the day after brutally long drives and no sleep. It didn't bother me. I loved bleeding to try and make it; not everyone felt the same way. This started creating a division in the camp.

Joe and I were on the same page. We pretty much made all the decisions—musically and businesswise. The rest of the dudes didn't have the same fire. It finally reached the point where Scott wanted out. He'd grown tired of the schedule and the musical direction. The grunge era had come in, and it seemed nobody was really digging metal anymore. We pleaded with him not to leave, but it didn't help. His departure meant the end of the band. The singer was over it, too. The new material was even further away from what he was looking to do musically. The band broke up in the summer of '92. Not only did this dampen my spirit, it affected my relationship with Joe.

I was still working at Coconuts, but due to our strained relationship, I was ready to do something new. We had taken the progressive stuff as far as we could, as far as I wanted to, and it seemed the natural thing to do was to look for something completely different. It's like when you break up with someone, you often look for the opposite of what you had.

I wasn't into the whole grunge thing. I felt a little lost musically. I still liked regular metal and hair metal. This grunge thing to me was bullshit: sloppy playing and boring stage shows with no vibe. There were a handful of grunge bands that were good at their craft, but to me, most of that movement was a complete waste.

Even before grunge took over, I liked Soundgarden. I also liked Jane's Addiction. I thought Nirvana wrote good songs and Alice in

211

Chains had a cool dark vibe. But shit like the Smashing Pumpkins killed my soul. Pearl Jam, too. Thank God bands like Pantera and White Zombie plowed through and made kick-ass records, because grunge really bummed me out.

I wanted to press forward musically and be in a band with a record deal. After the demise of C.O.D., I knew being stuck in Indiana would prevent me from reaching my dream. If I was gonna have a chance at making it in music, I had to get the fuck out of there. But first I needed to address the most important relationship of my young life.

For the past year, I'd been in a relationship with a girl I'll call Hailey. She consumed my thoughts to the point of obsession, no doubt enhanced by my addictive personality. I quickly put Hailey on a pedestal, and part of me felt that if I won her approval, I was more worthy. In no time, I built things up to be way bigger than they actually were. I always bought her flowers and the latest music. I thought if I did those things, she'd love me more. It was almost like a drug fix—constantly craving the rush of approval.

I was 100 percent codependent. In its own way, it was as sick as doing drugs, just not likely to kill me. However, it was equally distracting, because I used her to fill a void in myself. By focusing on her wants and needs, I could win her approval and get my fix, which made me feel better about myself. I was absolutely blinded by it; it was all part of learning and discovering my path.

In a lot of ways, Hailey, who was two years younger, was more mature than I was. Only later did I realize that she was just as into me as I was into her; however, at the time, I was so insecure that I thought if she couldn't see me one night, or even if she was busy, it was a form of rejection, which was devastating to my ego.

By the time C.O.D. ended, our relationship was suffering. I started resenting her for what I perceived as her not being into me "enough." My obsession with her meant constantly wanting her around, wanting to have sex, wanting to have her reassure me that I was "the one," too. I needed her to be emotionally on the same page as me, or so I thought. My insecurity kicked into high gear. Looking back, I see a needy, codependent person who was clueless about how to be in relationship. Everything was about me: how much things hurt *me*, how things weren't going *my* way. I was plagued by the thought that she didn't love *me* like I loved her because I was unworthy. I felt out of control, and having no control really frightened me.

I decided that the only way to keep from getting hurt was to break up with her. I broke it off, and it shattered both of us. It turned out she really did love me a lot. Unfortunately, I was so insecure I couldn't see it. As that old hit song by Neil Sedaka—and later the Carpenters—said, breaking up *is* hard to do! (Like any of those homely motherfuckers would know!)

It wasn't long until Joe had had enough of me working at the store. My attitude had turned negative. I couldn't wait to get out of the Hoosier State. I started fucking up at work—not on purpose, but maybe it was my subconscious guiding me out of there. One day while I was managing the store, I committed the crime of the century: I sold someone a *Wayne's World* VHS tape *the day before it was to be released*. Holy fuck! I'd committed retail homicide! (Back in those days, it was a big deal if you sold something before it was officially released.) Joe got written up by the higher-ups, and they suggested he fire me.

He called me at home. "I need you to come in today, but don't dress up. I have to let you go."

213

At first I was hurt, but then I realized this was the best thing ever. He was totally right to fire me. My attitude sucked, and now I'd made a heinous mistake. Thank God for *Wayne's World*! Without realizing it, it set me free . . . free to move to where I needed to be. I picked up my final paycheck, told Joe good-bye, and that, as they say, was that!

The universe finally heard my plea. Within days of losing my job, I heard from an old neighborhood buddy who'd just come back from the Marines. Bill had been stationed near San Diego but had recently moved back home. He told me he was thinking of moving back out there and said if I wanted, I could go with him and we'd get a place together. This was my escape from Hoosierland!

*I informed my parents I was moving to California, and they were com*pletely supportive. The timing was perfect because Dad had recently had two country songs recorded (one by Tammy Wynette), and they'd already decided to move to Nashville. Everything happened so fast. They sold the house, Bill and I helped them pack, and then we loaded up the car my grandma Helen had given me.

It was an '81 Ford LTD, the size of a fucking yacht (the perfect roominess for getting laid). It was a tank . . . built to last. With a whopping $600 in my pocket, I was ready to go make it as a drummer. My whole life had pointed to this moment. All the nights of visualizing had finally manifested in my escape from the constricting buckle of the Bible Belt. I told my parents and friends good-bye, and in December '92 watched Boonville, Indiana, fade in my rearview mirror. Thank ya, Jesus.

Heading west was so freakin' awesome. Bill and I took turns driving, and, since the car didn't have a stereo, jamming tunes on my boom box. Pantera, Cypress Hill, Helmet, S.T.P. . . . we even jammed death metal, like Malevolent Creation and Demolition Hammer. What well-rounded tuneage.

We stayed cranked on shitloads of coffee. Stoked, we stopped to sleep only once during the whole 2,500-mile trek. It was a truck stop somewhere in Texas, and mother of God, was it freezing outside. The car was too packed for us to stretch out; otherwise we'd have crashed there. Frozen, I carried blankets into the bathroom, where it was warmer, and slept on the floor. The aroma of piss, shit, and gasoline swirled up in our nostrils. The perfect balm for sleeping . . . not!

After an hour of trying, I still couldn't get comfortable on the nasty concrete floor. Plus the wind was howling so loud, whistling in the vents, it was hopeless. Add to that how excited and amped I was, sleep was impossible. By then a frozen Bill had joined me in the john.

"Bill?"

"Yeah?"

"You asleep?"

"What the fuck do you think?"

We decided to go back to the car. Leaning against the door, we nodded off for a few minutes at a time. When it got so cold we couldn't stand it, we'd run the heater for a while, then turn off the car to save gas. In no time we were completely frozen again. We finally said "Fuck it," popped a few NoDoz caffeine pills to keep from passing out and wrecking in a fiery crash, and headed out.

We drove like maniacs. We were the Duke Boys outrunning Roscoe! In all, it took around forty hours to get from Boonville to California. At last . . . the Land of Sunshine!

———◆◆◆———

*We went to the military base where Bill had been stationed, Camp Pen-*dleton. We met his friends, whom we'd be staying with until we got our own place. I thought they seemed cool. They were two gay dudes who worked at MCX, a big department-store complex on the base. We got the keys and went back to their place to get settled while they finished out their workday.

When they showed up a few hours later, we'd already had a chance to get cleaned up and relax a little. Instead of just two, it turned out there were three gay dudes living there: two were a couple. It didn't take long for them to get comfortable around us, either. They were kissing each other and shit. It was like, Great! My new life in California is starting off on a gay porn set.

They were cool enough to let me put my huge drum kit in their garage. It was incredibly loud, but I jammed anyway. I wailed out there for hours and no one complained. I tried to play during times I thought people would be at work.

———◆◆◆———

*After a few weeks, the arrangement was definitely starting to get annoy-*ing for everyone. Too many people crammed into a two-bedroom apartment. Bill and I crashed in the living room, one on the couch, the other on the floor. Even though we took turns sleeping on the couch, the damn thing was about as comfortable as a bed of nails. I

wanted to get out of there and get my own place, but an apartment was out of our financial reach.

To remedy that, his friends helped me land a job at the department store on base. I sold cologne, dress clothes, and other crap. I also had to pull my long-ass hair back in a ponytail. Boy, was I ever out of place. All the soldiers gave me weird looks, and I knew they were all judging me.

One day at work, a great song came on the radio. The melody was haunting and beautiful. I found out later it was a song called "Ordinary World" by Duran Duran. To this day it remains one of my favorite songs of all time. The song put me in a great mood. However, when I got back to the apartment, that mood ended abruptly.

Bill informed me he'd reconnected with some chick he used to bang on base, and she'd moved back to her hometown in Kentucky. He decided he wanted to hang out with her, so he was heading back to the Bluegrass State.

WTF?! I said, "Dude, don't leave me here. I don't know anyone and I can't afford to be here by myself." Besides, these dudes were Bill's old friends, not mine. Before he left, he arranged it so I could stay there—paying a little rent until I found a place. There I was . . . alone at the Playgirl Mansion. This was *not* how I'd imagined my big move to California and a new life.

Every spare moment, I worked at trying to find a band to jam with. I ran into some dude at the local mall who said he knew of a band that was a hair-metal-type band with a gnarly singer. Awesome! I thought. Let's start there. I didn't want to do any of the grunge horseshit. I would rather get eaten by a pack of wild coyotes and shat off a cliff onto a cactus patch. (Graphic enough?)

I got the guitar player's number by hyping myself up until the guy agreed to meet me. I went to his house. He and the singer were there. We talked about me learning some of their original tunes and coming back to jam. I took a CD with me. As soon as I heard the singer, I was like, Holy shit! This guy really can sing. I wasn't blown away by the tunes, but I dug his voice. I was thinking that this could be my ticket to getting something rolling out West.

I met up with the guitar player to jam on some tunes. I loaded my drum kit into his house, which was a pretty tight crib, with a bunch of people who were renting rooms there. I set up my kit and we started jamming. It was brutally loud. I'm sure the whole neighborhood hated it, especially the roommates.

After jamming a little while, he said he thought I was great and would be perfect for his band, which he called Love Drive, after the Scorpions album. I was excited, but apparently the singer and the bass player weren't too excited about *him*. It didn't take long for me to see why. His personality sucked. The singer and bassist kept flaking on us. Finally, the guitarist let me know there probably wasn't gonna be much happening for a while. Yeah . . . like never!

I was bummed and, at the same time, extremely lonely and homesick. I didn't have any friends. I was sober and incredibly insecure. Moving from a town that had about seven thousand people to a town that had millions was crazy culture shock. I felt like Tom Hanks in *Big*, when he's freaking out alone in that crack hotel. I kept trying to hang in there, but the homesickness got worse.

Fuck it, I thought. I'll move back to Tennessee with my parents. They'd just moved to Franklin, a suburb of Nashville, and were getting settled in. I thought they must have a cool music scene there

besides country, so I packed my car, said good-bye to the three Wills (and no Grace), and bailed out of there for Nashville.

I hauled ass. I stopped only once for a six-hour nap before plowing through in thirty-six hours. I arrived at my parents' new home and found it to be a major step down from the house we'd had in Indiana. I felt bad for Mom, because she'd moved to Nashville to support my dad—leaving behind the house she loved so much. Property prices in Williamson County were outrageous. This was a rental, and about all they could afford with Dad on a songwriter's draw.

They were happy to see me, and I was happy as hell to see them. I just wasn't quite ready to make the leap from a comfort-zone family home environment to the craziness of California. They said I could stay there as long as I got a job.

Since I had some retail experience, I applied for a job at a huge mall clothing store called Dejaiz. They sold hip-hop-style crap clothes. I had to wear some of that shiznit in order to work there. Remember those jeans: Cross Colours? In hindsight they were hideous, but I wore them. It was the sign of the times, and we sold them at the store.

The manager was a real cocktard! He was always busting my balls. Inside I was thinking, Dude, you have no idea the amount of shit talking I can own you with. But on the outside, it was grin and bear it. That was part of my people-pleasing trait. I was always passive-aggressive, until it would build up. Then I'd explode. I worked there a few months until I couldn't take any more of this asshole. I quit without notice, fucking his whole weekend.

I was getting restless as all hell in Nashville. I started calling the dude out West from the hair-metal band Lovedrive. He said he was

putting the band together for real, and that it would be a good idea if I came back out. I didn't waste any time. I packed my LTD and drove back to San Diego. This time I had $150 to my name and no job! I didn't care. The desire to make it in music possessed my soul.

When I got to Cali, I was expecting everything to be rolling. It turned out the guitar player who owned the house was really a total flake. He said he'd let me stay there until I got on my feet, hiring me to do odd jobs. That lasted about a week. The "jobs" turned out to be one job before he decided I needed to pay rent. There was no sign of the band doing shit.

A month elapsed before he asked me to move so he could rent the room for more money. However, he said I could move into his garage. It wasn't even the main part of the garage, but a closet he'd built in one corner. Literally, it was three by eight feet—and still I had to pay rent. I stacked my belongings in one end, leaving just enough room to sleep with my legs pulled up in a fetal position. Being the "great guy" he was, he let me keep my drums in the main part of the garage. My drums came out on the best end of that deal.

Man, was I depressed. I wasn't going to let it get me down and stop me, though. I got a job at the Wherehouse record store and tried my damnedest to make my life work.

At this point I was also running two or three miles a day. I was sober and had become a vegan. I didn't eat meat, dairy, caffeine, or sugar. I had more energy than ever. I was also really into self-help books and trying to better myself and grow as a person. I'd been reading a lot, latching onto a book by Dan Millman, *The Way of the Peaceful Warrior*. It was highly inspirational and helped direct my

thinking into a whole new place. I listened to a cassette series called *Pathways to Mastership*. I would spend time every day in my cramped little "bedroom" getting quiet and meditating.

I was really lonely and insecure, trying to figure out what the hell I was doing. I knew what I was capable of, but no one else did. I needed a sign that this was somehow going to work. I just hoped I had enough patience and perseverance to wait for one . . . and the "spiritual eyes" to see it when it appeared.

Months dragged by with nothing happening. The band never materialized. Every day after work at the record store, I returned to my cubbyhole. Knowing no chick would be impressed with my "pad" only added to my insecurity and loneliness. The car I'd been driving didn't help, either. It was a big beige boat . . . the opposite of a chick magnet.

I felt like I was on a deserted island with no one to help me except my higher power. That was my only relationship, and I counted on it being enough. I continued to run every day. I started noticing a red-tailed hawk flying over me some days. It was strange because I'd been asking the universe to give me a sign. Maybe this was it.

Later that day at work, while looking through the Ticketmaster computer system we used to sell concert tickets, I noticed this hard rock band I liked—the BulletBoys—was playing nearby in Riverside. I purchased a ticket and went to see them a few days later.

I showed up early at the tiny little club. Outside, I ran into the BulletBoys' drummer, Jimmy D'Anda. He told me that he and the guitarist, Mick Sweda, were leaving the band after one more show. Considering we'd just met, I thought it was strange he opened up to me. I watched the concert and thought they were great. They played their big radio hit, "Smooth Up in Ya"—they'd sold a million

records on the strength of that one single. After the show, I saw Mick Sweda outside and went up to talk to him. He told me he was looking for players for a new band he was putting together, and asked if I knew of any.

"Yeah, me," I said, without hesitating.

He smiled and said, "Right on, here's my manager's info. Send me a demo of you playing."

I couldn't believe it! It was too good to be true, but it seemed legit. Somehow I'd just walked up to a dude in a hugely successful band and been invited to send him my music . . . with the possibility of joining his band. I went back to my closet and thought about it all night.

I didn't have any recordings I wanted him to hear. I thought the C.O.D. stuff might turn him off because of the wackiness. So I set up a jambox and recorded myself just shredding a drum solo. I sent it to his manager's office, hoping he'd get it and respond right away. Days, then weeks went by . . . nothing. No response. I was getting bummed out and impatient. When I couldn't wait any longer, I called his manager's office and left a message with the receptionist. Still nothing.

A couple of months passed. I was starting think nothing was ever gonna happen. Isolated and sad, I slipped into a deep depression: living in that fucking closet and not being able to have company because I was so embarrassed wrecked me. I pleaded with the universe for help. During my meditations, I began visualizing Mick calling me. I did this every day. Not long after, while running, I saw a red-tailed hawk flying over me. Could this be another sign? I got back home after the run and the light on my answering machine was blinking. I hit play.

"Hey Jeremy . . . it's Mick Sweda . . . from the BulletBoys. How's

it goin', man? Got your tape . . . it sounds great! I'll give you a call real soon."

I sat there stunned. I replayed the message again and again. I was so excited I called my parents with the big news.

"This is it! Finally . . . my big break!"

Thinking "real soon" meant just that, I anxiously awaited the next phone call from Mick. Days turned into weeks, weeks into months. Every time I returned to that closet/bedroom, which felt more and more like a three-by-eight-foot coffin, I would rush to see if the answering-machine light was blinking. It got to the point where I wouldn't look at it at first, but then slowly I'd let my eyes wander over to it and if it was blank, I'd feel this overwhelming sense of despair.

I was so bummed I started doubting that the "signs" meant anything. Obviously, it was just a coincidence. I decided to take a more aggressive approach. I called his manager's office and left a message for Mick, inviting him to lunch.

Not long after, while running, I paused to catch my breath. It was a beautiful day. Physical exercise and just being out in the sunlight were about the only things keeping me from totally losing it. That's when I saw it . . . a red-tailed hawk streaking by. I was afraid to get too excited. I tried to prepare myself to be disappointed. Though I wanted to believe it was a sign, I had to guard against the reality that it was all just my imagination. When I returned from my run, the answering-machine light wasn't blinking. My heart sank.

Goddammit, this is bullshit. The hawk . . . all of it is bullshit. I left to go to work in a horrible funk. I made it through a god-awful day at work and could barely force myself to go back to that tomb. When

223

I walked into my closet, the light was blinking on the answering machine. Knowing it was probably from my folks, I waited to hit play. Finally I gave in. Sure enough, it was Dad saying he hoped I was doing okay. And then . . .

"Jeremy, Mick here. Hey man, sorry I didn't get back to you sooner. Got your message . . . yeah, cool . . . let's get together, do the lunch thing. And, if you want, bring your gear and we'll jam afterwards."

If I want? Fuck yeah! This damn patience thing was killing me, but I decided to never doubt the sign again. Think what you will about the hawk sign, but I know how it really went down. That hawk was a connection with my higher power, and it's something I have a strong connection with to this day.

I loaded my drums into the spacious LTD, cramming the trunk with toms and cymbal stands and filling the backseat and passenger side from floor to ceiling. I looked like an Okie from Muskogee, the Joads fleeing the dust bowl with everything they owned in *The Grapes of Wrath*.

LA was nothing like I'd ever seen. I thought San Diego was wild, but the traffic here was a long beast with a million red eyes: a bumper-to-bumper parking lot with kamikaze drivers dive-bombing from every on-ramp. The air was disgusting and dirty, like a big brown umbrella hanging over the city. There were homeless people and transvestite hookers, not to mention some really fucked-up people, on every corner. My little Midwestern, small-town sensibility was in shock. But I was so excited to meet Mick and to have a chance to do music on a real level, I didn't care.

I finally made it to Hollywood, and, with some effort, found the restaurant on Sunset Boulevard. With even more effort, I found a place to park the old beige boat.

I had no idea what to expect. I was really nervous. Fortunately, Mick, who was thirteen years older than me, turned out to be super nice. He wanted to know where I was from and what I was doing out West. Because of the age difference there was quite a life-experience gap, but we got along great.

We finished lunch and headed over to an hourly rehearsal spot, where we loaded in our gear. We were joined by a bass player who was also auditioning. He seemed really cocky, and I didn't think much of the guy. We jammed on some of Mick's riffs. I was trying my best to nail everything. I knew this could change my life forever. We played for a couple of hours, then loaded everything out. We went back to Mick's place. While we ate dinner, we chatted.

Finally, I asked, "So, what did you think of jamming with me?"

"Not sure yet . . . it was hard to get a read on it."

He'd been jamming with Jimmy D'Anda for the last six years, and Jimmy definitely had a certain style of groove. I asked if he would be into jamming more, and he said, "Sure." He wanted to know my plans for moving to Hollywood. I acted like I'd planned to all along—saying I was thinking about renting a room until I could get my own place.

"Why don't you just move your stuff in here? You can stay with me until you find a place. We can go in together on a rehearsal space."

I was like, "Fuck yeah, man! That would rule!"

I said I'd need a few days to get everything together before I could move. I headed back to my closet outside San Diego, feeling like I'd won a heavyweight fight against Tyson. This was a huge, life-altering day: a great musician, with one of the bands I loved, wanted to jam with me, *and* I'd have a place to live. Incredible! I

couldn't wait to get back to the dicksack guitar player's house and tell him I was moving out . . . tell him to roll his fucking closet into a neat cylinder and shove it!

I thought of him as the enemy. Looking back now, I see him as vital step in helping get me where I am. That's never an easy lesson, but one I've slowly come to learn. Even if someone seems like a prick, is someone you don't like . . . do the inventory and figure out why they're really in your life. There's always a reason. People are like mirrors—exposing things we need to work on. In this case, he helped show me my insecurities, how little I thought about myself, how I really didn't think I deserved better and was willing to tolerate being miserable.

Over time, I came to realize that I create everything that happens to me. It all starts with visualization—intentionally creating something better—or, out of fear, creating something worse. As much as I didn't like that dude and that cramped closet, at least he gave me a place that allowed me to be there long enough so I could eventually meet Mick.

So bless him . . . the fucker!

INTO THE DESERT, THEN BACK IN THE STUDIO

2010–11

Following our short Canadian tour, I returned home and continued to rampage for weeks on booze and blow. I could barely scrape myself up off the mat in time to go to Iraq to play for the troops. Some of our biggest fans were the military, and though getting there was tough, just knowing we could provide a little distraction for an hour made it worthwhile.

It's one thing to eat sand, dodge bullets and IEDs, and live in a tent; it's another to find yourself in one of Saddam Hussein's palaces. But that's what happened on this trip. The palace was only one of many Saddam maintained. After the insurgency, most of them were looted. This one featured cavernous inlaid-marble rooms, mosaic ceilings, and lavish crystal chandeliers. The bathroom fixtures were gold—not gold plated, but fucking gold. If you could've seen the rest of this impoverished country, you'd realize how obscene these palaces were and why these people needed him ousted.

Because we were with the military, no booze or drugs were allowed. Talk about hell: ten days of no partying and abstinence. Nothing like "entertaining" while detoxing! In actuality, being in a war zone—sober—helped the band reunite a little. The timing was good, because we were coming apart at the seams (like Ruben Studdard's undies before his latest stint on *Biggest Loser*). Being flown into a combat zone in helicopters, escorted by armed guards, wear-

ing flak jackets and hearing bombs explode has a way of bonding people . . . and, brother, did we ever need it.

One morning, as I sat at this humongous dining room table eating Cocoa Puffs, the absurdity of it really hit me: Jeremy Spencer dining at Saddam Hussein's table, 6,500 miles from Boonville, Indiana, and quite an upgrade from that garage closet where I'd lived in San Diego. It was pretty surreal, especially when you think about all the death and destruction nearby.

Military shows were insane because troops needed an outlet for their pent-up emotions. Many of them used our music to get prepared to face the possibility of death on patrols and mine sweeps. Like most of our fans, they already knew the lyrics to our songs, and they were really into it. Though the officers tried to contain their enthusiasm, we always managed to get them fired up, sometimes to point of moshing.

You could tell the gratitude was genuine, especially when the troops, who were clearly missing a remnant of something that smacked of home, lined up to say, "Thanks for coming." No matter your politics, just seeing what these men and women went through on a daily basis made us grateful for their tremendous sacrifice . . . not to mention for own cushy lives.

We finished up the Iraqi tour and flew to the UK to headline Hammerfest. DevilDriver wasn't thrilled we were the headliners, because they'd been around much longer. However, the band at the top of the bill is the one with the most sales . . . and that was Death Punch by a wide margin.

Having been forced to be "on the wagon" while in Iraq, it was time to resume old habits. Always accommodating, someone

brought a supply of cocaine—*synthetic* cocaine. God only knows what it was composed of. One night, after having done real blow and copious amounts of alcohol, I did an index-finger-size line of that synthetic shit. I spent the next two days wired and freaking out. Every time I tried to shut my eyes, they'd do a spastic flutter and spring wide open. Out of the next thirty-six hours, I managed a half hour of rest. I struggled through the show, but as soon as it ended, I found some real cocaine and booze and was up all night again.

Following that gig, we packed up and headed for the Download Festival. Download was great and much anticipated. Why wouldn't it be when we got to play for ninety thousand people? That's a nine followed by four zeros. Until you've stared out at a teeming throng that size, it's hard to imagine the rush you get; the energy from the crowd hits you in waves so tangible, it feels like you could lean on them and they'd hold you up. The feeling was almost as good as coke—and definitely not as dangerous. That is, until *thousands* started climbing toward the stage . . . all at once!

Ivan, who can work a crowd like a heavy metal Houdini, invited the crowd up to "shake his hand" during our song "Dying Breed." WTF was he thinking? In less than a minute, *five thousand* people came hurdling over the barrier. Like lemmings rushing to the sea, people were willing to risk being trampled to death just for the opportunity to . . . what? Oh, yeah: shake Ivan's hand! It was terrifying. Security had to stop the show before people were crushed. We were told, "If you can stop the crowd from coming over the barricade, you can finish your set. If not, you're done and you'll never play here again!"

Ivan, always the puppet master, brought the crowd under control and we carried on. Up to that point, I thought the show had

been flat. But there's nothing like thousands of wild-ass people charging toward the stage to amp up everything and reinvigorate a performance. We finished strong.

After the show, I wanted to keep the energy flowing, so I started slamming drinks and snorted a couple lines of blow before doing some press interviews. I was talking a mile a minute but still managed to be coherent. However, toward the end, the booze overtook my motor skills and my speech started slurring. I botched an interview so badly that I insisted the dude delete it right on the spot. Fortunately, he complied.

Afterward, as I was approaching our dressing room, I saw Ivan and Zoltan stepping outside . . . to fight! So much for the bonding we'd managed in Iraq. This was definitely not the perfect end to a perfect day. Ivan was screaming in Zo's face, and it was obvious Zoltan had finally reached a point of wanting to duke it out, employing some of his martial arts in a way that would not benefit anyone. It took quite an effort to separate them.

After that near fiasco, we went back to the hotel and I did cocaine all night, finishing off at least four bottles of wine on top of it. Having been awake all night, I was scheduled to fly back to the U.S. that afternoon. The van trip to the airport took hours. Fucked on no sleep and major chemicals, the trip was miserable. Listening to people bitch and complain about other people in the band only added to the discomfort. It was torturous. I tried to fake being asleep so I could disengage, but it was impossible to ignore. I couldn't wait to get home to party and isolate before our next scheduled slog, the Mayhem Festival.

Shit really started going sideways within the band right before we left for the Mayhem tour. Tensions were naturally high, and

some of us were unnaturally high. We've always had our fights, but then we'd make up. Band members get on each other's nerves. It's like being with your coworker twenty-four hours a day. But instead of going home at the end of the day, band members get to be in a bus—*together*—trekking across the fucking continent. Sound like fun? Pick three or four people who can irritate the fuck out of each other and go on an extended road trip. Dare ya.

———◆◆◆———

Though I didn't need any justification, band fights were an excuse for me to want to clock out and party, an opportunity to raise my endorphin level. However, booze is a depressant and blow is fucking deadly: it takes your life away—being high on that shit's not really living. Far from it! I'd been doing as much of it as I could, as often as I could, and I knew something had to give. So for Mayhem I decided to swear off booze and only do cocaine, the perfect example of addict logic.

I began commandeering bags of cocaine every day. To make it last as long as possible, I just did key bumps—like nibbling on a cake, a little sliver at a time, before giving in and eating the whole fucking thing. As a result, I'd end up snorting all of it. And, since I didn't have booze to come down with, I was up until ten A.M. or noon every day.

To try to get some rest, I took sleeping pills to come down, but they rarely worked. Stressed to the max and desperate for sleep, I finally ingested seven sleeping pills one night and passed out. When I awoke, I couldn't move the left side of my face. I couldn't even talk. Mom and my godmother, Mom's cousin Deb, were coming to the show that day in St. Louis. It was 100-plus degrees with debilitating

humidity, and I was facing a fucking drum solo that required coordination and endurance.

To add to the mayhem (pun intended), with paralysis face I could barely string two sentences together. Knowing Mom and cousin Deb expected to get together and talk after the show, I was up the proverbial shit creek without a paddle or a fucking canoe. I did my best acting, hoping to fake my way through a conversation. Though they had to notice my mush-mouth performance, they were kind enough not to say anything. Maybe it was my long-forgotten acting skills that got me through.

To insure that coke parties were well stocked, I started having blow FedExed out on tour, which was renamed the Cocaine Across America Tour. After completing the Mayhem dates, we did a show at the Sunken Gardens in San Antonio. To celebrate the end of that hapless junket, I scored the biggest amount of cocaine I'd ever seen. It was staggering. Impressed, I took pictures of it, but then I got scared and deleted them so they wouldn't come back to haunt me.

Cocaine had gotten a serious hold on me, but I was beyond caring. Determined to do what the fuck I wanted, if anyone got in my way, they were deleted—permanently. That's how fucked up my brain was: believing I was untouchable and so important that I didn't *need* anyone. That included chicks, unless they had blow—and even then, only until it was gone. It was cocaine and booze that I wanted.

No matter how hot a chick was, I had to take Viagra to even have a chance of getting a boner. Cocaine is the most enigmatic drug ever. You get sexually cranked in your brain, but your equipment doesn't respond the same because you're numbed out—feeling paralyzed. To quote Jason, "You feel like Ron Jeremy from the neck up . . . and

233

Christopher Reeve from the neck down!" Couldn't have said it better myself. (To illustrate the point, I later arranged a photo session with the famed Hedgehog and some killer babes. I wore a fake Superman suit and sat in a wheelchair. No disrespect to Chris Reeves was intended. But it's a powerful reminder of my "salad days" as a cocaine junkie.)

We had one final tour for the *War Is the Answer* cycle. This time we went out with Godsmack. At that point, I was doing megaamounts of drugs. I was so fucked up and depressed I decided I'd had enough of being what I considered "trapped" in my relationship with Angel. In truth, the only trap was my own self-inflicted, unresolved issues. I was extremely resentful toward her for my inability to man up and get out of our unhealthy alliance. So I sent her an e-mail telling her to get out of my house. Yes . . . *an e-mail*. Mr. Keyboard Warrior! Anytime in the past I'd tried to have the conversation in person, she managed to talk me out of it. So I resorted to wimp mail.

However, there was a catch. Actually, *two*. First, my sister was staying at my house for the first time ever. She was helping develop a Broadway show with a composer and librettist who lived in Vegas. Second, after I fired off the e-mail, my sister called to say that Angel was *pregnant*. Gut-punched, I retorted with the worst reactionary shit I could think of and hung up before she could respond. I was so angry it never occurred to me that I'd taken it out on my sister, who had been innocently thrown into the middle of this disaster. (Though I felt terrible about it later, it was a blessing she was there instead of me, or God knows what I would have done, considering the raw state I was in.)

All I could think was: That fucking bitch got pregnant to keep

me from ending it—tying herself to me with a kid. I was so into my-
self, I cared nothing about anyone's feelings but my own. I was full
of anger and resentment toward myself for staying in a relationship
I should have had the guts to end years before. But at that moment,
I blamed her and her irresponsibility. In my mind, all she had to do
was take care of my house, not overspend my money, and not get
fucking pregnant! Oh, yeah . . . and endure a fucked-up, angry, ver-
bally abusive, insecure, self-centered, cheating musician asshole
who thought birth control was a woman's obligation.

Blindsided, I had to seriously regroup and figure out how to get
out of this one. I was trying to live my thirty-year dream with a
band that had major momentum. The last thing I wanted was to
have a kid I'd never be around to see grow up, whose mother I didn't
want to be with. I was convinced that no one who chose this selfish
life should impose that on a child.

<hr/>

Earlier that day, before receiving the devastating news, Jason and I had
gone to a burger joint where the Godsmack tour had stopped, prior
to our next show. The chick behind the counter was a cute blonde.
After we were nearly finished eating, she came out to bus the tables
and we started flirting with her. We invited her to come hang with
us after she got off work.

"I'd really like to," she said, "but I don't have any clothes."

Jason said, "Perfect, you won't need any."

She gave us her number and he texted her throughout the day to
make sure she was still on board. Oh, and as the CEOs of Asshole,
Inc., we mentioned how it was standard operating procedure for the
groupie to supply the cocaine . . . a small price to pay for hangin'

with the celebs. She agreed, telling her boyfriend she was spending the night at her girlfriend's. In anticipation, we both popped Viagra and waited for the "lucky" little waitress to serve us up some poon tang and powder.

What followed was an embarrassing orgy. Not only was I a third wheel, I was an embarrassment. Jason and the girl did the nasty at least three times—while I tried to get it up to no avail. In addition to being numbed by cocaine, I was deadened by antidepressants and blood-pressure meds. Viagra didn't stand a chance against that onslaught of dick-numbing drugs.

After Angel's news, I was going to need even more . . . of everything.

<center>❖</center>

My plan to end our fucked-up association had taken a quick one-eighty. Now "with child," Angel convinced me it was only right that she should come out on tour with me. I pledged to use that time to force myself to do the right thing and support her decision to keep the kid. It was tough for me to not wanna smash her, but I got through it. The second she left, though, I wasted no time in distracting myself by hunting for chicks.

The afternoon before a show, I introduced myself to this older chick and arranged to meet her later that night. After the show, I went to the bar at the venue and started pounding drinks with our security guard. Sure enough, the chick showed up and we started talking. In short order, I pulled her into the dressing room to start making out with her. I was drunk and I was ready for sex. She tried everything humanly possible, but I couldn't perform. She'd have

had more luck getting laid in a nursing home. All I could think was, My sex life is over.

In honor of my flaccid cock, I did more blow and drank all night, sinking into an even deeper depression. Following another sleepless night, I spent my day off contemplating my life and what a total mess it had become. What could make it better? Suicide, perhaps, but certainly not the addition of an innocent baby! After hours of contemplation, I reached the only sensible conclusion: this cannot fucking happen. I didn't know how, but I was not going to be the absent father to a kid who deserved better.

<div style="text-align:center">—◆◆—</div>

When I got home from touring, I did my best not to destroy Angel, but that didn't keep me from destroying myself. I did shitloads of cocaine and alcohol. Then, before I accidentally ODed, the universe intervened. A few nights after I returned, Angel ran into the bathroom. I heard her yell, "Oh, no!" From the scream that followed . . . I *knew*. Like an asshole Rocky mounting the steps at Philadelphia's Museum of Art, I held my fist up and pumped the air! Forgetting what a loser I was, I felt vindicated.

"Are you okay?" I asked, with enough false sincerity to mask my hopefulness.

"I'm bleeding."

(Yes!) "Oh, you're just stressed."

"No, it's more than that."

I continued to fake concern, but I was so fucking relieved I had to stop myself from jumping up and down. My justification for being a prick was that she hadn't taken my feelings into consideration, and

now she was being justly punished. I convinced myself that this was divine intervention. At the time, I saw an answered prayer. Now I see a fucked-up, delusional, selfish drug-addict piece of shit with no remorse.

Once that tie was broken, it didn't take long for me to destroy Angel's fucking life once and for all. I went out of my way to be as hurtful and disgusting as I could. What I was really doing was acting out my self-hatred. Disgusted for being a codependent drug-addict drunk who'd lost his way, someone had to pay, and that was the role she cast herself in. Call it situation ethics—or the rationalization of an addict.

My drug intake skyrocketed even more, as did my drinking. I was totally out of control. All of this shit was happening, and within the same week we decided to make a lineup change in the band that escalated my depression even further. Just to pile it on even more, it was time to start making a new album. Years before, when I was imagining the rock-star life, none of this turmoil was part of the fantasy. Yet that's how I'd created it, or co-created it—for in shared "reality," everyone gets what they believe they deserve, be it good or bad.

The topic of getting rid of Matt had been surfacing for months. I was always the guy trying to tell him, "Dude, just chill. You get equal pay and you don't have to do shit except play bass. Just be cool, and everything will be fine."

Personally, I found his sarcastic mouth entertaining. Together, we could annihilate anyone. But when it came to being professional in front of the media, he had no filter and seemed proud of it.

The reality was, there were lots of issues with him I could no longer defend. He acted with disdain toward people and his cyni-

cism spilled over into interviews in ways that reflected negatively on the band. Not to say that everyone else was perfect, because our band has as many fucked-up personalities as Sybil. *It's a fucking band!* (What do you call a rock band in three-piece suits? The Defendants!) Every band has issues, or at least any band that's relevant. However, the Matt situation had reached a crisis point. The negatives finally outweighed the positives. He had to go.

Following a particularly embarrassing interview episode, Zo called and fired him. I'd gone out to dinner and a movie and had my phone turned off. Matt was blowing my phone up and I wasn't answering, so he thought I was being a pussy, but I really was at a movie. He texted me and reamed me out and told me to lose his number, which really hurt because we'd been good friends. Still, I could only imagine how bad he felt. I'd always liked him and appreciated his acerbic personality. But I agreed with the rest of the band that it had reached the point of no return. It killed me to do it—haunting even my dreams for months afterward.

<hr />

The dreaded time had come to start making the next Death Punch album. Never an easy process, but now, with the stress of the last few weeks, this was going to take all the strength and focus I could muster. I needed a break from partying anyway, so I thought I'd try to clean myself up so I could function enough to make a good record. Even being fucked up, I knew that if we didn't make good records, our career would fizzle and die.

I started out strong. I'd been sober for six weeks and I was working out every day. But I resented feeling trapped. I verbally brutalized Angel daily, hoping she'd finally leave me, because I sure as hell

was too lazy and insecure to leave her. The abuse was always verbal, never physical. But compared to the shit I dished out, a beating would have been welcomed. I vented everything I could on her. I hated the feeling I got from doing it, but I couldn't stop myself. I relished the juice I got from the anger. And when that wasn't enough, I started drinking again.

Writing sessions soon began, and the first thing I heard that could be turned into a song was something Jason wrote. It later became "Coming Down." We worked up the track and I helped dial it in before we turned it over to Kevin Churko, who was once again producing.

Since Angel was out of town, Jason made up some excuse to his girlfriend so he could stay over for a night of partying. I was drinking and doing blow, which I called "doing the gas and the brakes." Jason wasn't drinking, only doing coke, so he was on full acceleration. I managed to get two hours' sleep; Jason was up all night. He freaked out when he got a call from Kevin to come to the studio to record "Coming Down." Irony abounds.

When we arrived, Jason tried to play it cool, but he looked mangled. When Kevin left the room for a minute, Jason turned to me in a panic. "Dude, I can't play . . . I'm ruined." I'd never seen him so weirded out. We heard Kevin returning. "Man . . . help me out here. What am I gonna do?"

When Kevin walked in, he could tell something was amiss. I explained that Jason was ill and that we'd have to reschedule. It was obvious Kevin knew that was bullshit, but he said he understood. We hadn't been back to my place five minutes when Kevin called. First words out of his mouth were, "Was Jason high?" I felt reluctant to narc out my friend, but anyone could have told that Jason was

fucked up, so I said yes. We talked for a while longer and I assured him that Jason would be fine, that it wasn't a big deal, and that it wouldn't happen again.

"Coming Down" became our first No. 1. The irony of its creation is that it influenced so many people in such a positive way. We still receive feedback about how that song gives people hope. It just goes to show that people get what they need from music, because *coming down* was just the opposite of what we were doing at the time.

A week or so later, while Jason and I were dining at a local restaurant, I heard an older song playing in the background. I loved the chord progression. I told Jason to get inspired by the vibe, a vibe that resulted in the powerful ballad "Remember Everything." We now had two of the four singles we needed for the record.

"Back for More" was a track that came off Jason's first solo record, one he and I had done together back in '04. We overhauled it and made it more Death Punch. When we were asked to contribute a track to *Madden 12,* that was the song they chose.

Believing it could make us or break us, I knew our third record had to be awesome. Now that Matt was gone, I didn't want to project the appearance that there were any cracks in the foundation. I became obsessed with the whole process, and it stressed me out. Part of the stress was that I didn't feel the same fire from certain people, and it frightened me. So I did what I thought was necessary to rally everyone and get us on track. When Ivan came to stay with me to start recording vocals, I joined him nightly for vast quantities of alcohol.

With Ivan around, it wasn't long before the two of us were get-

ting fucked up on a regular basis. One night I took him to my local watering hole, Bomas. Though we ate, the majority of the night was spent drinking. We guzzled our way through eight or nine greyhounds each when I decided that what was missing was cocaine. By the time the dealer arrived, we were both hammered. After snorting some key bumps in the john, I decided to take the party back to my house. To prove how fucked I was, I let Ivan drive my Mercedes.

Somehow he managed to keep it between the lines—barely missing a median or two. We made it home unscathed. But when he pulled into my garage, he ignored the hanging tennis ball and smacked into the metal pole that guarded my water heater—denting the bumper. I would have been pissed, but I was more interested in getting inside to do more blow.

Other than jamming tunes on the patio and constant drinking for the next few hours, I don't remember much. What I do remember is Angel and Ivan shaking me awake as I lay on the patio. I could barely pry my eyes open. She was yelling, and everything was a blur.

"You stopped breathing!" she shouted, obviously relieved I was alive but still angry because I'd scared her.

They helped me upstairs and into bed. I lay on my side so if I vomited, I wouldn't choke to death on my own puke. I said I was sorry, but I wasn't. I didn't care. Sure, my body had finally reached a toxic level of booze and blow, but it was my mind that was poisoned. The last thing I was worried about was leaving the planet. Life was shit, and I welcomed any exit strategy.

When I dragged myself downstairs later that afternoon, Ivan said that before I passed out, I was swilling vodka straight out of the bottle. "Dude, you looked like Chris Holmes in *The Decline of Western Civilization, Part II*." He said it as a joke, but I could tell he was

concerned. Shaken, Angel obviously didn't find anything humorous about any of it. Can't say I blame them for being upset, but at the time the thought of not being able to breathe, of just slipping away, seemed very attractive. My response to their being so serious was to laugh, which wasn't well received.

The only thing that kept me from repeating that sorry spectacle was the realization that we had an album to complete. Getting it finished and making sure it was the best it could be was important enough for me to postpone a meet and greet with the Grim Reaper.

With that current mental state, it didn't take long before Zoltan and I were at odds for a variety of reasons. It seemed to me he was more interested in doing his martial arts—and promoting his participation in various tournaments—than focusing on writing a record. In his defense, he'd written shitloads of material for those first two records. Also, he handled most of the band business, as well as designing our merchandise . . . so he couldn't be expected to do it all. Still, what I perceived as his lack of participation on this project became a bone of contention.

Ivan hadn't prepared much either, so he struggled at first to get going. The "problem" was that Ivan wasn't particularly angry at this particular moment in time; since anger had always served as his muse, not having it to feed on made the process all the more difficult for him . . . and us.

Jason had yet to move to Vegas, so he was working at Kevin's home studio. Tons of people were constantly running in and out, which made it almost impossible for him to concentrate. It didn't take long before he became frustrated with that situation, joining me in booz-

ing it on a daily basis. Now back into a full-blown alcoholic haze, I was completely worthless. At this rate, it was questionable whether or not we'd be able to produce any album, let alone one we could be proud of.

Not long into the process, Zo, Ivan, and I had a major falling-out. The pressure to deliver had gotten to everyone, and what needed to be a creative atmosphere had become a fucking nightmare environment. I pulled away and slipped into heavy cocaine use. I needed any endorphin rush I could get, even if it was fake.

To add to the turmoil, Angel and I were at each other night and day. She was determined to "save" me and micromanage my life. And I was determined to get rid of her once and for all. I bought her a ticket to fly back East to visit her mom. After dropping her off at the airport, I wasted no time in calling one of her friends to come meet me at a local bar.

By the time she showed up, I'd already downed five greyhounds. I continued to drink and managed to get her drunk, one of my specialties. A stripper, she said she had to stop because any more booze and she wouldn't be able to work that night. I asked her how much she'd make that night stripping, and she said that since it was midweek, a slow night, she'd probably only rake in a couple hundred. Without pause, I went to the ATM and got enough money to more than pay for her lost wages and purchase enough cocaine to get us both trashed.

We were so completely destroyed by the time we got to my house that I dented my Mercedes pulling into the garage. Like the last time, I didn't care because I couldn't wait to get inside and do more blow. While she poured drinks, I broke a Sharpie in half and used it to snort up huge rails of coke. The minute we sat down on the sectional in the TV room, she took out my cock and started sucking it.

244

"See what two hundred bucks gets you?" she said. For a second, it occurred to me how much Angel would be hurt if she knew how easily her "friend" could betray their friendship. But that thought quickly passed as she continued to blow me.

At some point the party moved to my bedroom, where the debauchery continued. After banging each other and doing more blow, the night ended with me jerking off and her using Angel's vibrator while we watched every kind of porn imaginable. Yes, I said *Angel's* vibrator. How fucking low was that? Always a "gentleman," I did wash it off before I put it back in the drawer. My shittiness knew no bounds, but I didn't spend five minutes on the guilt train. I was beyond caring, because I knew where this train was headed. It had already entered a darkened tunnel . . . with no light visible at the end. What I didn't know was when it would finally go off the rails.

━━━◆◆◆━━━

*The creation of our third album was slow to emerge, but that didn't pre-*vent management from demanding a lead-off single. I was confident we had singles two and four covered, but I also knew we had no "breaker." Zo finally came to the table in a big way with a riff he put on top of some drums I'd done for another song with Jason. It ended up being our title cut, "Under and Over It." Because I thought the verses were too aggressive, I wasn't sure it was the single we needed. Still, the label pushed for it, and in hindsight they were right. As my grandma Helen used to say, "Even a blind sow finds an acorn now and then!"

Because the whole experience of making *American Capitalist* was so nightmarish, I couldn't even bear to listen to it for a long time. Hearing it rekindled the pain of making it. To relieve my

agony, it debuted at No. 3 on the *Billboard* charts and sold more than ninety thousand units the first fucking week! Had Adele's freaking supernova not still been selling megamillions, it would have charted even higher.

As they say, No rest for the weary. Our producer had recorded all the bass tracks on the album, but we had to find a new bass player to replace Matt. I hated the thought of having to audition someone new. The process itself was mind numbing. I could tell within thirty seconds if someone could fill the bill. Having to endure dozens of would-be players wasn't something I had the patience for, but it had to be done. It went exactly the way I expected. We auditioned several guys who were good at playing but not adequate at singing backgrounds. Others played and sang well, but had the wrong vibe. Finding the right combination proved to be difficult.

One night, Jason received a message from a dude on Facebook saying, "You don't know me, but I'm your guy." Jason thought that was pretty ballsy, and asked if he could sing backgrounds. Having fronted his own band, he said, "No problem." He sent over some songs he'd played and sung on. We thought he sounded pretty good, so we asked him to come in for an audition, which he seemed excited to do. Within half a song, I looked at Zo and nodded my head. We both knew he was the guy.

His name was Chris Kael . . . and he was just what we needed. Not only was he a better player and singer than Matt, but he was also a really positive guy. Extremely enthusiastic and hungry, he had the right look and vibe—plus he lived in Las Vegas like the rest of us. Though fans are usually resistant to someone new, I knew Chris would quickly erase Matt's shadow once people got a chance to see him.

We did a few radio festival dates with him. It didn't take long to

work out the kinks. And Chris turned out to be a fan favorite since, unlike his predecessor, he actually welcomed the interaction. At least that problem had been solved. Now I just had to find the strength to get through the gigs.

I decided, once again, to get sober. (Detecting a pattern here?) I needed some way to stop drinking besides sheer willpower. So I started taking Antabuse, a drug that's supposed to prevent you from drinking, because if you drink, you not only get sick, vomit, and become barely able breathe—you also swell up like a fucking balloon. All in all, a fairly effective deterrent.

We finished up the last of the summer dates right before making the video for the first single. Somehow, a few of us ended up at the Bunny Ranch in Reno. When we pulled up in the bus, ten nearly naked girls ran out the front door. I knew I couldn't handle what we were getting ready to experience, so I poured a drink.

I instantly started breaking out in hives. Within minutes I'd swollen up like Violet Beauregarde in *Willy Wonka and the Chocolate Factory*. I staggered into one of the rooms to lie down. Feeling so bad I wanted to die, I called Jason and asked him to help me out of there and onto the bus. While he was walking me to the bus, I began violently puking up my guts. When he got me to my bunk, I tried to pass out. Before I could, I heard chicks' voices. Then my bunk curtain slid open.

"Are you Jeremy?" asked one of the Bunnies.

"Just barely . . . " I mumbled—using all the strength I had to turn my head in her direction.

"Do you want us to suck your cock?"

I started to ask who "us" was, when I spotted the other two huddled behind her—brandishing big toothy smiles.

"Yeah, sure," I said. "Could you come back . . . in an hour?"

She frowned and glanced back at the other two, who seemed equally confused. I mean, who turns down a blow job other than a human dirigible, someone who looked like he's been stung by an entire beehive?

Once they left, I staggered to my feet, barely making it into the bathroom before I tossed my cookies again. Just as I finished, I heard people getting back on the bus. After discovering the Bunnies wanted a thousand bucks an hour for their services, no one opted for a blow job or anything else. We promptly hauled it out of there.

———◆———

We decided that we needed a rockin' video for "Under and Over It"—something that epitomized the capitalist theme. So, we arranged to shoot it at a mansion belonging to a friend, Gavin Maloof, owner of the Sacramento Kings NBA team. We also were given the use of his private jet for some of the scenes. To make sure it was as decadent as possible, our security guard brought in a vanload of scantily-clad hot chicks for the shoot. Even so, I was dreading it until I saw the enormous open bar and found out that one of my drug dealers was scheduled to be in the video.

In preparation, I started slamming shots of Jäger. By the time shooting began, I was already buzzed. To keep it going, the second the director yelled "Cut!" I'd grab a different chick and hit the bar. Though this was more fun than usual, something was still missing; that's when I realized that something was coke. To ensure the shoot would continue on a positive note, I bought a bag from my dealer as soon as he arrived. Once the cocaine orgy began, it wasn't long be-

fore I started getting sketchy. Knowing the "cure," I guzzled booze to balance it out.

Now sloppy drunk and cranked, it was time to film the scene in the enormous swimming pool, where Zoltan tackles me. Bikini-clad beauties were macking on each other, water jets were squirting from every direction, lights were flashing . . . it was sheer chaos. While underwater, I suddenly realized my bag of cocaine was still in my pocket. *Fuck!*

Not waiting for a director's "cut," I scrambled out of the pool, ran inside, and pulled the bag out of my pocket. Thank ya, Jesus—it survived the chlorine bath! We were shooting a million-dollar video, yet all I cared about was my bag of cocaine: the perfect example of my fucked-up priorities and perspective. Somehow the video turned out great, but it wasn't due to my contribution.

The daily struggle of cocaine addiction was total misery. Finishing my drum tracks early, I did nothing but party or lie on the couch for days at a time. I'd avoided playing drums for weeks. I needed to learn a bunch of songs from the new record, but I was in horrible shape. Rehearsals were about to begin. My legs weren't working, and I was mentally fucked. Just thinking about going on tour kept me depressed, scared, and miserable.

One night, before rehearsals were to begin the next day, I went to dinner with Kevin Churko and Kelly Paiste from Paiste cymbals. I'd promised her I wouldn't be drinking, because I had rehearsal the next day. But even before she showed up, that promise had evaporated. Deciding it would be okay to have just *one* little glass of wine with Kevin, that one promptly turned into ten, followed by God knows how many vodka shots. By the time we started dinner, I was wrecked. Ever the cool one, Kelly said nothing.

While they continued to eat, I excused myself and went to the john, where I phoned my drug dealer. Returning to the table, I ordered more food and drinks. I waited a few minutes before excusing myself again to go meet my tardy dealer. The meet-up took forever, but I scored blow and went to the bathroom to do several lines.

Kelly started blowing up my phone. "Chop, chop! Food's getting cold."

I raced back and made up an excuse—which no one believed—that I'd had to take a call from Angel. I took one bite of the overpriced steak, and that was it for food. The dinner ended with me contributing incoherently to the conversation. Kevin and I split the bill, which was nearly a thousand bucks. Boy, did I ever know how to have a good time!

We said our good-byes, but before I could depart, I ran into some old friends from LA. Never one to put a quick end to a bad thing, I bought drinks and did blow every ten minutes. We drank until 5:30 in the morning, and when it was obvious the party had finally ended, I announced it was time to drive home. My friends thought better of it and put me in a cab. Once home, I was still so amped I couldn't sleep.

Rehearsal was at noon, and I was a zombie. I had my drum tech pull the kick drums out of the monitors so the guys couldn't hear how fucked I was. I felt horrible guilt that I was about to start a tour in such shitty condition. How much lower could I go? My life had become the cliché of every rocker who ever fucked it all away. Always one to make big declarations, I announced that I was really going to clean up . . . and this time *I really meant it!*

The Share the Welt tour would be a sober journey or else . . .

CHAPTER 14

DECADE OF BROKEN DREAMS

1994-2004

I packed up everything and moved to Tinseltown, dragging my few possessions into Mick's studio apartment. Though small, compared to the closet I'd been sleeping in, it seemed really roomy. He said he didn't expect me to pay half the rent, since I'd have to *sleep on the floor in the living room.* And by living room, I mean the only room. There wasn't a bedroom; his bed was behind a curtain.

In spite of this new exciting start, I was lonely and sad. My insecurity was brutal, and not being able to drink or do anything made it really hard. Still, I was determined to stay sober.

We started jamming at a rented rehearsal space in North Hollywood. Mick invited a different bass player to come down and jam with us. We began hashing through Mick's ideas, tracking a couple of things on his twelve-track recorder. We'd stay at the studio until three or four in the morning, then come home and listen back to what we'd recorded. He was brutally honest with me, and I was learning a lot from him. However, when he first suggested I "lose the second kick drum and start practicing with a click track," I was a little miffed. Still, I knew he was right. I could shred, but my sense of groove and being tight in the pocket was sorely lacking. I bought one of his old drum machines and practiced with it every day. It took a while, but I learned to play with a click track, something that would serve me well in the future.

I needed a job. As luck would have it, I got one right around the corner from our apartment at Guitar Center in Hollywood. Working there sucked balls! I was assigned to the drum department, where these broke-ass fuckhead kids would come in and bang relentlessly for hours on drums and cymbals. I was forced to listen to this hideous horseshit forty hours a week. I had to answer phones with kids hammering drums so loud you couldn't hear yourself think. When I couldn't take it anymore, I'd grab the sticks and say, "Dude, you have to stop. If you're not gonna buy it, you don't get to practice on it!"

I endured it for six or seven weeks . . . that was all I could stomach. About the time I quit, my LTD decided to get lung cancer. It was coughing, sputtering, and wheezing—showing all the signs of the inevitable death rattle. I sold it to a guy who worked at a body shop for three hundred bucks and was happy to get it, though being carless in LA is akin to being boatless in an attempt to flee Cuba. No car, no job, and what little money I had was all but gone.

Dad was helping me with rent, and that's when Mick decided to start charging me half. Those tight quarters were apparently starting to wear on him. The reality was Mick was broke and had only infrequent work. He needed me to help him out. He'd gone from a million-selling rock band to no band and no income, a definite comedown from being a rock star. I realized it must have been really hard to have to rejoin the real world. (Having experienced this frenetic, nomadic life, with moments of sheer exhilaration—playing in front of huge crowds—I can't imagine wanting to go back to normal day-job bullshit.)

Trying to assemble a functioning band had also reached a dead end: the bass player was a flake, and the singer, who used to be in a

band called the D'Molls, was not only a "born-again" Mormon but was also unavailable most of the time. As for me, I was broke and terrified of Hollyweird.

It was the culmination of everything that caused me to contemplate smoking pot again. I'd told Mick about my problem with drugs in the past. When I mentioned I was thinking about wanting to use again, he suggested I "just take a few hits and don't go sucking on cars." That seemed to make some kind of sense, but I was scared to start—remembering how quickly things went from pot to full-blown addiction.

Later that morning, I picked up the bong and held it to my lips. Grabbing a lighter, I lit it and held the flame to the end of the bong, just short of actually lighting it. I wavered for a moment—fear overwhelming my desire to numb out. A deep well of sadness engulfed me, and I sat there weeping like a frightened child. I needed help. I needed to find an A.A. meeting . . . fast. It so happened that there was one in a church by our apartment on Fountain Avenue.

I didn't care if it was N.A. or A.A. or A.A.R.P., I just needed to get the fuck in the room with other addicts and talk. Among the street people seeking free coffee and donuts, I discovered a few celebrities I can't name due to the group's requirement of anonymity (even though, from my experience, that word is used pretty loosely). In New York, nearly every waiter and bartender is an out-of-work actor. In LA, nearly everyone is in "the biz," be it film or music. This particular meeting seemed to be about out-of-work actors or would-be screenwriters trying to "gherm" (take advantage of) some producer, director, or celebrity in attendance.

Over the next few days I went to more meetings, but nothing would relieve my depression. Being sober, feeling my feelings, not

medicating them, and having no place I could call my own was too much for me to handle. Plus it didn't matter that if I met a chick, I had no place to bring her . . . and nothing to offer. The whole experience had turned me into a virtual recluse. That's when I decided to head back to Tennessee. While I was packing, Mick came home. I could tell from his expression he was taken aback. But after his initial overreaction, he realized how badly I needed to leave and was cool about it.

I carried my one small box of belongings to a UPS store and mailed it to the Volunteer State. Then I purchased a cheap plane ticket from the classified ads. The next morning I was on my way back to Nash Vegas . . . once again.

When I ascended the airport loading ramp, I could barely hide my joy in seeing my parents waving at me. Just being back with people who loved me, who made me feel safe again, helped me realize how beaten up I'd felt in Hollywood. However, somewhere on the drive to Franklin, it hit me: I was back in conservative Tennessee. After Hollyweird, Nashville seemed even more like the home of the Waltons, Minnie Pearl, and Gomer Pyle. Every would-be country star who came to town looked like a Garth Brooks wannabe. The rednecks who used to threaten me because I had long hair now had even longer hair or those god-awful Billy Ray Cyrus mullets. Country music was starting to sound like bad '70s rock. Things were seriously skewed.

Not long after I arrived, I got a job at Camelot Music. I'd missed being around music and selling it. Though I met some cool people, I still had no desire to hang out socially. I missed my friends from Indiana, people I felt comfortable around. I was going through an incredibly lonely period, and I was actually scared in the presence of

anyone I didn't know. My daily routine consisted of going to work, coming home, hanging out with Dad, and watching TV.

I practiced drums every day in the spare bedroom. Practicing to a click track was markedly improving my drumming. I did have a double pedal, and in spite of Mick's advice, I was still playing double bass; I couldn't give it up. That was me, that was what I did. However, his suggestion helped focus me in a whole new area and, as a result, I improved even more.

I hadn't been gone a month when I discovered Mick had replaced me with another drummer. I now felt stranded in Tennessee with no hope. I began to wonder if my dream of playing music professionally was just that: a dream, with no reality attached. Then, a little opportunity presented itself.

Dad was working with a new country artist, James T. Horn. Together they'd written an album full of songs. With Garth Brooks's original manager, he had a deal on Curb. As a favor to his old manager, Garth had promised to let this new guy open five shows, which would have launched his career big-time.

James T. was getting ready to showcase for a large group of concert buyers and promoters and needed a drummer. Dad pulled a favor and got me the chance to do the showcase. I was by far the youngest guy in the band. Everyone else was a seasoned studio musician, A-team players. Most had toured with the biggest country acts and were now stalwarts in the studio. One of the guitarists, C. Michael Spriggs, was a longtime friend of my dad's. They'd written a recent hit song, "The Car," which would go on to have a million-plus radio airplays. "Spriggers," as my dad called him, made me feel welcomed.

Though I was intimidated, I did everything I could to rise to the occasion. Although I'd learned all the songs, when they started chang-

ing shit on the spot, my inexperience showed. It quickly became apparent I wasn't familiar with some of the drumming styles they required. Everyone looked like, Man, I don't know if this kid can pull it off.

I could tell James T. was nervous, too. This was his big chance to land tens of thousands of dollars' worth of bookings before he even had his first record out, and he couldn't afford to have anything go wrong. However, Dad assured him I could handle it, so even though he had his doubts, he went along.

To make a long story longer, I kicked ass the next day at the showcase. James T. was so impressed he asked me to join his touring band. It would have been good, steady work, two or three times what I could make working retail, a chance to play in some huge venues—opening for Garth Brooks, the biggest name in country music . . . hell, in music, period. But the more I thought about it, the more I realized this wasn't what I wanted to do, wasn't what I was *meant* to do. That little voice inside said, "Suck it up. Go back to Hollywood!"

I called Mick. When he told me the new drummer wasn't working out, that was all I needed to hear. I hung up the phone and told my folks I had to give it another try. They agreed. Dad gave me his old '91 Chevy S-10 pickup. I loaded it up and got the fuck out of Tennessee—for good this time.

The trip back to California was like a journey into my fears, an exploration of self-doubt. The last time, I'd been scared because of the unknown; it suddenly occurred to me that even though I'd survived it once, I had no way of knowing if I could endure more of the same. After a fourteen-hour marathon drive, wired on NoDoz, I stopped somewhere between Tucumcari and Albuquerque, New Mexico, and called home.

Mom answered. Though I didn't come right out and admit it, she could tell I was having a full-blown anxiety attack. I expressed my doubts about my decision to return to Hollywood, saying the more I thought about it, maybe I should just turn around and come back to Tennessee. Though she empathized, she said to stop second-guessing myself.

"You have to go, Jeremy. You can do this. But you've got to *believe* you can."

She knew if I didn't go now, I'd never be able to live with myself later. So I hung up the phone and manned up. After showering in a shitty truck stop near Albuquerque, I popped a few more NoDoz and continued west on I-40, which followed the famous Route 66 "mother road." In Arizona, I came within miles of the famous meteor crater where Starman Jeff Bridges gets rescued by his fellow aliens. I tried not to dwell on it, but I knew I was about to be an "alien" once again, virtually friendless and alone.

The last fifty miles, I fought to stay awake. I was nodding off when I suddenly hit the traffic pouring into LA: the stop-start red-taillight monster that stretched for miles. I rolled down my window and stuck my head out, hoping the brisk, smog-filled air would wake me up. The last thirty minutes was a struggle with my eyes closing, head dipping forward, and the jolt of waking just before avoiding crashing into the car inching along in front of me.

I arrived totally enervated and exhausted. Mick had moved to a bigger apartment with his new girlfriend. Too tired to even talk, I crashed. When I woke up several hours later, he informed me we were going to meet the rest of the band. Starving, I stopped and got a couple of bean burritos (my cheap-ass go-to meal for years) on the

way. They didn't do a lot to settle my stomach, which was already wrecked from the nonstop, thirty-seven-hour marathon drive.

We ended up at a dingy club/bar in the crappiest part of Hollywood. It reeked of stale cigarette smoke, body odor, and urine. The management had assembled a lineup of some of the worst bands in existence. To top it off, the soundman at this bleak hellhole was our band's guitarist, whom we discovered asleep at the console. Somehow he'd managed to crash out in spite of the overamplified blare of the suck-ass band that was playing. I thought it was hilarious that we had to wake him. He stood up, stretched, looked at me, and smiled.

"Hey, man . . . how ya doin'? I'm Jason." That handshake was my introduction to Jason Hook and the beginning of a friendship that would one day reunite us, after a long and circuitous road, in Death Punch.

The bass player showed up a while later. He was a really big dude: super tall, and, did I mention . . . *big*! I had no idea about his musical abilities, but he was unquestionably creative, because he'd randomly shaved certain parts of his hair—including so much of his hairline that it now receded to the middle of his oversize cranium.

So . . . this was the band: a former rock star hoping for a second act (Mick), a Canadian illegal-alien guitarist (Jason), Basszilla with a zombie 'do (Jon), and me, as nervous and insecure as ever. As a bonding experience, the plan was to go to a strip club once Jason finished his shift. That seemed like too big a challenge to my sobriety and my stomach, which was churning from the combination of bean burritos and nervous-energy juice. Plus I was still fried from the drive. I begged off and went back to Mick's to chill.

259

I awoke the next morning, amped to rehearse with the band. We drove down to an industrial part of LA called Vernon, where they'd rented a cheap rehearsal place in a run-down building. The way a magnet attracts metal filings, this shithole had attracted fifty god-awful bands, all renting rooms and blaring insipid, overwrought music. Although it was a cockroach-infested dump, I didn't care if we rehearsed in a slaughterhouse. I was just happy to be back on track, trying to achieve my childhood dream.

Mick informed me that nothing was set in stone, that this was merely an audition. To get the gig, I had to meet the approval of the other guys in the band. I felt prepared and confident because I'd learned all the tunes from the tape he'd sent. The minute we started jamming, I got into it like I was playing the Great Western Forum. I'd always heard coaches say you only play a sport as good as you practice. That's how I approached practicing, and it paid off . . . I nailed everything. The guys agreed: I was in!

The next thing on my agenda was to find a job, hopefully one I could tolerate. Guitar Center had taken part of my fucking soul. Besides, I preferred selling music. So I applied at Tower Records on Sunset Boulevard. The interviewer seemed impressed with my previous record store experience and hired me. It wasn't long before I'd saved enough money to get my own place.

Before you imagine a lovely little studio apartment, let me explain that on an hourly-wage salary, I was lucky to afford the toilet of an apartment I found on Cherokee and Yucca. (Try Google Maps and be ready to pity me.) You'll discover it's right off Hollywood Boulevard—at the corner of Crack and Murder.

My apartment looked like something out of *Seven*, where Brad

Pitt and Morgan Freeman discover a five-hundred-pound gluttonous mound of flesh lying in his own excrement. If serial killers needed a place to vegetate, this apartment building was perfect. The tenants were hopped up on smack. You had to watch your step, literally, because the stairwells were filled with dirty needles, crackheads, and tweakers. For the unenlightened, the old saw goes like this: the difference between a crackhead and a tweaker is simple: the crackhead will steal your shit and bounce; the tweaker will steal your shit and then help you look for it.

Yes, indeed, I'd found home sweet hell—in more ways than one. To survive the stifling heat and hopefully to catch some z's, streetside windows had to remain open. To add to the freakish ambience, helicopters patrolled overhead all night, every night. Someone was always running from the cops and being arrested right under my window or in the hallway outside. The street noise and the creeps in the next room kept me awake; the only way I could fall asleep was with earplugs, though knowing I couldn't hear a homicidal maniac sneaking into my room was more than a little unsettling.

The manager of this horror show was an older woman named Shirley, who talked to me anytime she saw me coming or going. Under normal circumstances, I would have made an effort to avoid her, but I was so lonely and desperate for human contact that I actually looked forward to our confabs. When Shirley learned what I did, she promised that once the band got going, she and her "boyfriend" would come to see us perform.

The band rehearsed long hours, getting tighter as a unit with each passing day. Finally, we had the opportunity to play some live shows. Mick's old BulletBoys bass player asked us to open for his

new band, Ham Sandwich. I couldn't imagine a worse name until it was decided that our band would be called Brain Stem Babies, a name truly destined for greatness. (Sarcasm acknowledged.)

On the night of BSB's first show, I was as nervous as the proverbial long-tailed cat in a room full of rocking chairs, but I managed to get through it. It was just the first of many gigs in derelict-looking clubs up and down the strip. One of our mainstays became the Coconut Teazer.

It was during one such performance at the Teazer that Shirley and her weirdo scumbag boyfriend showed up. This dude was strung out, and I couldn't understand what she saw in him. After the gig, I went to their table and thanked her for coming. She introduced me to Silas, who made me so uncomfortable, I quickly excused myself.

The next day, I was awakened by the sound of someone crying. I stuck my head out into the hall, and a woman spotted me before I could duck back inside. "Did you hear about Shirley and her boyfriend?"

I shook my head no.

"Someone found their bodies in her apartment this morning. He killed her, then himself. Thought maybe you heard the shots."

"No," I said, totally shocked and creeped out. I'd gotten so used to shutting out the sounds of Hollywood Boulevard, a gunshot had become commonplace. Though I didn't know Shirley that well, the incident really disturbed me. I couldn't stop seeing them sitting at the table in the Coconut Teazer just twelve hours earlier. When I looked out of the window, medics were wheeling their sheet-covered bodies out to an awaiting ambulance. That would be an image seared into my brain for months.

I never slept through the night there ever again. I stopped using earplugs because I wanted to hear some murderer trying to break into my apartment and slit my throat. To continue the self-terror, sometimes I imagined that when I opened my eyes, Shirley would be lying next to me. That nightmarish experience would serve me well later: learning how to survive on little sleep.

For the next nine months, the band did little except rehearse and play dives, peopled with a few drunks and hangers-on. Jason and I were growing tired of Mick's constant need to control things and his inability to find better gigs, though we never questioned his playing because he was an exceptional guitarist (one of my favorites to this day). In an attempt to move forward, we began demoing some of our own material at Jason's apartment.

The previous year, Jason had been in a band produced by Beau Hill, who helmed hit albums for such big '80s bands as Ratt, Warrant, Winger, Alice Cooper, and Europe. Though Jason's project was eventually shelved and never released, he and Beau remained friends. We took our demos to Beau. He was into our material and asked us to put together a project he could shop for a deal.

We were excited, but we knew we had to leave Mick's band in order to pursue our new direction. Of course, when we explained our situation, he was upset. I felt bad about leaving him, but at the same time this seemed like a great opportunity, and great opportunities didn't come along very often.

Over the next few months, Jason and I demoed lots of material. In order for Beau to be able to shop it, we needed a band. Jason knew some guys back in Canada: a singer I'll call Aaron, and Dan, a bass player. When Jason told them about our project, they were eager to be a part of it.

Aaron was the first to arrive. I agreed to let him stay with me in Murder-Suicide Manor. Since I'd never met him, having him in my small space was a little invasive. But since I was used to having *no* space, I gave him my bed and slept on the floor. Though inconvenient, it actually helped me get to sleep—knowing that while he was in bed getting his throat slit, I might be able to crawl to safety, unnoticed. I was willing to make any sacrifice to get the band rolling as soon as possible.

Not long after Aaron arrived, Dan followed. (Like Jason, both were here without green cards.) Now I had two people living with me in a tiny room. *Three's Company* it wasn't.

Luckily, my sister was touring with a Broadway musical and had to be in LA for a couple of months. She'd acquired a really nice apartment not too far away. I happily bestowed my place on Aaron and Dan and moved in with Natalie. It was a spacious apartment and I had my *own* bedroom, which was a major upgrade . . . like going from a cardboard box in a back alley to a suite at the Beverly Hilton.

We called our band New Pop Eden. (Don't ask.) After we managed to write some fresh material, Beau began setting up private showcases—with record labels—in our rehearsal space, where we'd perform three or four songs. Each time, we were certain this time would be the one. But after nearly twenty label showcases, it was obvious no one was interested in signing us. Part of it was due to our material; part to the skittishness of those in attendance.

Most of the label people who came were low-level A&R guys whose existence was predicated on keeping a job most weren't qualified to do in the first place. The prevailing philosophy: Hate everything, sign nothing . . . keep your job! And whatever you do, don't

lose the schmooze account. A typical day in the life: to work by 11:00, lunch at 12:30, back at 2:30, shuffle paper, fuck around for a couple of hours—schmoozing on the phone with other hangers-on—until leaving for a late-afternoon/early-evening showcase or a "business" meet-up at the local watering hole. Tough gig, eh? If one lucked out and got a promotion, they inevitably hired down for their replacement—fearing anyone with real talent would soon surpass them or take their job.

Standard operating procedure: wait for something to hit, then sign a million things just like it. Star making via Xerox. If they happened to stumble across something unique, they immediately tried to change it into whatever was currently popular—destroying any uniqueness the act originally possessed. In times of prosperity, they flung shit against the wall, hoping something would stick. If, by chance, something did, they happily took all the credit, claiming to have the kind of rare intuition that can spot a diamond in the rough. In the case of New Pop Eden, no one was willing to risk his precious expense account to see if we could become a hit act. More precisely, our shit didn't stick because no one had the guts to fling it against the proverbial wall.

About this time, Dad sent me my first guitar. While my sister was out performing, I'd noodle around on it and write songs, demoing them on a four-track Jason lent me. It was great for me because Beau didn't care who wrote the material as long as it was good. He took my initial ideas and helped mold them into decent songs.

Aaron, Pop Eden's lead singer, was into his own vibe. His lyrics were artsy-fartsy and vague. Even melded with really strong melodies, they were too esoteric to make it in mainstream pop. Ever so sensitive, Aaron was offended if anyone suggested a lyric change. In

spite of our differences, we tried to make it work. But when we started hearing from labels that the lyrics weren't cutting it, we knew something had to give.

Unbeknownst to us, Beau cashed in a favor, securing a development deal with Atlantic Records. A friend of Beau's at Atlantic arranged for us to record a few sides in Rumbo Studios, where Guns N' Roses recorded *Appetite for Destruction*. We busted out eight songs in a just a few days, and Beau mixed it. Unfortunately, it didn't turn out like I'd hoped, but since he'd had lots of success mixing his way, I tried to stay positive.

He turned in the mixes to a V.P. at Atlantic. Without so much as a how do you do, he passed. We later learned it wouldn't have mattered if it had been Michael Jackson's *Thriller,* because the Veep had a personal vendetta against Beau. It turned out that when Beau was having tons of success in the '80s, he made some enemies. This fucker turned out to be one with a long memory. It was payback time, and we became the innocent victims of it. (It's rare for anything that happens in the music business to be about *the music*. It's almost always about something else: the battle of egos, who owns the publishing, whose uncle runs the label, or who has the biggest political dick. In this case, the something else was revenge.)

All our hard work was for nothing. Immediately, the band's differences emerged. Aaron and Dan weren't really digging the style of music Jason and I were cranking out. So we decided to part ways.

Once again, I learned a lot from the whole experience. It helped me realize the importance of songs and to understand structure: how to cut through the fat and construct well-crafted tunes. I also learned a lot about how the music biz worked. At the time, it seemed

like a bummer not getting signed, but it was a blessing. There were bigger things ahead . . . but bigger ain't always better.

Jason and I got involved in another project with more of his Canadian friends. This time, it was a guitar player, Theo, and his wife, Carmen. From the beginning, I wasn't a fan of the material. It was like a "B" version of Alanis Morissette. As soon as I heard her first song, I knew we would be inundated with even worse Alanis knock-offs. And, baby, there were a fuckload of them.

Once again Beau came on board to try and shop this project, which was extremely short-lived for me. I had too much respect for music to be part of this bullshit. I wanted to do music I liked and get a deal for doing something I believed in. I'd sacrificed a lot up to this point, so I thought, Fuck this, I'll start my own project.

I was burnt on what was happening musically in the world anyway. Nu metal was the flavor of the day, and I wanted no part of it. Metal appeared to be moribund. I decided to do a complete one-eighty. I'd always had a huge love for '80s-style new wave music. Devo had been a big influence on my desire to do music when I discovered it as a six-year-old. I've mentioned my admiration for Prince, David Bowie, and Duran Duran. So I decided to get a keyboard and do my version of techno pop. (Dat's right . . . fucking techno pop!)

I wanted to write it, sing it, produce it, and record it like Prince. But first I needed equipment. To equip a modest home studio, I took odd jobs on the weekends, along with a horrible office job where I sat forty hours a week doing mind-numbing data entry. I also did landscaping and cleaned houses—even scrubbing people's fucking gross birdcages. I worked my ass off and finally scraped together

enough to buy a Roland sixteen-track hard-disk recorder. Soon I added cool Tannoy speakers and a Roland JX-305 keyboard. I also purchased a LinnDrum like the one Prince used. It didn't take long to learn how to operate the gear.

I began writing and recording songs right away, and it started to click. I stumbled upon a cool sound and direction and completed a record in no time. Totally nouveau new wave, I needed an appropriate persona and chose the name Dynamite. Thinking I had something commercial, I soon discovered (surprise) that nobody would bite. Although Beau tried to help, no one bought it. Thinking that once someone saw me perform they'd get it, I decided to do a one-man show with me on keyboard, wearing a wireless headset mic like the '80s artist Howard Jones (not the singer from Killswitch Engage). Fortunately, none of this exists on YouTube!

Desperate to have a chance of getting noticed, I knew I had to create something "different." My girlfriend at the time, Abby, agreed to wear fetish outfits and go-go dance onstage. Holding nothing back, I painted my body in fluorescent body paints that really popped under a black light. I donned crazy-looking fluorescent-yellow contacts and dyed my hair to match. I looked like a complete freak, but I was able to secure some gigs at various dance clubs around LA. All the while, I wrote more songs until I had enough for a second album. (I still have a few hundred CDs I'm willing to part with for a thousand bucks each!)

I continued shopping material and finally got an offer to put a song on a compilation album in the United Kingdom. As no offer to sign me outright was forthcoming, I kept shopping. I found another label willing to put out both albums. I got really excited until I saw

the contract—a total rip-off I couldn't force myself to sign. Before I could regroup and give it another shot, yet another opportunity presented itself, prompting a period I've since affectionately christened Three Years I'll Never Get Back.

Theo and Carmen reemerged in a new band (I'll call it Snow, still another name for cocaine) that was starting to get a big buzz around town, drawing huge crowds. It was a gimmicky, crazy-costume-wearing live show, like a poor man's Cirque du Soleil with a Pink doppelgänger as lead singer. When their drummer, a member of an '80s hair-metal band, was fired for extensive drug use, Theo called and asked me to fill in until they found a permanent replacement. I needed a break from wearing every hat in my own project—plus, I missed playing live. So I agreed to do it.

Snow's first show was insane, totally sold-out to a wild-ass, enthusiastic crowd. I thought this band just might get signed and be an easy way for me to make a record, go on tour, and escape the fucking struggles of trying to exist as a musician in LA. Even though I thought the music was inane—and soon realized Carmen was a head-case control freak—I was fucking burnt on working a boring day job, being rejected by labels, and playing dives with two people in the audience. So, in spite of feeling like I was selling out, when Theo offered the gig on a permanent basis, I caved.

In no time, Snow was SRO at big venues like the Key Club, even on a Tuesday. We were the buzz of Hollywood. Label reps peopled every gig. When offers started pouring in, I finally allowed myself to get excited. Snow was the hottest thing in town. Labels were champing at the bit to sign the band; that is, until the old fear bug started biting everyone. Remember the sign-nothing-and-keep-your-job

policy? Once label heads discovered Carmen's age (pushing the big four-oh, although she looked younger), word spread and the death knell sounded. Offers were withdrawn.

The industry's really brutal that way. If you're too old, they can't control you and mold you into their moneymaker, so they run the opposite direction. Young and naïve artists tend to have more of a threshold for pain; it helps to be uneducated as far as the business goes, because newbies are willing to go through shit in order to achieve their dreams. The last thing a label wants is for you to know how things work, because it's harder to take advantage of you. Besides, it's tempting to drink the Kool-Aid just to get in the game. (I should know. I've consumed more than a Jim Jones Kool-Aid junkie.)

I was torn about leaving the band at that point, because we continued to sell out every show. Though Carmen was insufferable, Theo was a great guy and incredibly talented. Because I really liked him, I struggled with whether or not I should stay on. With my luck, I figured the minute I said adios, they'd get signed. So I stuck it out—for *three fucking years*—totally losing myself in the process. With each passing year, I built up even more resentment from the fact that I allowed myself to stay in something—something I didn't even like—for the supposed "big payoff." (Anyone detect a pattern here?) It was like being stuck in a shithole in the ground and trying to dig myself out.

To make a living, Jason had been playing guitar in a few different bands. He'd recently joined the solo band of Vince Neil from Mötley Crüe. Financially stable, he was ready to upgrade his living situation, so we decided to get a place together. That change happened at just the right time. And it would be easier to work on our music together. However, the reality was that he was rarely there.

It was hard watching him have fun touring the world while I worked a boring data-entry job in Sherman Oaks. We'd started his first solo record in between tours, but now he was gone so much, it was difficult to complete the fucking thing. I'd been planning to use those recordings to find another gig. I felt like time was running out and my dream was fading fast.

To add to my depression, my grandma Heyde died. In a way it was a relief, because she'd lived the last decade of her life in a nursing home, suffering from Huntington's chorea (the same hideous disease that killed Woody Guthrie). It's one of those weird genetic diseases that turns you into a human mobile. If that wasn't bad enough, my dad's sister died of ovarian cancer two months later. I loved Sherry, my only aunt, and her death—in such close proximity to Grandma's—really devastated me. Couldn't get much worse, right? Wanna bet?

Before I could get my bearings and begin to process the loss, I found out my parents had decided to divorce after thirty-five years of marriage. Three years earlier, they'd invited my grandma Evie to come live with them, and it resurrected old issues between her and Mom. Old resentments—like Mom blaming her for her father leaving—resulted in major confrontations that always put my dad in the middle. After nearly sixty years, he thought it was ridiculous for them to keep harping on the same unresolved crap. Having recently lost his mother, their bickering made it even more unbearable. He finally said he needed a little peace in his life and, that quickly, the marriage was caput.

To turn this tragic scenario into a bizarre situation comedy, when Dad returned from settling my aunt Sherry's estate in Topeka, Kansas, he discovered that Mom had "moved" to be near my sister

in a Chicago suburb—leaving her mother in his care! (This farce could be another chapter unto itself, but know that after three months, Dad took equity out of the house and moved Grandma back to St. Louis to be near some of her relatives.

Multiple deaths and a devastating divorce, all in the matter of a few months. Christ, wasn't there anything I could rely on? My abandonment buttons were pushed to the max. Suddenly I was questioning everything and everyone. I felt betrayed and ungrounded . . . and deeply sad.

I'd never really gotten comfortable in my own skin the whole time I'd been sober. I'd somehow managed to stay sober, even through the worst challenges. It had been more than fourteen years since I'd touched a drug or any alcohol. Everyone I knew used or drank, at least occasionally. Yet I never allowed myself to because I was told I was a drug addict who couldn't handle even one little sip of alcohol. All this just added to my anger and misery.

Changes were needed . . . and fast. I told Theo I was out. I broke up with Abby after five years of living together, and immediately started searching for something fun to take my mind off things. I found an ex-stripper to distract me. That was pretty short-lived, as she and I had little in common other than the fact that we liked some of the same music. I didn't love her and I certainly didn't want to settle down with her in her tiny-ass studio apartment. The negatives continued to pile up. Everything contributed to my depression: the music biz, my job, and my sobriety. It wasn't long until I found my way to Angel . . . and that first sip of wine that led to the next thousand. Even though my addictive behavior was on the rise, for the next eighteen months, I started to regain my emotional footing.

And then . . . the universe plopped a big ol' cherry bomb on top of an unbelievable shit sundae. That's when I got an e-mail from Dad that shook me to my very foundation. It said he'd fallen in love with a man and they were gonna live together. His bisexuality had never been a secret, and I shouldn't have been surprised that after thirty-five years of marriage, he was ready for something different. But instead of choosing someone in the vicinity of his own age— fifty-seven—leave it to my dad, who never did anything in a conventional way, to choose someone a decade younger than I was. This wasn't one of those older men playing daddy to a younger, penniless cub. Hardly. This guy came from a very wealthy family, and he'd given up a sizable trust fund to be with my father. Still, none of that made it easier for me to accept.

Dad had always been someone I could turn to for advice. He was my best friend. We both loved sports and had gone to college basketball and professional football games for years. We shared a love of music. We had lots in common, including an irreverent sense of humor. But this shocker was too much! It made me feel like I was being replaced by a total stranger. It really hurt, and it didn't go down any easier finding out in a *fucking e-mail*. Why this . . . and why now?

I tried to look at it spiritually, but it was a challenge. I kept thinking, What am I supposed to do, sit around during the holidays and make small talk with a twenty-one-year-old? I spent the next few months trying to process the whole thing, and finally reached the conclusion that love is love. Like Dad, I'd never been one to settle for the conventional approach to anything. If he and Brad had a connection and wanted to be together, who was I to question it? (After I finally met Brad, he turned out to be a cool guy, and I was glad my

273

dad was happy. They live in Canada and have been together for a decade.) However, initially, it pushed my buttons and made me more sensitive and insecure.

As noted, I'd been through some difficult periods before, but suddenly my life appeared to be heading into the shitter: a train wreck. As hard as I tried, I couldn't see a light at the end of the tunnel. And if I did, I feared it would be an oncoming train. Even more depressing, musically I had nothing happening and nothing on the horizon.

In total despair, the universe acknowledged my pain and tossed me a bone, or so I thought. Out of the blue, my ex hooked me up with W.A.S.P. I couldn't believe my good fortune. Without rehashing it, it proved to be a short-lived fiasco with Blackie and the boys. What looked like a real opportunity to play with a legendary band quickly devolved into another major disappointment. As the cliché goes, that was the last straw. In my mind, I'd contributed my pound of flesh. For a decade I'd withstood every disappointment, managed to overcome every hardship. But after announcing to everyone I knew that I was to be a member of W.A.S.P., only to have it fall through . . . I decided I'd had enough. That's when I called Dad to say, "I'm giving up." Fortunately, he talked me into one more try— which led to the creation of Death Punch. Pretty sure there's a lesson in there somewhere. I'll leave it to you to determine what that is.

So that brings us full circle. If you've been skipping every other chapter, searching only for Death Punch goodies, you've missed out on what made me . . . *me*. But you'll be happy to know that the next chapter describes the culmination of an out-of-control addict who was about to face the Reaper once again . . . and probably for the last time.

CHAPTER 15

THE BEGINNING OF THE END

2010

eath Punch launched the ten-week Share the Welt tour. With my body still fucked, I decided this tour had to be a sober one or I wouldn't survive it, physically or mentally. On the road, with the help of the chiropractors and massage therapists we lined up in various cities, I worked hard every day to rehab and get back into playing shape. I stretched more than an hour every day. It took a couple of weeks before things started realigning and I could actually play.

Before I left, I told Angel I had no intention of being "exclusive," and if she didn't like it to please, for the love of God, find someone else. Her welcomed response: "Just don't tell me . . . and it'll be all right."

Knowing I had the green light, I wasn't all that anxious to hook up. However, about two and a half weeks into the tour, in Boise, Idaho, our security guard walked two hot chicks backstage before the show. I pulled them into the dressing room I shared with Jason. They wanted booze, so we sent our security guard to purchase some. After the show, Jason and I escorted the girls back to our dressing room.

Both sober, he and I drank nonalcoholic beer while the two girls chugged the real thing. Jason hadn't had alcohol for two years, only blow. We'd been drinking for a bit when I noticed that he'd picked up one of theirs by mistake.

"Dude, that's *real* beer!"

He pulled it away from his lips and in disgust said, "Aw, shit!"

Instead of pretending it was an accident, no big deal, I added, "You might as well enjoy it now—you've technically relapsed." (What a dick!) Then I used *his* "relapse" as an excuse to drink a real one myself. With that icebreaker, I power-slammed four in short order. I figured, if I'm gonna dive off the fucking cliff, I might as well do a cannonball. I soon found the beer lacking, so I sent someone on the hunt to get a bottle of Jack. No reason to tiptoe into a relapse. Bring it the fuck on!

We took the girls back to their car. That's when the real drinking started. The hunt for cocaine soon followed. I woke up the next day majorly hungover and feeling really guilty. So much for touring sober. I was back on the party train, and I was determined to stay on it, even though it was destined to crash.

Angel called and said she'd decided she wanted me to be honest with her after all; if I fucked someone, she wanted to know *all the details*. (Talk about the need to experience pain.) She said she was tired of me being resentful toward her for having to hide my encounters. Wasting no time, I met a cute little Latina in San Antonio and took her with me on the bus to the next city. It was a cocaine-fueled sex orgy all the way.

Suspecting I had someone on the bus, Angel flew to Oklahoma a few days later. She kept after me, insisting on knowing who, where, and what. I was drunk, so I decided to supply her with all the details of my recent escapade—testing our new agreement of "openness." Honesty, in this case, was far from the best policy. She went ballistic. For four days, we fought continually. I was miserable.

I remembered she'd been prescribed Adderall, so I stole some from her purse. I crushed and snorted them. Not bad. I couldn't

277

remember the last time I'd been so alert. When she caught me taking more, she tried to hide the bottle. That really pissed me off. The arguing accelerated. I insisted she fly home. I couldn't wait for her to leave so I could have what I hoped would be fun. The minute she was gone, I upped the ante.

After that first drink in Boise, my desire to party had escalated. My hatred toward myself—and pretty much everyone in my life—was at an all-time high. I made a conscious choice to destroy myself on this tour and see whether I could survive it or if it would kill me. Either way, I was ready for it.

The routine consisted of snorting cocaine and drinking all night after a show. I'd sleep until four in the afternoon, then drag myself to a meet and greet with the fans. After forcing down some food, I'd go back to bed until an hour before showtime, get up, make a pot of coffee, and start warming up. After hacking my way through the show, I'd pour a red Solo cup full of Jack Daniel's, adding just a splash of Diet Coke to top it off (an homage to my grandpa Dutch's cola-and-Old Crow highballs). I'd chug it, then ramp it up with cocaine.

I did this every single day. Nothing could deter my quest for stimulation. I added a daily pack of cigarettes to the mix because coke and booze made me want to smoke and talk. We'd stay up all night in the jump seat next to the bus driver, chain-smoking and yakking away half the night.

I balled everything I could on the tour. I wasn't very selective. A perfect example was a stripper I brought onto the bus. In between blow and drinking, we tore each other up. The next night Jason rode my bus because he wanted to party. It wasn't long before he and my stripper chick were getting flirty; they went into the back lounge and locked me out. WTF! I repeatedly pounded on the door, pissed

I'd brought her with me only to have her lock me out while fucking my friend. I kept pounding until I heard her say, "You're acting like a dick." Even in my inebriated state, I found it difficult to understand how I was being a dick for getting locked out of the lounge while she was servicing my buddy. Okay, fine . . . I could get blitzed without her. And believe me, I did.

To top off the shit salad that had become my daily fare, Angel insisted on coming out on tour *again* . . . for Thanksgiving. I could find little to be thankful for, particularly after she stole my phone password and read all my text messages. I'd gone out of my way to be honest with her about my tour agenda, but that wasn't good enough. Oh, no! She needed to torture herself with all the details, and there were plenty of damning details in my phone.

I knew then that as soon as the tour was over, I was ending this madness once and for all. Aware that this time I was deadly serious, before she left, she asked me to buy her some fake boobs as a parting gift. Feeling guilty, I gave in. Eight thousand dollars' worth of silicone! Guilt, under the influence of booze and blow, can be very persuasive. Though fake boobs never did anything for me, I decided she'd more than earned them. She'd wanted them forever and, having put her through a hundred kinds of hell, it only seemed right.

Jason knew my situation with Angel. He said, "Dude, now that you're breaking up with her, you're buying her boobs? I don't get it. You're basically sending her out with a new lease on life at age thirty-six. It's like you're setting her up to find your replacement. If I were you, I'd make her sign over your dog Bean in exchange for new knockers."

That may sound ridiculous, but he knew how much I loved Bean. This little Chihuahua knew all my secrets and was still there to give

279

me unconditional love. In my inebriated state, Jason made a lot of sense. So I called Angel and told her that in order to get the boobs, she had to put—*in writing*—that Bean was mine. She agreed! I drafted up a contract. (Pretty rock 'n' roll of me, eh?) I thought, If I live long enough to tell my story, this will be one for the book.

She ended up signing my homemade contract, but reworded it to read that when we officially broke up, Bean was mine . . . but the boobs were a Christmas present. (Clearly, I wasn't the only one who was fucked up.)

I staggered across the finish line of the tour. I'd never been more relieved to see the gaudy lights of Vegas. I may have survived the tour, but that didn't mean I had to end my suicidal game. Besides, the game was rigged. I controlled the dealer and held all the cards. Instead of folding, I went all in. I'd barely walked in the door before I ordered a ton of cocaine. For the next two days I orchestrated the perfect storm of drinking and snorting my brains out.

During this feeding frenzy, I made it impossible for Angel to reach out. I cut her off at every turn. There was no way I was going to let her manipulate me into giving "us" another try. There was no *us.* I was through pretending it was ever going to get better. I'd put myself in jail and kept myself there, and I was determined to let myself out at last, one way or another. I was the jailed but I was also the jailer—I had the key all along. If destroying myself was the only way to free myself, I was determined to make it a spectacular end.

At some point during this drug-and-alcohol orgy, Angel came downstairs and planted herself on one of the steps. Won't she ever just give up? I thought. But instead of trying to guilt me into "one

280

more try," she said, "I've finally had enough. I can't do this any-more." Unlike all the other times, she was calm and resigned. I knew she was sincere.

This was my chance to be a little understanding. Instead, I replied, "Cool, be out by Tuesday."

She was finally giving me an opportunity to take control of my life, and I wasn't going to fuck this one up. Of course, while I waited for her departure, I made sure to verbally abuse her and do as many drugs and booze as I could.

My routine over the next week was to go to a bar by noon, get drunk as fast as possible, then order an eight-ball of cocaine. I did that four days in a row. Near exhaustion, I'd get a few hours of sleep, then repeat the process. My friends were calling and texting me with concern. Even my drug dealer knew I was in trouble.

"Man, you're going pretty hard."

The last goddamn thing I needed was a lecture on the sanctity of life from the man who was helping me kill myself.

"How fast can you get here with more blow?"

"Sorry, man, I'm not gonna sell you another eight-ball."

"Half a ball, then." No way was I taking no for an answer.

Even though he'd received texts and calls from my friends and my security guard, threatening to beat him up if he sold me more cocaine, my persistence finally wore him down. Besides, he knew if he refused, I'd get it from someone else. Ironically, I'd just met a friend of our security guard, and he sold me blow on the down low. All I had to do was get him high, and I knew he'd continue the supply. Either way, I'd score.

Though Angel and I were through, she couldn't move out until she found a place. Since I'd been supporting her for the last few

years, she had no money, belongings, or a real job. She been pursuing certification in Pilates instruction so she could start building a clientele, but until that happened, she was going to need my financial support. She agreed to stay in a hotel—giving me some alone time in the house. I took advantage of her offer and drove her into town.

Those few days alone weren't much fun. Knowing I could keep Angel in a hotel for as long as I wanted, I arranged to fly out a chick I'd met on tour. I'd already booked her flight when my home phone rang.

"I'm not staying in this hotel another night! I'll call a cab and be there tomorrow."

"Fuck it," I said. "You stay here and *I'll* get a hotel room." I quickly packed a bag and left for what would be the finale.

The next day I picked up the chick from the airport and headed for the Mandalay Bay. A meth addict, she'd been up all night. I decided we could both benefit from some food. We went to dinner, blowing a wad of cash. It was quite the extravagant feast, which we washed down with a few martinis. I kept texting my dealers, but no one would answer. I was on the verge of getting really pissed until she told me she had meth. Just knowing I was going to get high gave me a euphoric rush.

We purchased a refrigerator-size bottle of Jack Daniel's and some smokes on our way to the room. Once inside, we started carving lines of meth. The music was blaring, the drinks were sloshing, and smoke choked the air. Our clothes came off and the party moved into the bathroom, where it continued in and out of the Jacuzzi for several hours until she finally passed out.

I power-slammed as much booze as I could to come down, hoping to pass out myself. It worked for about an hour, until my eyes

sprang open and I was wired awake again. I started pouring drink after drink until I finally reached a dealer, who showed up with a shitload of coke. To thank him for the score, we went downstairs and sat in the lounge, drinking.

When we got back to the room, the chick was awake and angry I'd left her alone. I got rid of the dealer. When I showed her the blow, she calmed down. We did multiple lines, which resembled furrows in a snowy field, before plowing through them as fast as we could. During minibreaks from some pathetic attempts at sex, we continued snorting until she finally passed out again.

As I lay there, dazed and destroyed, my heart began thudding in my ears. The double bass was pounding in my chest . . . and then it skipped a beat before it began an irregular palpitation. I grabbed my chest, hoping I could force it to stop, but it wouldn't. Nothing I could do helped. Electrical impulses were directing the rhythm section, thirty-second beats followed by a set of pulverizing quarter notes!

I started convulsing. My heart was spasming. Though I was burning up, my body shook like I was freezing. Flop sweats, like those I'd experienced following a horrible dream, drenched me. But this wasn't a dream. This was the worst kind of reality.

As my mind raced, one thought prevailed: You really fucked up this time, Jeremy. You finally did it, ol' buddy. You've gone too far . . . and there's no way back. This time . . . you're gonna die . . .

EPILOGUE

As I write this, I've been clean and sober for two years and two weeks; that's 744 days. Having previously experienced sobriety for more than five thousand days, I'm only too aware of how the specter of drugs and alcohol continues to hover in the corners of my consciousness, awaiting the opportunity to dominate, derail, and destroy my life . . . once and for all.

Having read your way through some pretty ugly and disturbing sections of my story, I hope you can tell I've tried to be brutally honest, albeit with a measure of my twisted humor.

When I began the process of healing on January 8, 2012, the intention behind telling my story was therapeutic. I needed to clean out the garbage in an effort to make room for positive change. What I discovered along the way is that I share much in common with many fans, some also in recovery . . . and others who are struggling. That initial draft eventually became *Death Punch'd*. And, with it, the hope that my story might benefit others.

My journey toward recovery began with admitting myself to a drug-rehab program and engaging in therapy to work on my unresolved issues (low self-esteem and anger primary among them).

Initially I also attended some twelve-step recovery programs, but soon found I couldn't just be another anonymous person seeking to remain abstinent. Once someone discovered I was in a band, things changed. In short, those types of meetings don't really work for me (although if I felt an overwhelming desire to use again, I'd go to one in a second).

What did seem to work for me was the decision to quit harming myself . . . *and meaning it.* A strong connection to my higher self, asking for guidance, asking for the tools I need to do whatever will make life better, asking to be "used" for a higher purpose, taking part in a daily regimen of positive affirmations ("as a man thinketh in his heart, so he is!"), and making a concerted effort to eat healthy and exercise have helped me to feel better now than I ever have.

My relationships within the band have improved along with my attitude. In the past eighteen months, I won *Revolver* magazine's Golden God award for Best Drummer of 2012, been on the cover of *Drum* and *Tattoo* magazines, helped create the franchise *Uncle Colt & Cletus* (with some exciting prospects on the way), and written the memoir you've just read.

Five Finger Death Punch released two incredibly strong albums in 2013. *The Wrong Side of Heaven and the Righteous Side of Hell: Volume One* debuted at No. 2 on *Billboard*'s Top 200 Album chart in August, and *Volume Two* also debuted at No. 2 in November. The first two singles went to No. 1 on rock radio. In support of the albums, we've toured the United States and parts of Canada, Scandinavia, Europe, and Australia. New and exciting band projects are already in the works for 2015.

It is my desire to use my experience with the "dark side" and my ongoing recovery to help others—especially disenfranchised teens

with addiction issues. I'm very fortunate to have this opportunity. Many other rockers' lives followed a similar path; however, they weren't lucky enough to survive the fatal "death punch." With the help of my loving family, my friends, and fans, I hope to show others that there's another way . . . that there is *always* hope.

Thanks for coming along on my journey, which I laughingly call *Cheers to My Sobriety*. Though every day brings a new challenge, with the guidance of my higher power, I can summon the inner strength to forge ahead . . . and celebrate the creative process that is life.

Rock on!

–JEREMY SPENCER
JANUARY 22, 2014

ACKNOWLEDGMENTS

First and foremost, I want to thank my mom and dad for their incredible unconditional love and support throughout the years. I couldn't have asked for more loving and awesome parents! I love you.

To my sister, Natalie, who has always been there for me when I needed help: I miss our days of watching '80s movies and dancing around the living room.

To my bandmates and brothers: What a hell of a journey this has been. I have nothing but love and respect for each of you. You've helped me achieve dreams far beyond my wildest expectations. I'm honored to be alongside you for the ride, even though there have been days when I've wished it could have been us who crashed in the plane instead of Lynyrd Skynyrd. Seriously, thanks for being supportive of me writing my story. I look forward to reading yours.

To Bobby, whose humor and friendship continue to make the tedium of touring bearable. Thanks, buddy.

To all of my fantastic friends back in Indiana: I miss and love each and every one of you. You helped prepare me for this dream, and I will always cherish the times we shared together.

ACKNOWLEDGMENTS

To my management: Thanks for kicking ass every day, and for helping with the process of this book. I hope you've seen some growth in my character and no longer have reason to dread my phone calls.

To my agent, Kirby Kim, at William Morris Endeavor: Thanks for all your expertise in helping shape this project.

To my editor, Mark Chait, at HarperCollins: Your enthusiasm and insight have made this entire process so enjoyable. Thanks for your encouragement and professional guidance. I'm honored to have worked with you and your colleagues—including Bethany Larson and Heidi Lewis.

To Angel, a huge part of my life: I can't express how sincerely sorry I am for my ruthless and insensitive behavior, for how alcoholism and addiction altered my personality and made a lot of our time together so unpleasant. We served as mirrors for each other—illuminating areas where we each needed to grow—and for that I'm grateful. I wish you only the best, now and in the future.

And, lastly, to the fans: Many of you have been with me and Death Punch from the beginning. I hope you know that in spite of my personal problems, fueled by addiction, I've always been grateful for your love and support; it has given me a reason to keep going. Thanks for allowing me to grow and to become a better person. Your unbridled enthusiasm and genuine concern continue to help me more than you'll ever know. You rock!

In loving memory of Josh Wright

ABOUT THE AUTHOR

Jeremy Spencer, cofounder and drummer for the metal band Five Finger Death Punch, received the 2012 *Revolver* Golden God's award for Best Drummer and was named Best Drummer of 2013 in *Loudwire*'s Music Awards. He is the son of country-music songwriter Gary Heyde, who is also a novelist under the nom de plume Austin Gary, and actress Glory (Kissel) Heyde. Jeremy is known for his wicked sense of humor and his YouTube video pranks.